LOST WORLDS

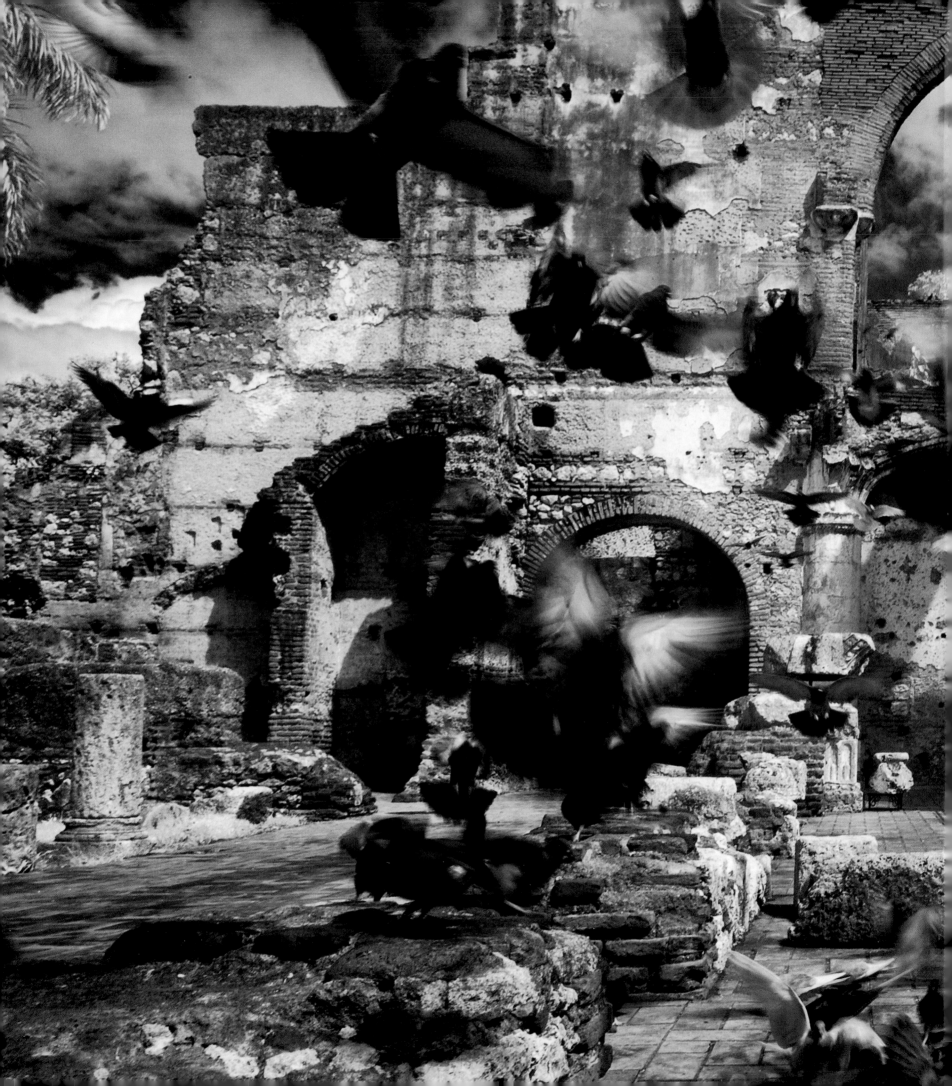

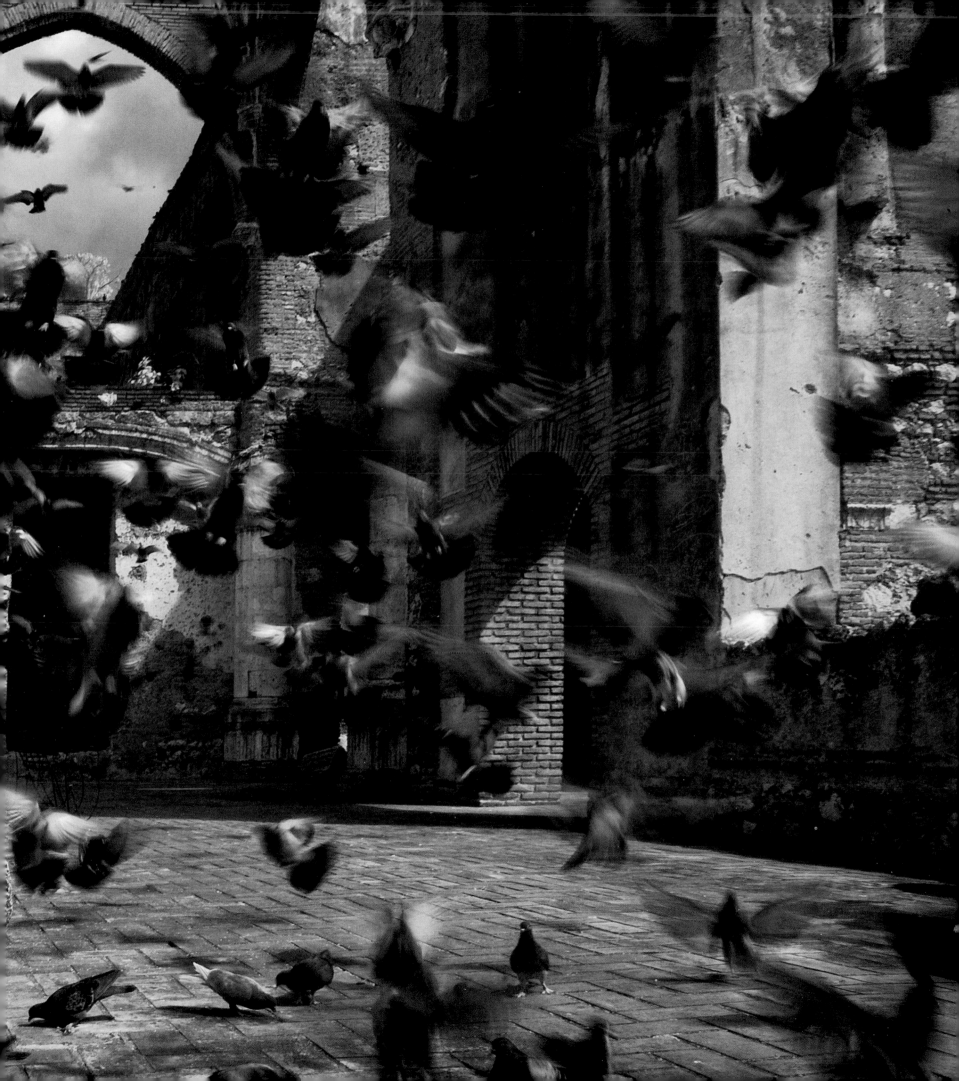

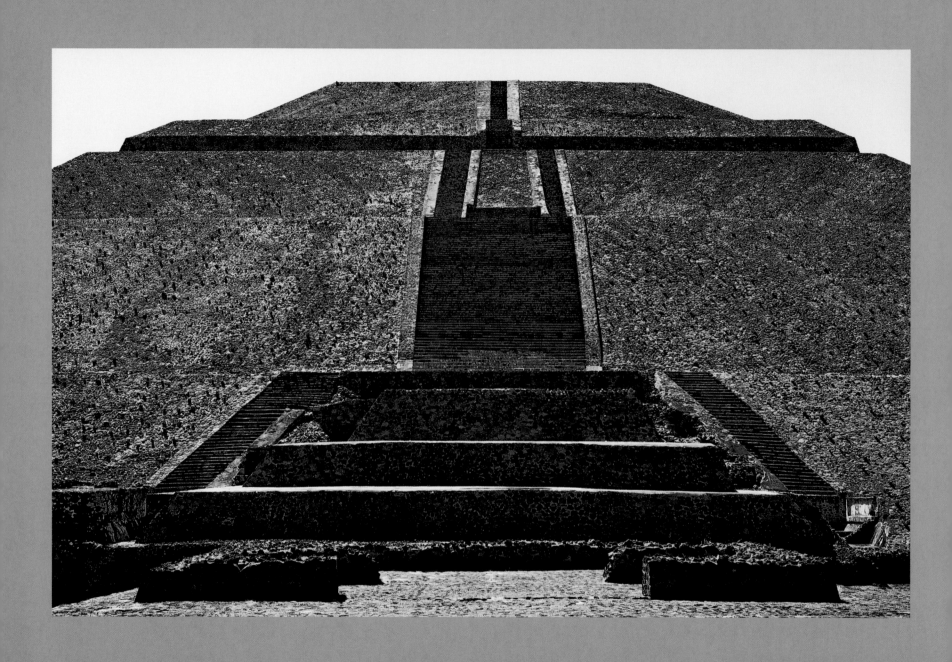

LOST WORLDS

Ruins of the Americas

PHOTOGRAPHS AND TEXT BY ARTHUR DROOKER

FOREWORD BY PICO IYER

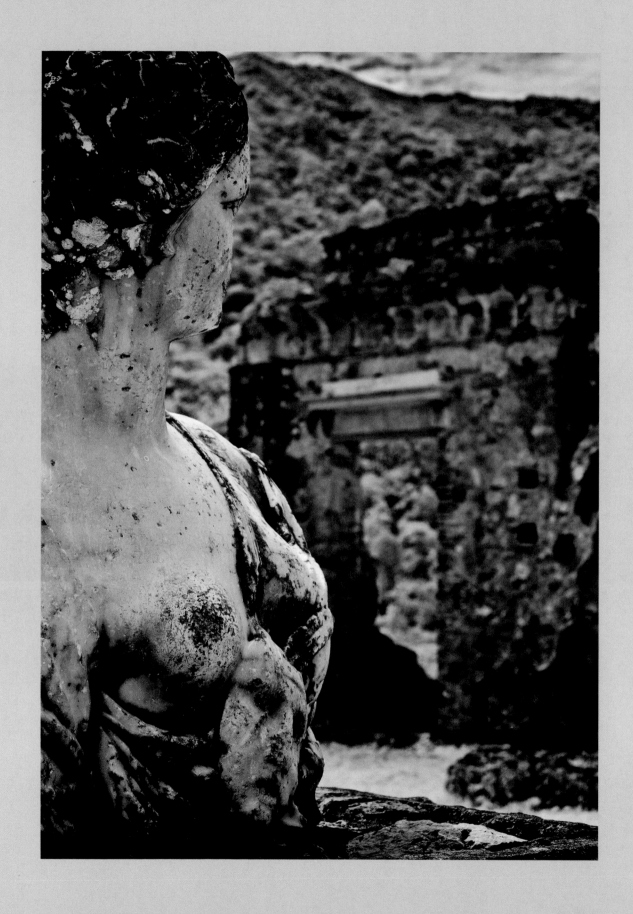

FOR IVY

MEXICO

ATLANTIC OCEAN

Tula El Tajín
 Uxmal Chichén Itzá
Teotihuacán
 Kabah, Labná, Sayil Sans Souci
 San Nicolás de Bari
 Mitla Palenque Tikal Folly Mansion
 Sugar Mill Ruins

Church Ruins Copán CARIBBEAN SEA Brimstone Hill Fortress

 Mt. Pelée Ruins

 Mansion at Farley Hill

 Panama Forts
 Panamá Viejo

PACIFIC OCEAN

 SOUTH AMERICA

 Chan Chan
 Machu Picchu
 Ollantaytambo
 Sacsayhuamán

 Tiwanaku

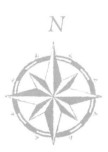

N

Jesuit Missions of the Guaranis

CONTENTS

THE SELDOM SEEN POWER OF DÉJÀ VU

BY PICO IYER

I had just stolen out of my fifteenth century high school in England, with its Gutenberg Bibles, its medieval cloisters, its long rows of names of the dead on every other wall, when, at the age of eighteen, I took a bus from Santa Barbara, California, down to Tikal in Guatemala, the jungles of Colombia, and the great ruined cities of Peru and Bolivia. I remember finally riding on horseback for hour after sore-bottomed hour through the wilderness near San Agustín in Colombia to come upon statues that, my ten-year-old guide assured me, were still barely tamed by tourism, and falling into a ditch as the night descended around the haunted buildings of Tikal.

When I took the long drive out across the desolate, entirely empty, blue-skied Altiplano, to see the faces and underground courtyards of Tiwanaku, barely excavated, it was as if I had come upon a question that none of my formal education had prepared me for. A question that, I realize now, I will never answer, and one that seems much deeper and more penetrating than any conclusion I could come to.

The underlying power of these haunted sites—the mystery of their presence, their undying presence of mystery—came back to me with eerie force when I began looking through the extraordinary assembly of ancestral memories that Arthur Drooker has gathered for us here. So many of his images are the opposite of simple: they take us into complex patterns of light and shadow, to forces of movement in an unearthly

stillness, to ancient places that seem weirdly pristine, as if no one has yet managed to domesticate or bring them under control. Though his sites are often associated with cultures we think of as dead, many of them could not seem more alive or brooding, sometimes almost uncomfortably so; though we travel to them in search of our own and our culture's moments of déjà vu, some point unexpectedly into the future.

I have traveled back again and again, over the space of twenty-eight years, to Tiwanaku, but I have never seen its subterranean temple, so prickly with sharp angles and staring heads, as I see it here. And while many of us feel we know a little about the ruins of South and Central America, who has thought to look for—let alone find—them in Barbados, St. Kitts, and Martinique? For many of us, these places are framed in too-simple postcard images of blue skies and sandy beaches; but the specially adapted infrared camera that Drooker carries brings back a sense of jaggedness, of imminence and unruliness, in these over-visited and under-observed places that no color print could catch. In Santo Domingo alone he somehow captures images that not only seem to belong to some place in the mind, or the shadowed imagination—not many viewers would be able to situate them in the Dominican Republic—but also hold us as might the lines of Shelley's traveler who sees in the desert a ruined statue of an Egyptian pharaoh and reads its inscription:

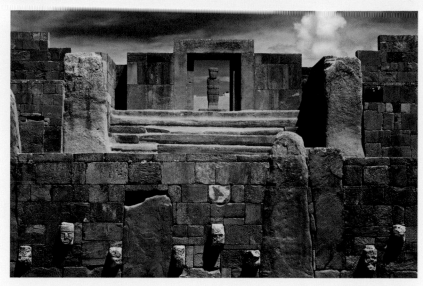

Tiwanaku, Bolivia

'My name is Ozymandias, King of Kings:
Look on my works, ye mighty, and despair!'
Nothing beside remains. Round the decay
Of that colossal wreck, boundless and bare,
The lone and level sands stretch far away.

The skies, it seems to me, are as much protagonists in these images as the places they hover over, which adds a complexity and vibrancy to them that you would rarely see in photographs of only the walls or buildings; and in the Pyramid of Niches, we see its broken pinnacles seeming to defy and try to break through the clouds. Great photographs show us not only what the naked eye could make out but also what the mind begins to see, the heart to feel as a premonition; that is why the image from Panama's Fort San Jerónimo, though as unpeopled as every other, seems to me as much a study of religion as the Graham Greene novel for which it could be a perfect cover.

Those who have seen Arthur Drooker's first book, *American Ruins,* know that he feels uncommonly at home in the presence of the past, those places that prick at us a little in the way of a melody we cannot get out of our head, or our sense, as unanswerable as it is inexplicable, in certain places, that we have "been here before." But in the act of restoration and communion that he shares with us in *Lost Worlds,* he gives us something particular to the Americas, as if, in seeing what the continent has been, we can see what it might be, once the

Transamerica Pyramid in San Francisco is just an outline or New York's high walls of glass are scattered ruins.

When I look at his picture of Sans Souci in Haiti, I see both the picture of a nation that was, excitingly, triumphantly, the first independent nation in Latin America and the shadows and ghosts of all that the country has suffered since, as earthquake follows dictatorship follows massacre.

Many of us can visit any of the lost worlds pictured in this book tomorrow; but it takes a rare eye—and vision—to find in them, as Arthur Drooker does, such life, such intensity, and such immediacy. He reminds us that we travel to Machu Picchu or Copán mostly to find some lost corner in ourselves. Some of these images may look like still lifes; but in most there is still life enough to suggest that vanished worlds are places that still breathe, within us and without. The beauty of the lost world is that there is so much to be found there.

FINDING MYSELF IN LOST WORLDS

BY ARTHUR DROOKER

Lost Worlds represents the culmination of a journey that began in 2008. At that time my first book, *American Ruins*, a photographic survey of historic ruins within the United States, had recently been published and I began seeking a new project in which to immerse myself. Still enamored with making photographs of ruins, I decided to venture beyond my native borders and explore sites in the Americas. The journey lasted nearly three years and took me to more than thirty ruins in sixteen countries.

My intention was to create an eclectic yet representative series of images that offers a visual narrative of the cultures, conflicts, and conquests that forged the New World. With their crumbling façades and overgrown walls, each ruin writes its own chapter in an epic that is all too human yet worthy of the gods in whose honor many of them were originally built.

With each place I visited, from the heights of Brimstone Hill Fortress on St. Kitts to the Subterranean Temple at Tiwanaku in Bolivia, it became increasingly clear that this narrative is not linear but rather cyclical. Civilizations rise, flourish, and fall, only to be conquered or replaced by another. The buildings left behind go through a similar process. A sacred temple in one culture frequently becomes recycled construction material in the next. What architecture survives eventually succumbs to nature's embrace before being unearthed centuries later by a trailblazing explorer.

Moreover, this narrative, being cyclical, has no end. It continues in perpetuity as a reflection of the future. The conditions that led to the demise of the civilizations whose ruins fill these pages, including climate change, depletion of natural resources, political upheaval, and warfare, all exist today. In spite of our technological advances we are just as vulnerable as the Maya and the Inca, two of the greatest indigenous civilizations the Americas ever produced or, maybe more appropriately, ever lost.

In creating *Lost Worlds* I humbly followed in the footsteps of those who established the tradition of photographing ruins in the Americas, a colorful narrative in its own right. The tradition began in 1840, only a year after the invention of photography, when Emanuel von Friedrichsthal, an Austrian diplomat posted to Mexico, made the first known daguerreotypes of ancient Maya cities. They were exhibited in New York, Paris, and London but unfortunately, all traces of them have been lost.

Von Friedrichsthal was inspired to make his daguerreotypes after reading *Incidents of Travel in Central America, Chiapas, and Yucatán*, written by John Lloyd Stephens with illustrations by artist Frederick Catherwood. Hailed by Edgar Allan Poe as "perhaps the most interesting book of travel ever published," it became an instant best seller and a classic of the genre.

Stephens and Catherwood were among the first outsiders to explore ruins in Mesoamerica, a region extending from central Mexico to parts of Central America, where the Maya and other civilizations flourished. As pioneers in the field of pre-Columbian

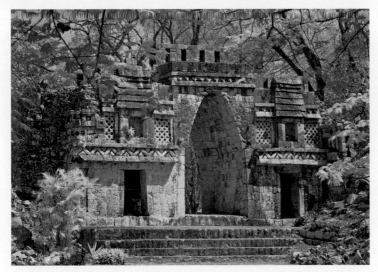

Arch of Labná, Arthur Drooker, 2010

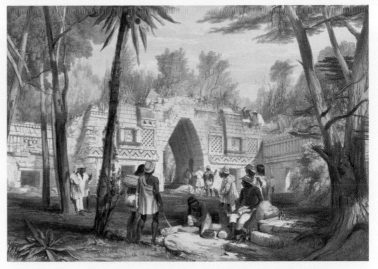

Gateway at Labná by Frederick Catherwood, 1842, Newberry Library/Superstock

archaeology, they made history as they uncovered it. Stephens' passage describing his and Catherwood's anticipation of seeing the ruins at Labná, barely known even to their local contacts, captures the spirit of their expedition:

> *Since our arrival in the country we had not met with anything that excited us more strongly, and now we had mingled feelings of pain and pleasure; of pain, that they had not been discovered before the sentence of irretrievable ruin had gone forth against them; at the same time it was matter of deep congratulation that, before the doom was accomplished, we were permitted to see these decaying, but still proud memorials of a mysterious people. In a few years, even these will be gone; and as it has been denied that such things ever were, doubts may again arise whether they have indeed existed. So strong was this impression that we determined to fortify in every possible way our proofs.*[1]

In 1841 Stephens and Catherwood embarked on their second and last expedition to the region, this time taking a "daguerreotype apparatus" to document their discoveries. After they returned home to New York, a fire destroyed the photographic plates. Despite the loss of what surely would have been historic

images, their sequel, *Incidents of Travel in Yucatán,* became another bestseller.

Von Friedrichsthal was not the only photographer inspired by Stephens and Catherwood. In the early 1850s, Claude-Joseph Désiré Charnay, a young Frenchman, read *Incidents of Travel* and found his calling. In 1857 he arrived in Mexico and over the next three years made what are considered to be the first successful photographs of ancient American ruins using the then-new wet plate collodion process. What makes Charnay's feat all the more remarkable is that he had to overcome many hardships, including intense heat, frequent rain, swarms of insects, and even civil war, to achieve it. Moreover, the French explorer often had to hire large crews of local inhabitants to slash and burn centuries of jungle growth from the ruins, then scour and scrub their façades just to get them camera-ready.

In 1862 Charnay published a collection of his groundbreaking images in *Cités et Ruines Américaines: Mitla, Palenqué, Izamal, Chichén-Itzá, Uxmal,* a large volume that gave Europeans their first photographic look at American antiquities. The pictures received critical praise and helped legitimize the new visual

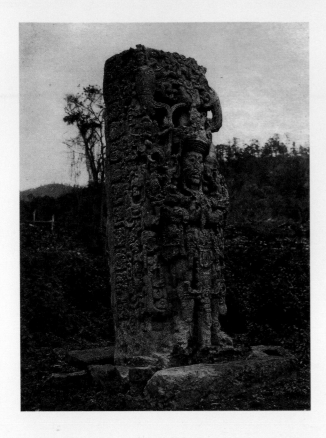

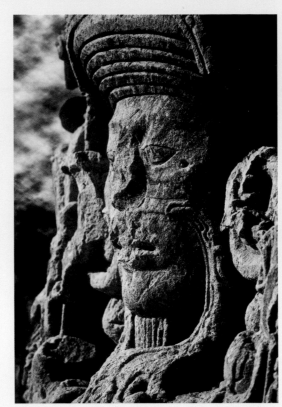

Left: Stela B, Copán, A.P. Maudslay, 1885. Photogravure image courtesy of Chris Webster, Webster Collection, Santa Fe, New Mexico

Right: Stela B, Copán, Arthur Drooker, 2010

medium, which some had dismissed as a gimmick. "Following Charnay's example," wrote Keith Davis, Charnay's biographer, "photography became a requisite tool for serious archaeological research." [2]

Of those who followed Charnay's example, Alfred Percival Maudslay produced the most significant photographs of ancient American ruins. He had traveled to Central America in 1881 merely to escape the winter cold in his native England, but seeing Guatemala's old monuments transformed that vacation into a vocation.

Maudslay returned six times to Central America where he methodically excavated Maya sites, most notably Copán, and documented his finds using the newest advance in photography, dry plate negatives. Like Charnay, he employed *Incidents of Travel* as his guide and endured similar hardships.

In 1902 Maudslay presented his research, including his photographs, in *Biologia Centrali-Americana,* a lavish five-volume compendium that founded Maya archaeology and secured photography's vital role in verifying antiquities.

Though I followed in the footsteps of Stephens and Catherwood, Charnay, and Maudslay, I took my own direction. My illustrious predecessors were driven to document a site, while I desired to capture the essence of a place. They conducted archaeological investigations, while I pursued artistic interpretations. They proved these ruins' existence, while I emphasized their transience.

These differences go to the heart of why I photograph ruins. It is my way of making a personal connection with those who came before us and of preserving what they left behind. In this creative communion I confront my own mortality and become most alive.

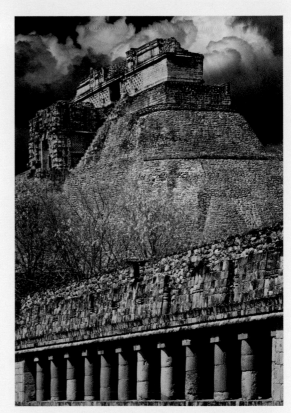

Left: Pyramid of the Dwarf, Uxmal, Claude-Joseph Désiré Charnay, 1860, Washington, The Library of Congress

Right: Pyramid of the Dwarf, Uxmal, Arthur Drooker, 2010

I have three criteria for selecting sites: they have to be preserved as historic ruins; they must make a distinctive architectural and geographic contribution to the series; and they should be suitable subjects for infrared photography, a format that best evokes their inherent mystery.

Infrared light is invisible to the human eye, but I use a specially adapted 35mm digital camera to record it. Infrared's ethereal effect illuminates the otherworldly atmosphere that haunts ruins, allowing a photographer to capture their melancholy beauty as no other format can. In this way I hope *Lost Worlds* makes a worthy contribution to the tradition of ruins photography in the Americas.

As civilizations rise and fall and their architecture soars and crumbles, photographers come and go, playing their part in that grand cyclical narrative. With this in mind, I reserve the last words of my introduction for future photographers who may see *Lost Worlds* and draw from it sufficient inspiration to visit these ruins as well as those unearthed in their time: Preserve them with your unique vision. Extend the tradition of ruins photography in the Americas and ensure that the future has a past. And just when you think you have seen it all, remember the lines that spurred on Hiram Bingham who found Machu Picchu, the ruin that graces the cover of *Lost Worlds*. They come from "The Explorer," a poem by the British writer Rudyard Kipling:

Something hidden! Go and find it!
Go and look beyond the Ranges—
Something lost behind the ranges.
Lost and waiting for you. Go!"

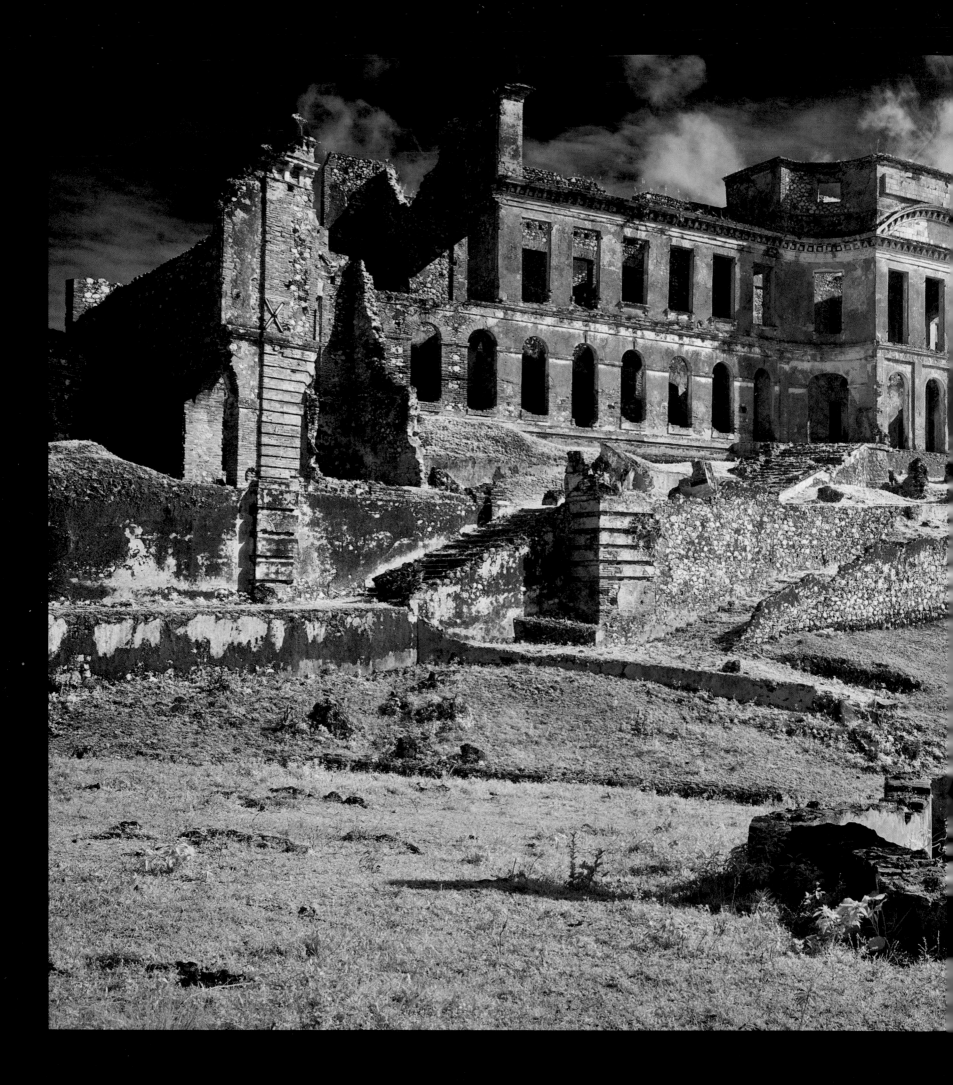

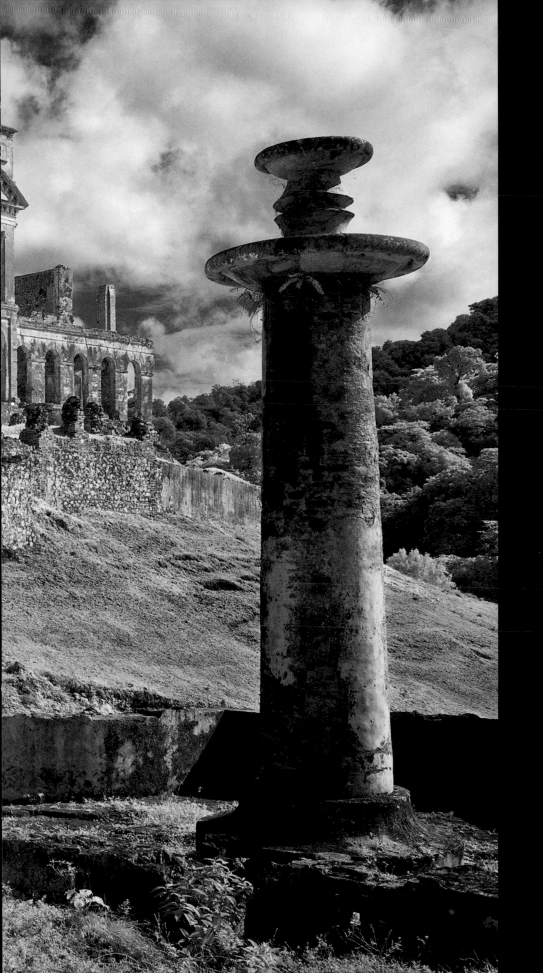

THE
CARIBBEAN

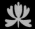

SAN NICOLÁS DE BARI
IL MONASTERIO DE SAN FRANCISCO
SANTO DOMINGO, DOMINICAN REPUBLIC

Santo Domingo proudly promotes itself as a "city of firsts." This is no idle boast. The city rightfully claims to be the site of the first cathedral, the first customs house, the first university, and other primary landmarks in the Americas.

This pride stems from Santo Domingo's origins. Founded in 1498 by Christopher Columbus' brother, Bartholomew, Santo Domingo served as the headquarters for Spain's exploration and conquest of the New World. More than six centuries later, the capital of the Dominican Republic remains the oldest continuously inhabited European settlement in the Americas. The last ruins standing in the city's historic Colonial Zone conspicuously confirm Santo Domingo's reputation as a city of firsts.

Il Monasterio de San Francisco, constructed between 1512 and 1544, was the first monastery in the New World. Built for the first order of Franciscan friars to come to the island of Hispanola, this once glorious structure with its massive dome and three connecting chapels, suffered a series of disasters that must have tested the friars' faith. First, it was looted and torched by Sir Francis Drake when he seized the city in 1586. Restored, Il Monasterio sustained more damage during earthquakes in 1673 and 1751; after both temblors it was rebuilt. It served as an insane asylum from 1881 until the early 1930s, when a hurricane damaged it yet again. After this last disaster, Il Monasterio was never restored.

San Nicolás de Bari, the first hospital in the Americas, treated patients who suffered from diseases and illnesses resulting from the earliest contact between indigenous peoples and their would-be colonizers. In 1503 Governor Nicolás de Ovando issued an order to build the hospital and an adjoining church after observing a dedicated black woman treat the sick and infirm without any official assistance. When it was completed in 1508, San Nicolás accommodated up to 70 patients at a time, comparable to its most advanced European counterparts. Though it withstood the natural disasters that befell Il Monasterio, San Nicolás suffered devastating damage during a hurricane in 1911. In the aftermath, several walls deemed hazardous to pedestrians were demolished. It was never rebuilt.

In 1990 UNESCO declared Santo Domingo's Colonial Zone a World Heritage Site, acknowledging its connection to Columbus and its importance as the site of some of the earliest European-style architecture in the New World.

PRECEDING PAGES: *Sans Souci, Milot, Haiti*

Il Monasterio de San Francisco

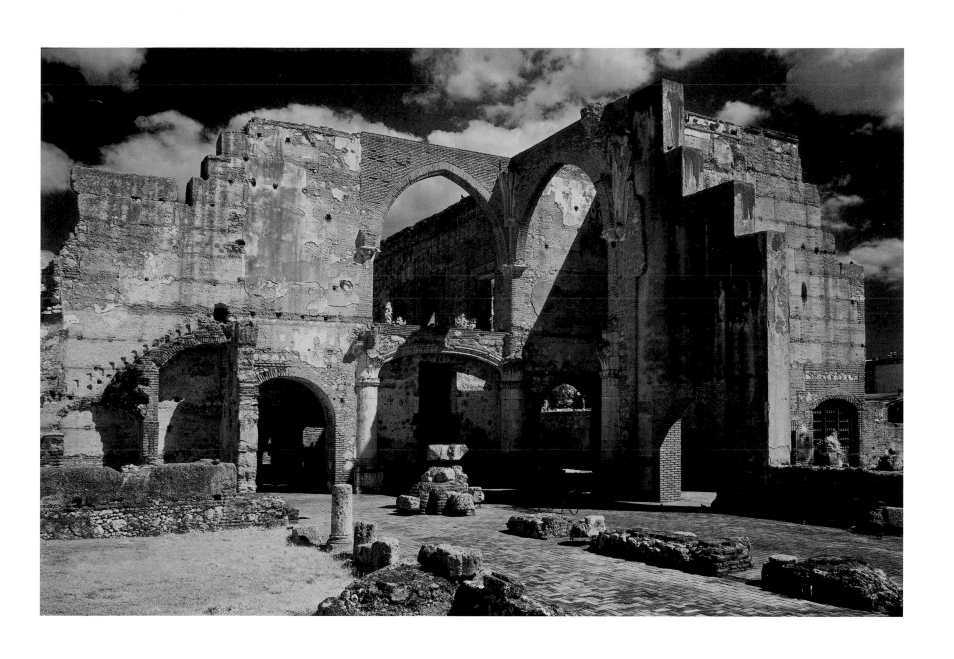

OPPOSITE AND ABOVE: *San Nicolás de Bari*

BRIMSTONE HILL FORTRESS, ST. KITTS

European powers fiercely protected their colonies in the Caribbean. At stake were great wealth, political prestige, and military supremacy. Fortifications were often the first structures built on these outposts of empire and every island had its own network of coastal defenses. None could match Brimstone Hill Fortress. In its scale and grandeur, this extraordinary example of military architecture signified St. Kitts' importance as the first Caribbean island to be settled by the British and the French as well as its key role as a springboard of colonialism during the seventeenth and eighteenth centuries.

The British first mounted cannon on Brimstone Hill in 1690 to recapture Fort Charles, another stronghold on the island, from the French. It took a Herculean effort to haul those big guns up Brimstone, which is nearly 800 feet (244 m) high, very steep, and heavily wooded. That same year the British began construction on the fortress. African slaves cut blocks from the hill's black volcanic rock and made the mortar to cement them from limestone that covers the slope. Construction continued intermittently for the next hundred years.

Strategically, Brimstone Hill supported Fort Charles and protected the important commercial town of Sandy Point and its harbor. However, Brimstone was designed to be primarily a refuge fortress, built to accommodate prominent planters and merchants during times of war.

In 1782 the French invaded St. Kitts. The local militia, 350 strong, plus several "free coloureds" retreated to Brimstone Hill. After a month-long siege, the heavily outnumbered and cut-off British garrison surrendered. A year later, the Treaty of Paris restored St. Kitts to the British, who began work to expand and strengthen the fortifications. When completed, Brimstone Hill never again fell to an enemy and became known as the "Gibraltar of the West Indies."

By the mid-nineteenth century, the British had abandoned Brimstone Hill as European powers turned their attention away from the Caribbean and toward potentially more profitable domains in Africa and Asia. Left undefended, the once impregnable fortress was overrun by vegetation and fell victim to hurricanes and to vandals, who destroyed whole buildings for the cut stone.

In 1965 The Society for the Restoration of Brimstone Hill began an active program to repair the site. These efforts led to Brimstone Hill being named a national park in 1987. Citing it as "a testimony to European colonial expansion, the African slave trade, and the emergence of new societies in the Caribbean," UNESCO declared the fortress a World Heritage Site in 1999.

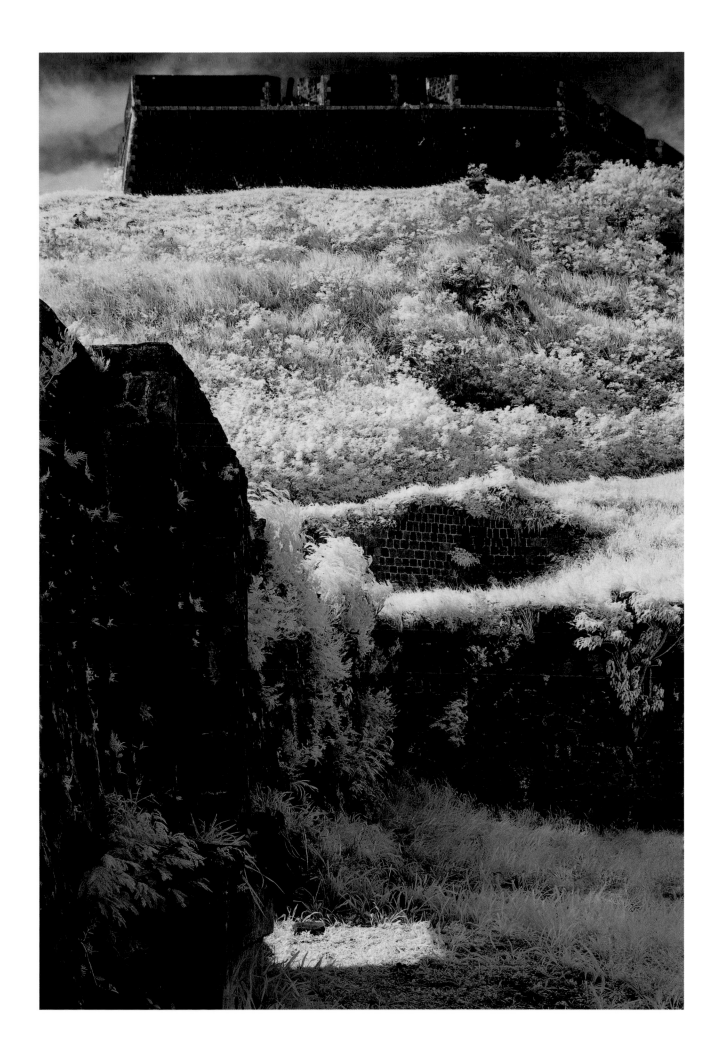

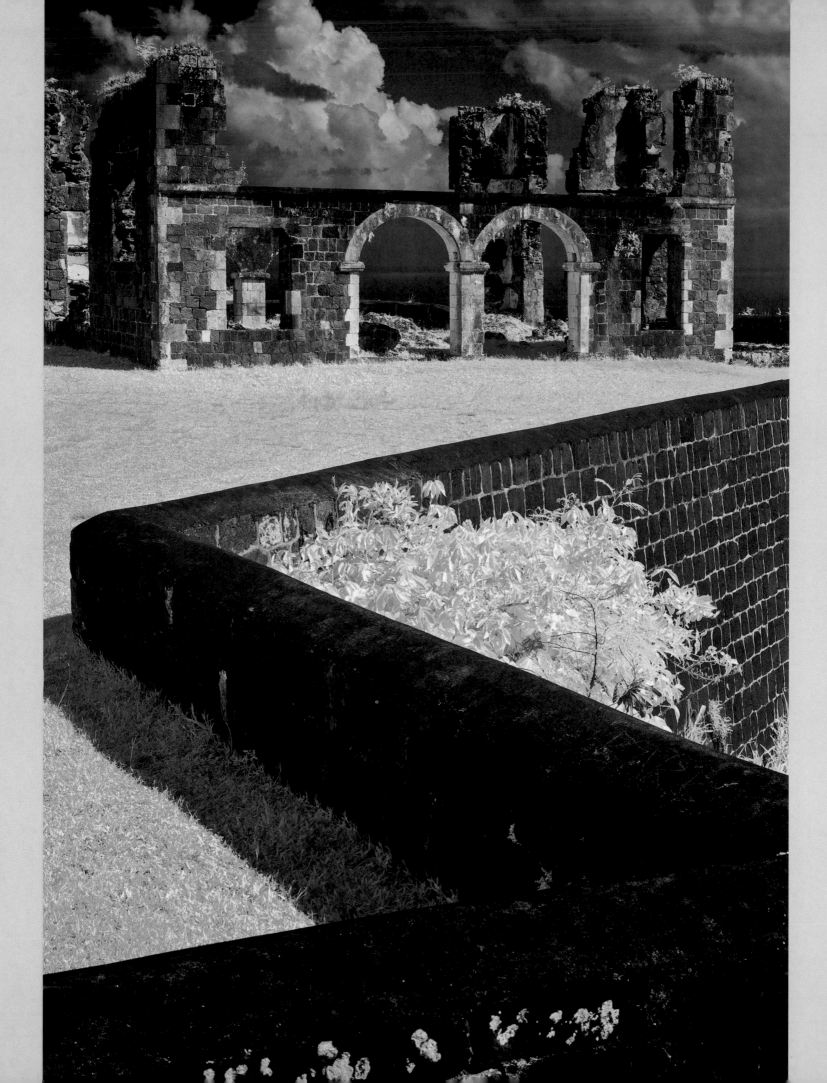

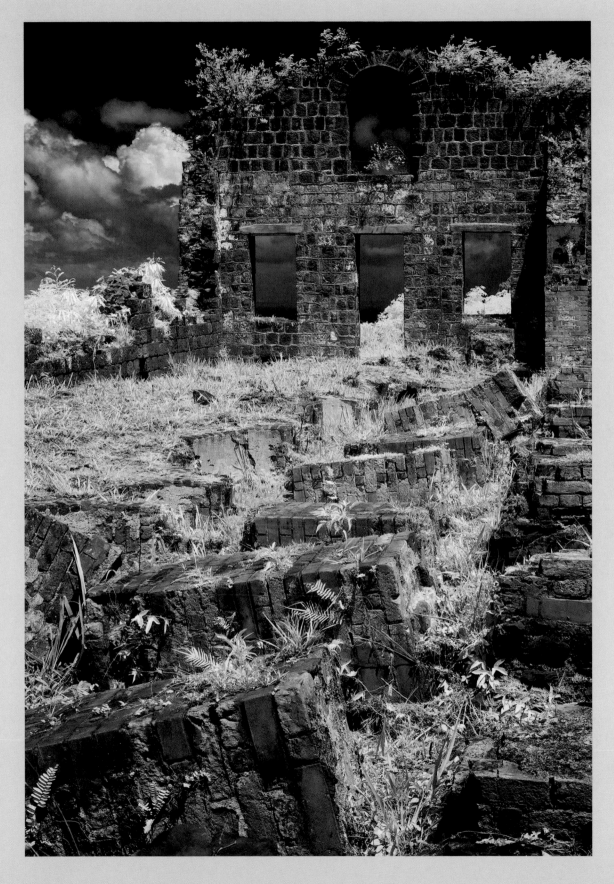

OPPOSITE: *Artillery officers' quarters* ABOVE: *Barracks*

SUGAR MILL RUINS, ST. JOHN, U.S. VIRGIN ISLANDS

Sugar mill ruins are ubiquitous in the Caribbean. Their great number serves as a reminder not only of how profitable this commodity was during the colonial period but also of the human price paid to transform a New World paradise into an Old World sweat factory. St. John, much of which has been preserved as a national park, has perhaps the most and best preserved ruins of this bygone era of any island in the region.

Danish planters from nearby St. Thomas built the first sugar plantations on St. John in the early 1700s. Among them was William Gottschalk who named his spread Annaberg, meaning "Anna's Hill," after his infant daughter. Today Annaberg is the most intact plantation ruin in the Virgin Islands.

Cultivating, harvesting, and converting sugar cane into crystals demanded backbreaking work. Only slave labor imported from Africa made the entire enterprise profitable. With all the sugar plantations on the island, it was not long before slaves vastly outnumbered freemen.

In 1733 the slaves rose up against their masters, attacked Cinnamon Bay and other plantations, and took over St. John for six months. During the revolt, Amina tribesman used the Catherineburg farm as their headquarters. It took the arrival of several hundred French and Swiss troops from Martinique to quell one of the first major slave rebellions in the New World.

In 1848 Peter von Scholten, the Governor-General of the Danish West Indies, abolished slavery. After emancipation, the sugar industry on St. John began to collapse. Many plantations, including Caneel Bay, were sold and the new owners switched to cattle raising and provision farming. Those who continued their sugar operation used steam power instead of slave labor to make the process more viable. However, depleted soil and foreign competition lowered sugar prices, leading to further decline. After a severe hurricane in 1916, Reef Bay Mill, the last in operation, closed, and with it, the sugar era on St. John came to an end.

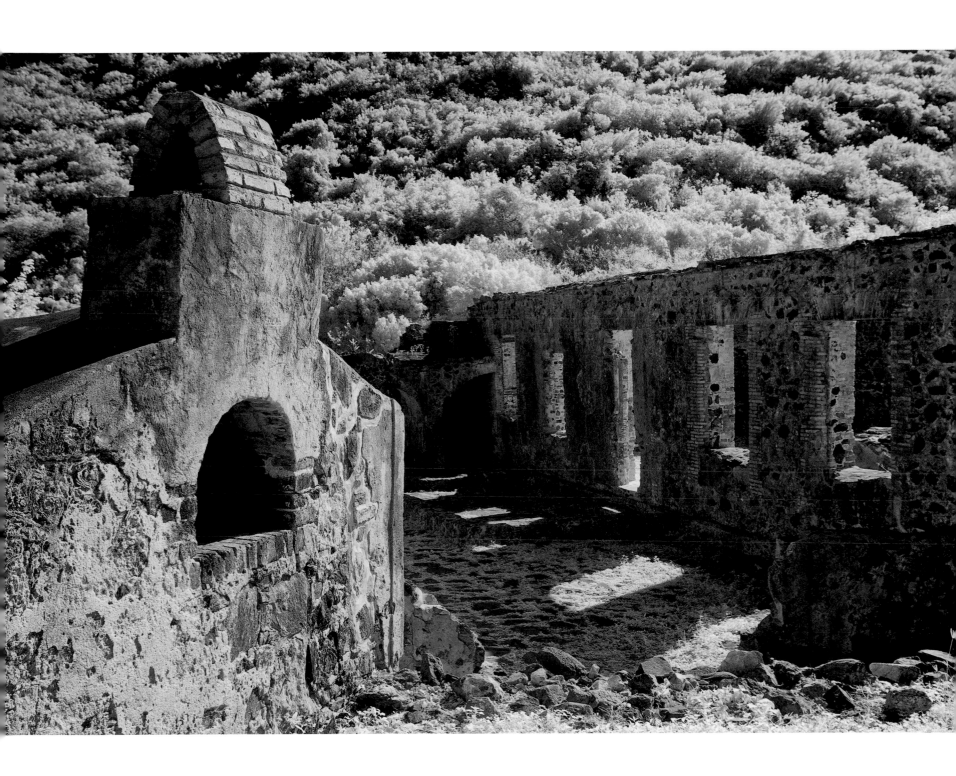

Annaberg

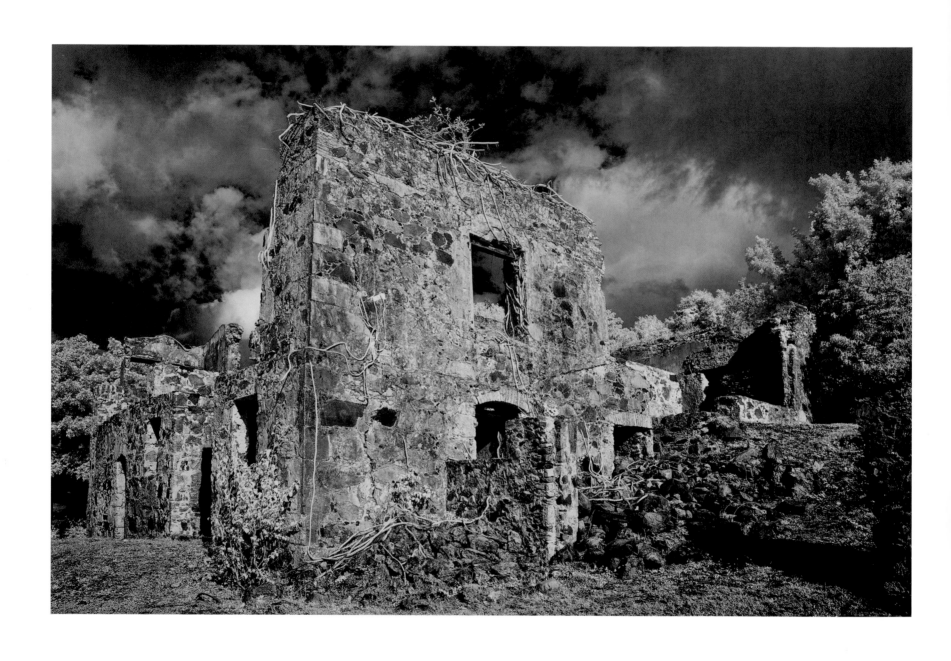

ABOVE: *Caneel Bay* OPPOSITE: *Cinnamon Bay*

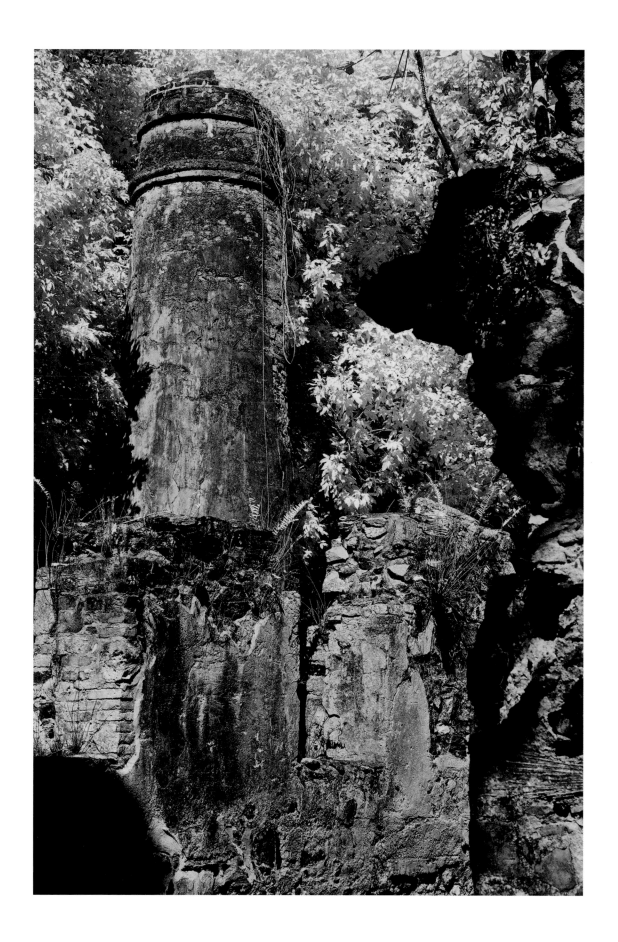

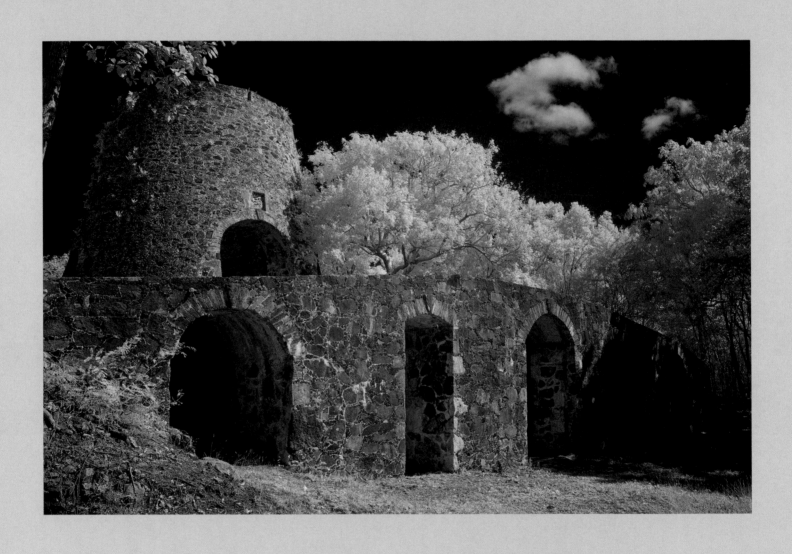

ABOVE: *Catherineburg* OPPOSITE: *Reef Bay*

SANS SOUCI, MILOT, HAITI

Translated from French to English, *Sans Souci* means "carefree." But in any language the tragic story of this ruin belies its lighthearted name.

Overlooking the town of Milot in northern Haiti, this former palace served as the royal residence of King Henri I (also known as Henri Christophe), his wife, Queen Marie-Louise, and their three children.

Henri had risen from slavery to become the first black king in the western hemisphere. He desired a home that reflected not only his own ascendance but also Haiti's emergence as a free and independent nation after a long and bloody struggle against France. In 1810 construction began. Three years later, Henri's vision of a palace to rival Versailles had become a reality. Sans Souci had its own hospital, arsenal, print works, and even an *atelier de couture* all neatly laid out on landscaped grounds decorated with fountains and marble busts.

Despite his efforts to boost his country's fortunes, Henri's autocratic rule made him an unpopular monarch. Insurrection in the army erupted soon after he suffered a stroke that left him partially paralyzed at age fifty-three. Fearing capture, Henri committed suicide on the palace grounds on October 8, 1820, shooting himself, according to Haitian legend, with a silver bullet.

Ten days after Henri took his life, rebels entered Sans Souci and bayoneted to death his 16-year-old son and only heir, Jacques-Victor Henry, Prince Royal of Haiti. Loyalists escorted Queen Marie-Louise and her daughters to safety while looters plundered the palace. In 1821 she and her children left Haiti forever and eventually settled in Pisa, Italy.

Sans Souci sat a shell of its former self until 1842 when a severe earthquake destroyed much of the palace. It was never rebuilt.

In 1915 U.S. troops occupying Haiti stole the marble busts that decorated the grounds. When soldiers came to take the last one, La Comedie, so named for the smiling mask nestled between her breasts, Haitians resisted. The soldiers relented, but not before one of them leveled his rifle and pulled the trigger, shooting off her nose.

In 1982 UNESCO designated Sans Souci and the Citadel, the fortress Henri had built above the palace, World Heritage Sites, stating that they "serve as universal symbols of liberty, being the first monuments to be constructed by black slaves who had gained their freedom."

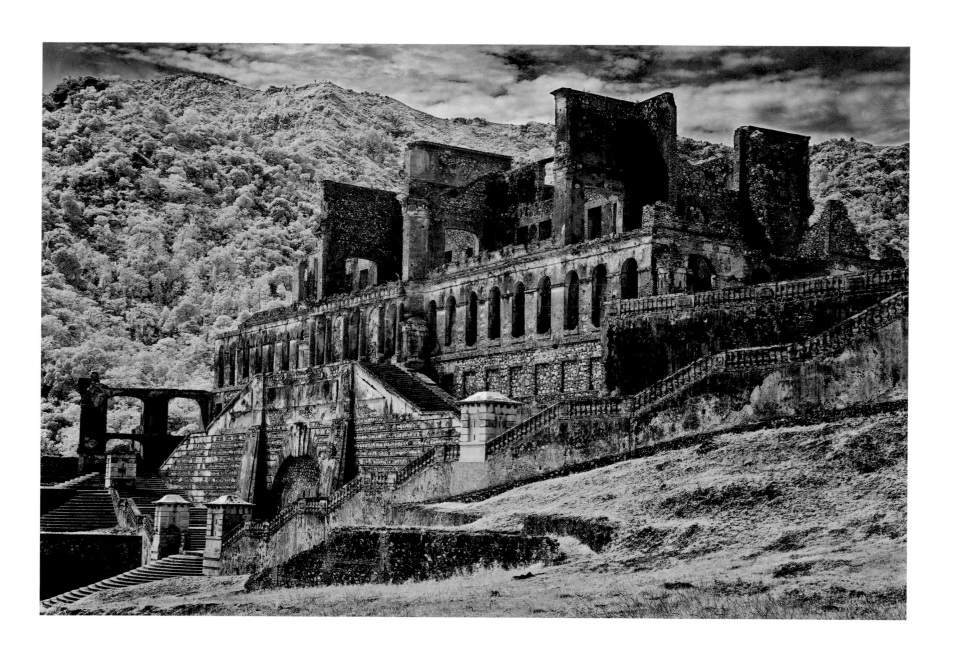

Front view

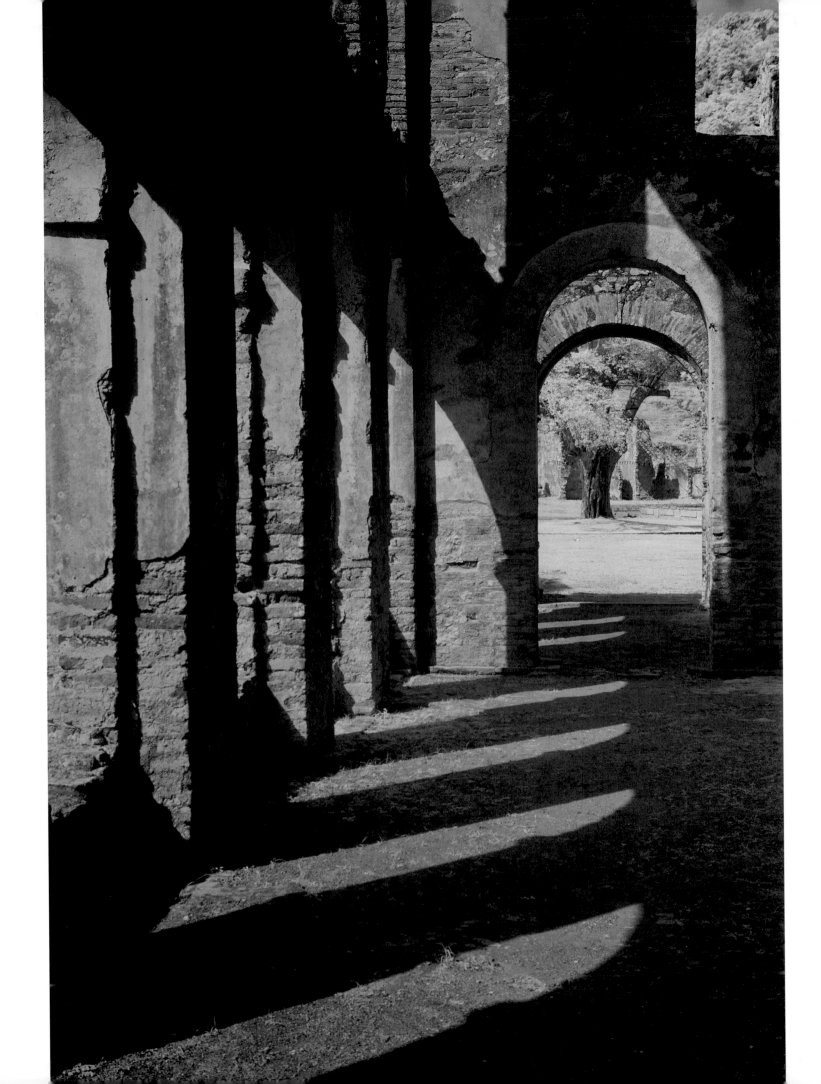

OPPOSITE: *Palace interior* ABOVE: *La Comedie*

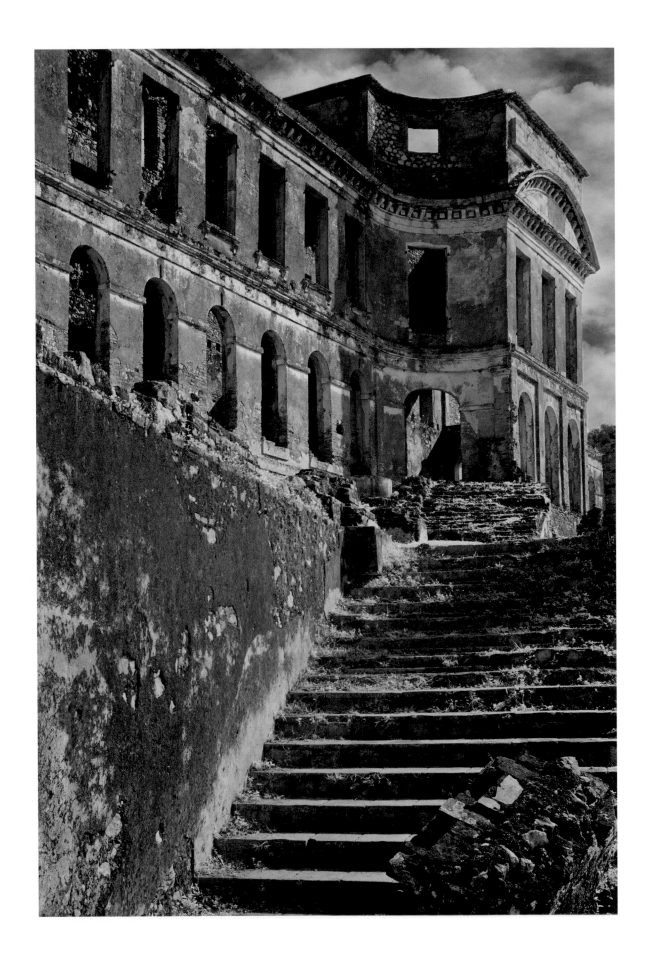

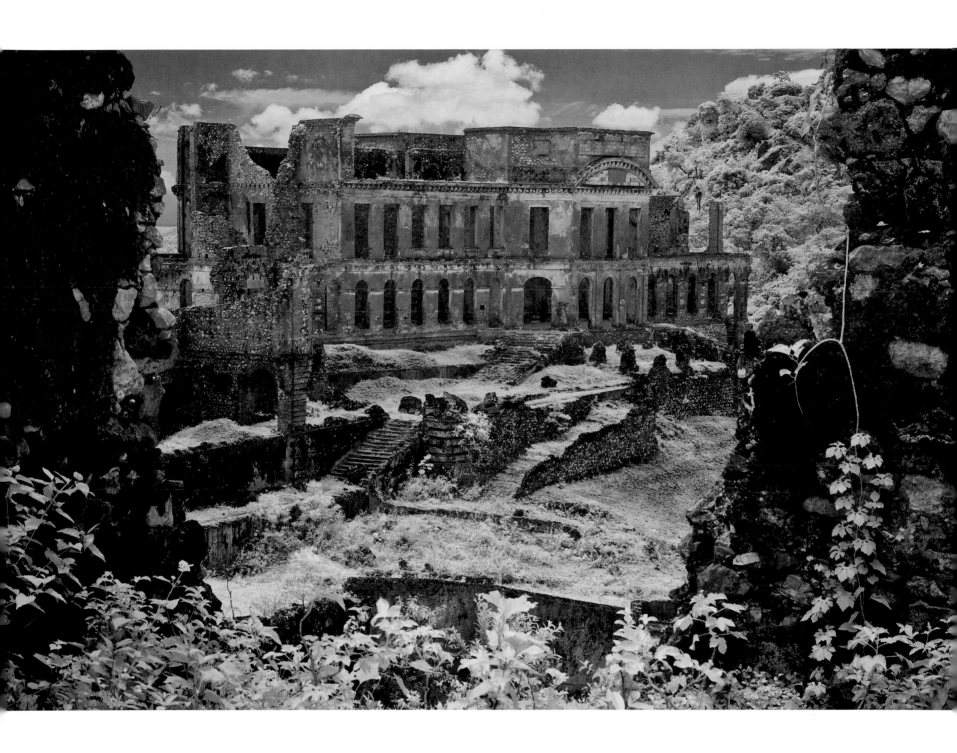

OPPOSITE AND ABOVE: *Rear views*

MANSION AT FARLEY HILL, ST. PETER PARISH, BARBADOS

Set among virgin mahogany trees and overlooking the rugged Atlantic coast, the Mansion at Farley Hill was said to be "the most splendid of the old Barbadian merchant palaces."[3]

The original part of the mansion is thought to have been built around 1818 and was known as Grenade Hall. In 1856 Thomas Graham Briggs, one of the wealthiest planters on the island, took possession and renamed the property Farley Hill. Briggs developed the estate into one of the finest homes in the Caribbean, adding a south wing, library, dining room, billiard room, bedrooms, and gardens.

According to the British author and historian James Anthony Froude, who visited Farley Hill in 1888, the mansion was "a palace with which Aladdin himself might have been satisfied, one of those which had stirred the envying admiration of foreign travellers in the last century."[4]

Among those foreign travelers were vacationing members of the British royal family, including Prince Alfred, Duke of Edinburgh, whom the influential and socially connected Briggs hosted at Farley Hill in 1861, and King George V, who visited Barbados in 1879.

Upon Briggs' death in 1888, the house was given to his brother-in-law, Benjamin Courbank Howell who lived there with his family for almost half a century. When the Howells moved out, the property was briefly rented for $25 per month, then remained vacant. In 1940 Mr. W. W. Bradshaw purchased the mansion but it was in such decay that it served only as a weekend resort.

In 1956 Farley Hill was partially restored to its former splendor for some scenes in the film *Island in the Sun*, starring James Mason, Joan Fontaine, and Harry Belafonte. Large quantities of wood and other flammable material were used for the restoration, which later caused a fire that destroyed everything except the walls made of coral stone.

The Government of Barbados bought the property in 1965. The following year H.M. Queen Elizabeth II officially opened it as Farley Hill National Park.

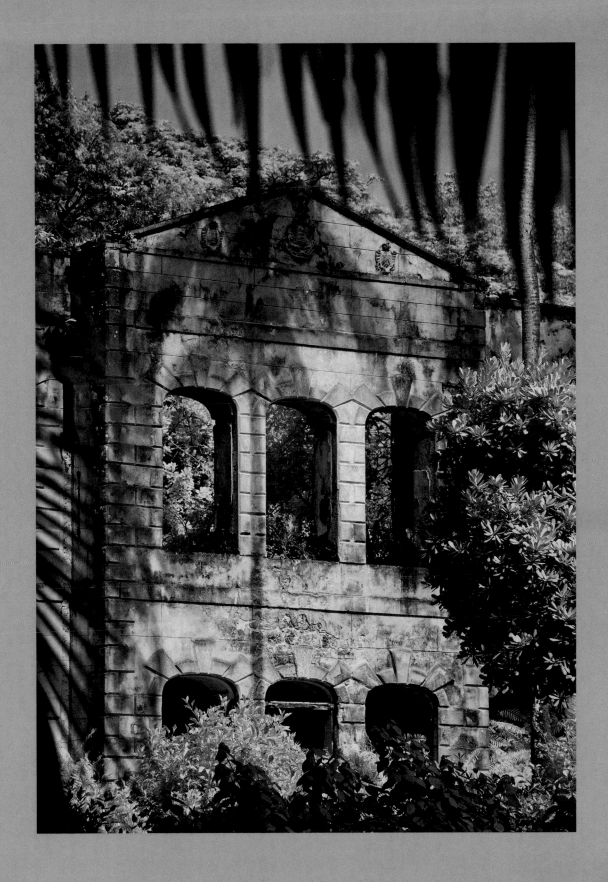

Front view

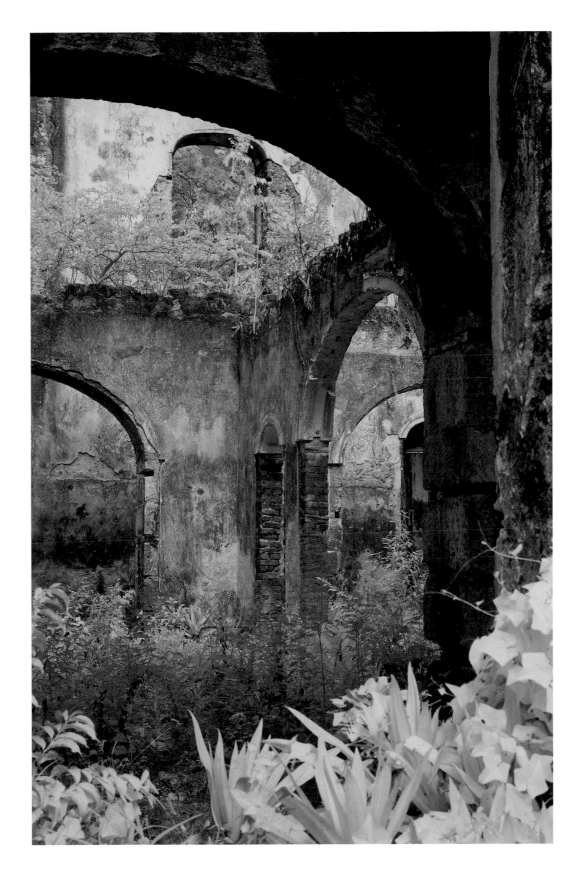

OPPOSITE AND ABOVE: *Interior views*

MT. PELÉE RUINS, ST. PIERRE, MARTINIQUE

"There was hurled straight toward us a solid wall of flame," an eyewitness recalled. "It sounded like a thousand cannon."[5]

It was a natural disaster like no other. At 7:52 AM on May 8, 1902, Mt. Pelée, a volcano located on the northern tip of Martinique in the Lesser Antilles island arc of the Caribbean, erupted, completely destroying St. Pierre, the island's principal city.

Two dense, dark plumes consisting of superheated steam, ash, and dust had exploded from the convulsing volcano at a speed of more than 420 miles (675 km) per hour. One plume rolled upward, forming a mushroom cloud that blackened the sky for a radius of 50 miles (80 km). The other shot out horizontally and raced down the mountain toward St. Pierre four miles (6.4 km) below. In less than a minute, the toxic mass, glowing hot from within at temperatures exceeding 1,967 degrees F (1,075 degrees C), engulfed the entire city, instantly killing all but two of its 30,000 inhabitants. "The town vanished before our eyes," said a shocked eyewitness on a boat at sea.[6]

One of the survivors, Louis-Auguste Cyparis, a 25-year-old roustabout, was locked up in an underground jail cell when the volcano erupted. Rescued days later, he recovered from his burns, received a pardon, and eventually joined the Barnum & Bailey Circus, touring the world as the "Lone Survivor of St. Pierre."

The 1902 eruption of Mt. Pelée was the most catastrophic volcanic event in the twentieth century and remained the deadliest natural disaster in Caribbean history until January 12, 2010, when an earthquake rocked Haiti, killing more than 200,000 people.

St. Pierre was gradually rebuilt, but never regained its former status. Today its inhabitants live below the still active volcano and among the ruins of L'Eglise du Fort, the old theater, and "the lone survivor's" jail cell. These charred vestiges mark that infernal instant when the city once called the "Paris of the Antilles" became forever known as "the Pompeii of the Caribbean."

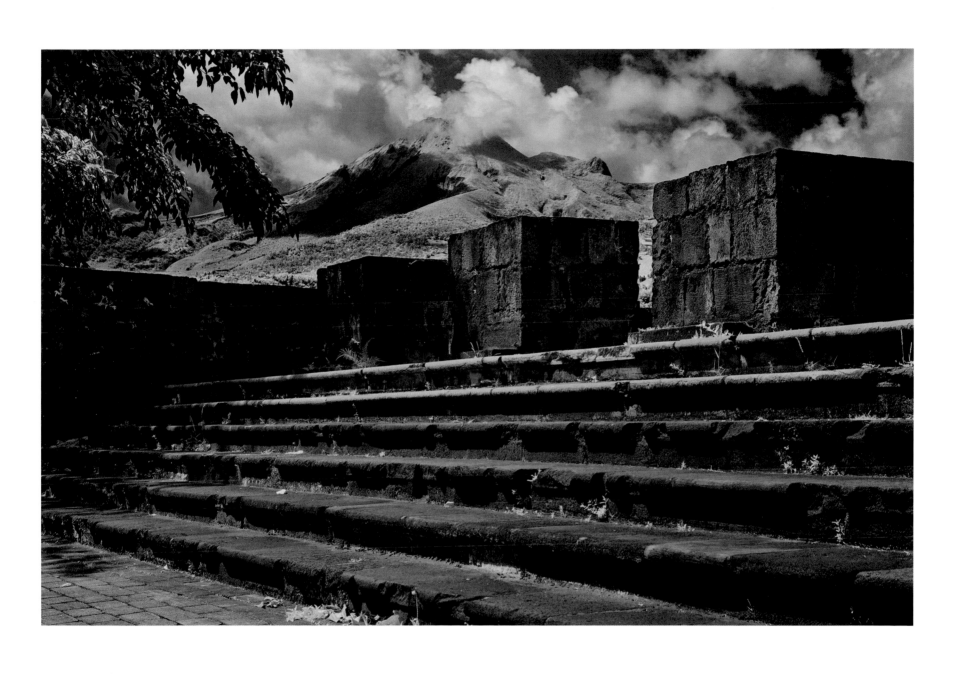

Mt. Pelée and theater stairs

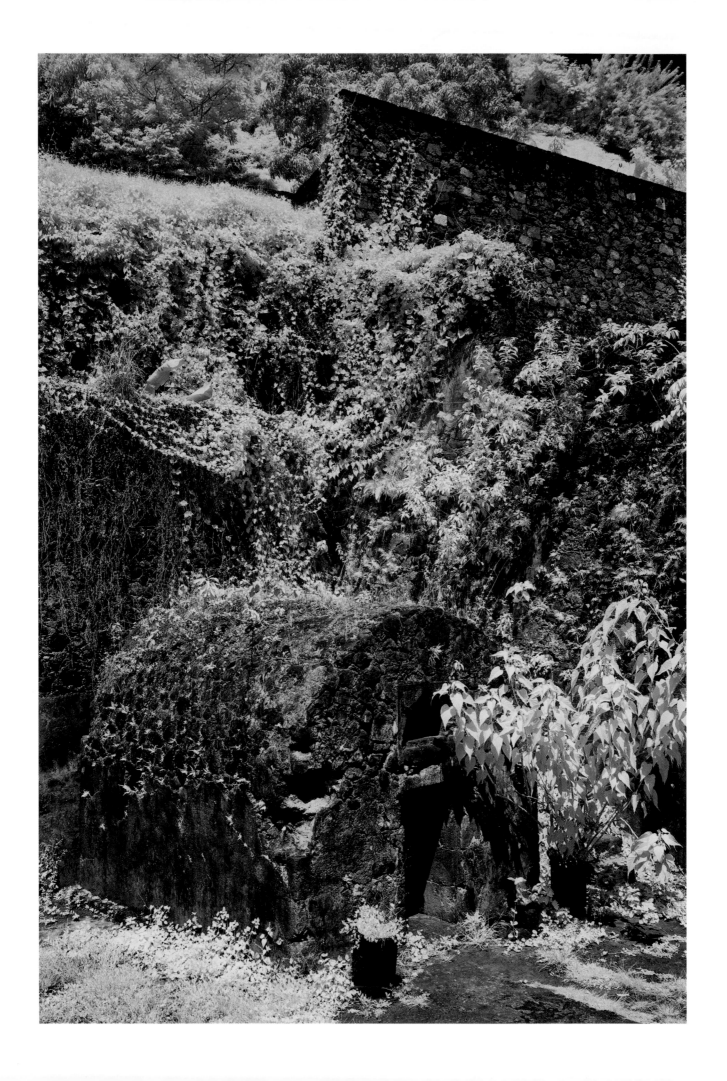

OPPOSITE: *"Lone survivor's" jail cell* ABOVE: *L'Eglise du Fort*

FOLLY MANSION, PORT ANTONIO, JAMAICA

According to a local legend, this once splendid mansion was built as a wedding gift. When the groom carried the bride across the threshold, the great house began to crumble. Hysterical, the bride ran off, crying, "What a folly!"

Here is the true story of Folly Mansion: In 1905 Alfred Mitchell, a retired mining engineer from Connecticut, built a winter home near Port Antonio, Jamaica, for he and his wife, Annie, a Tiffany heiress, and their family. The Roman villa-style residence had unheard of amenities such as a steam-powered electrical generator and an indoor swimming pool. The Mitchells named their home "The Folly," not after any legend, but rather after Folly Point, the peninsula where they had it built.

The Mitchells kept animals on the property, including peacocks and monkeys. Mitchell's son-in-law, the explorer Hiram Bingham, who would become famous for bringing another ruin, Machu Picchu, to the world's attention, brought the monkeys, who roamed what later became known as Monkey Island, just off shore from the mansion.

Mitchell wintered at the Folly with his family until his death at age 80 in 1911. His widow sold the estate to the son of a United Fruit Company executive who later abandoned it. Eventually, the Folly was taken over by the Jamaican government and fell into ruin.

Around 1935 the roof collapsed giving rise to another legend. This one claims that the builders had used salt water to mix the concrete, causing structural elements to rust and the building to crumble. In truth, Mr. Mitchell, a very successful engineer, had the mansion built with all imported materials, including the water. Vandals who had ripped out the second floor columns that supported the roof probably caused the collapse.

During the 1950s the actor Errol Flynn and his wife, Patrice Wymore, lived in Port Antonio and had wanted to refurbish the mansion and turn it into a resort. The Jamaican government would only lease it to them and their grand plans never materialized.

Though in a state of advanced decay, the Folly comes to life each summer when locals gather there for the annual Portland Jerk Festival, a celebration of traditional Jamaican cooking and music.

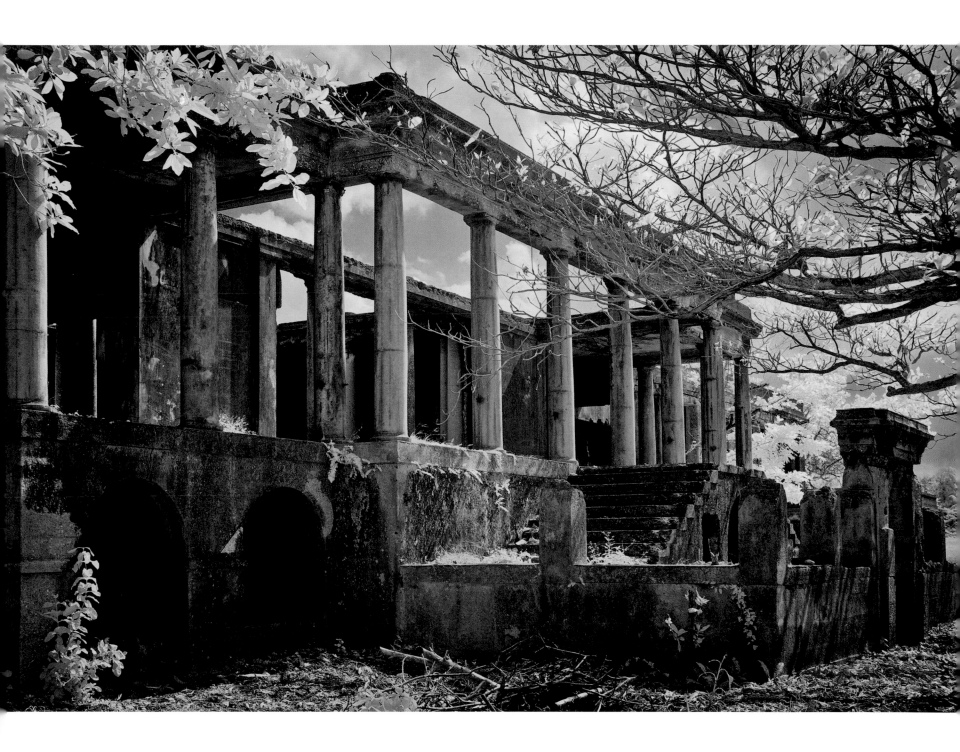

Front view

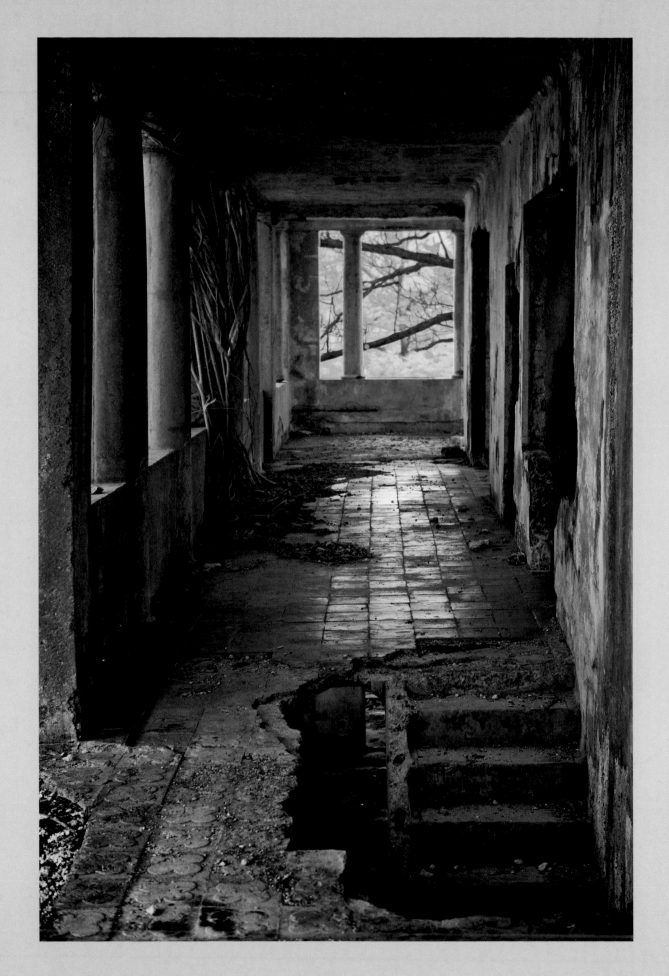

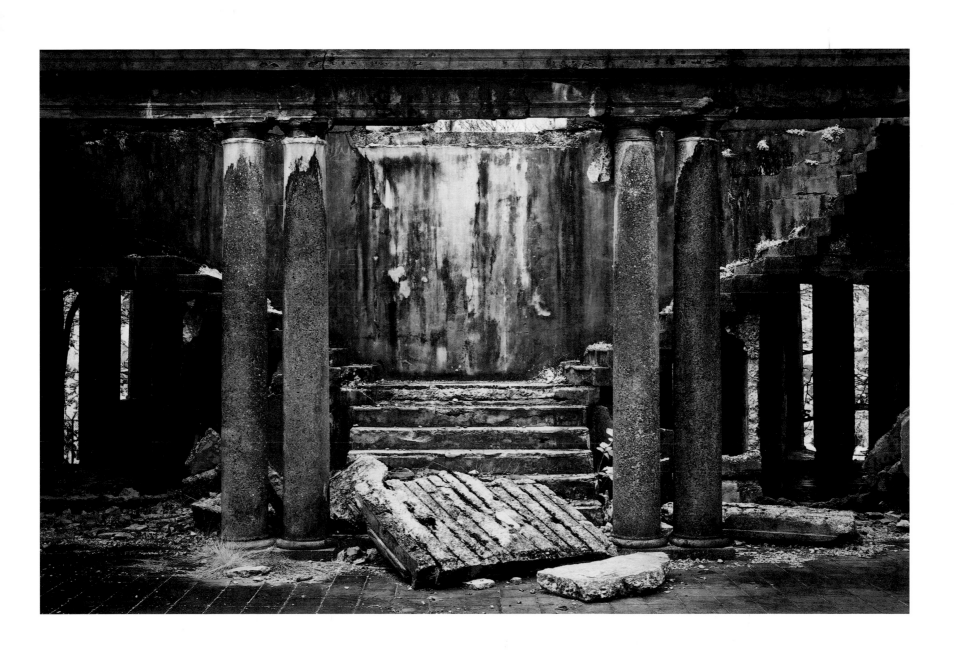

OPPOSITE: *Veranda* ABOVE: *Grand staircase*

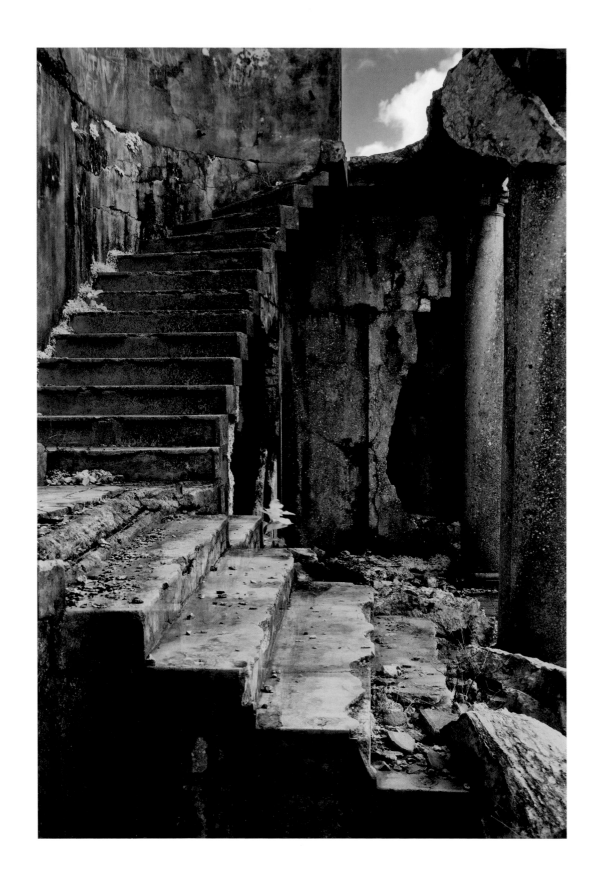

ABOVE: *Grand staircase* OPPOSITE: *Colonnade*

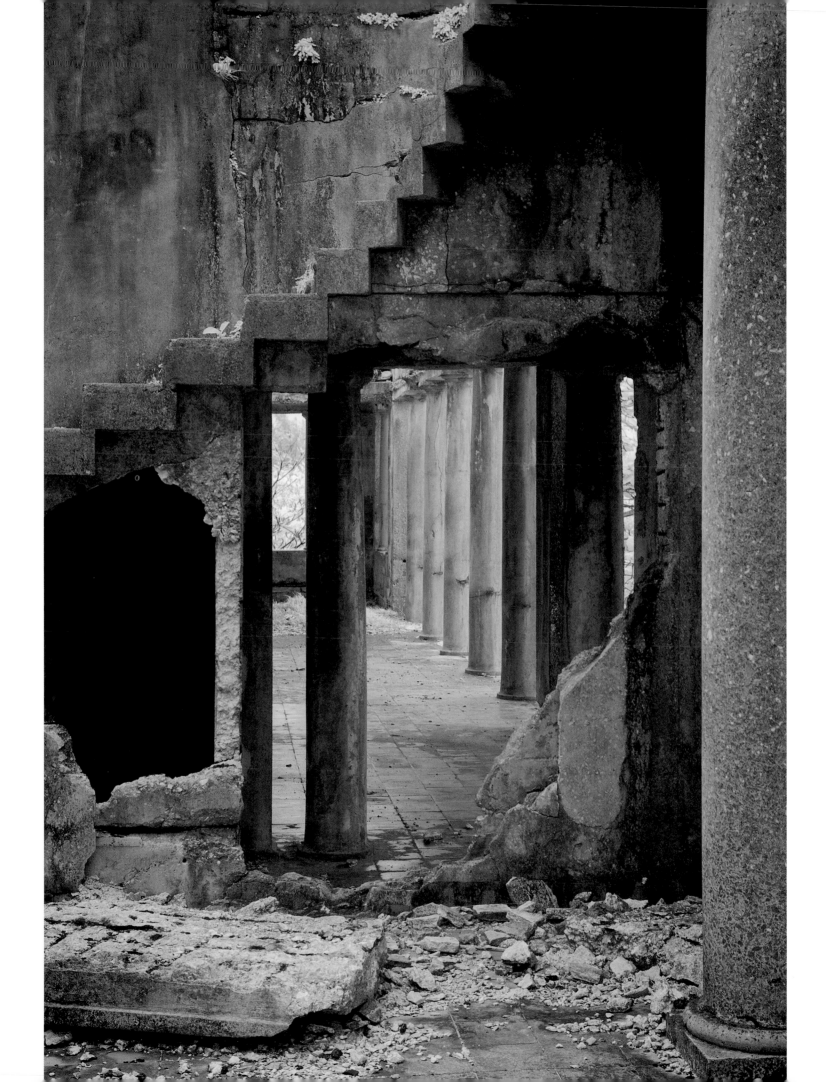

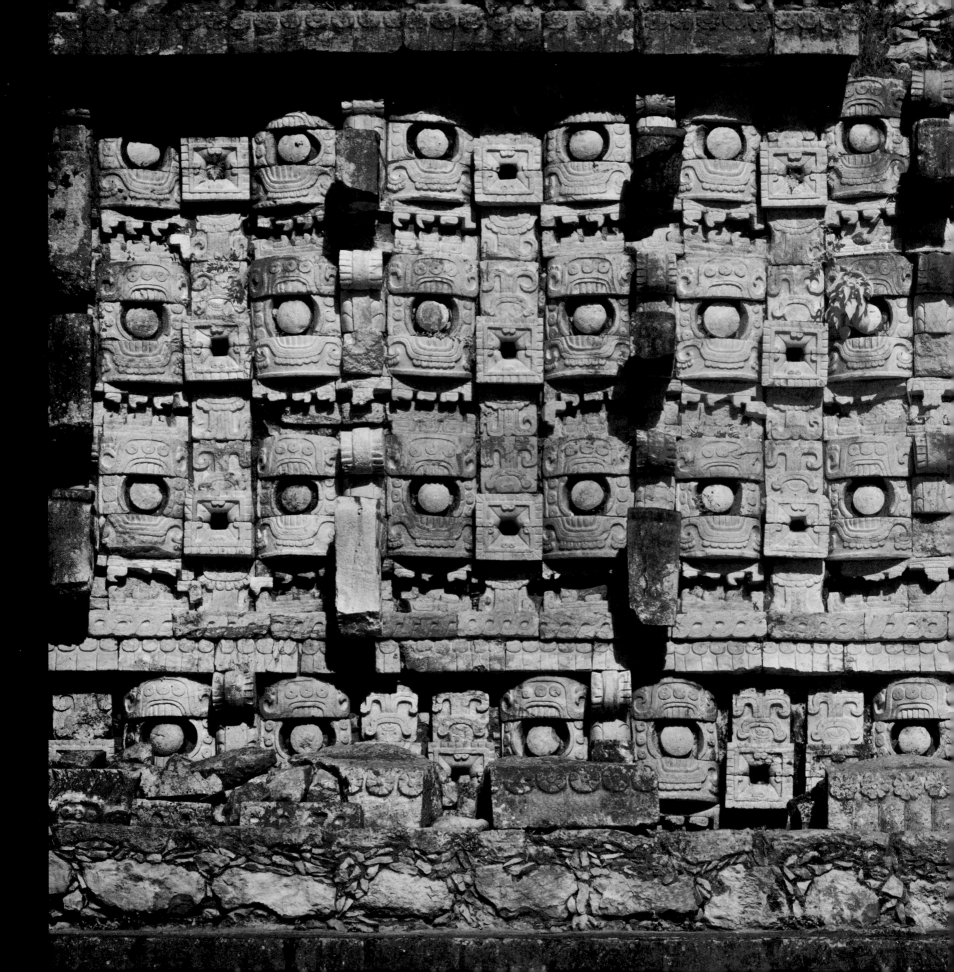

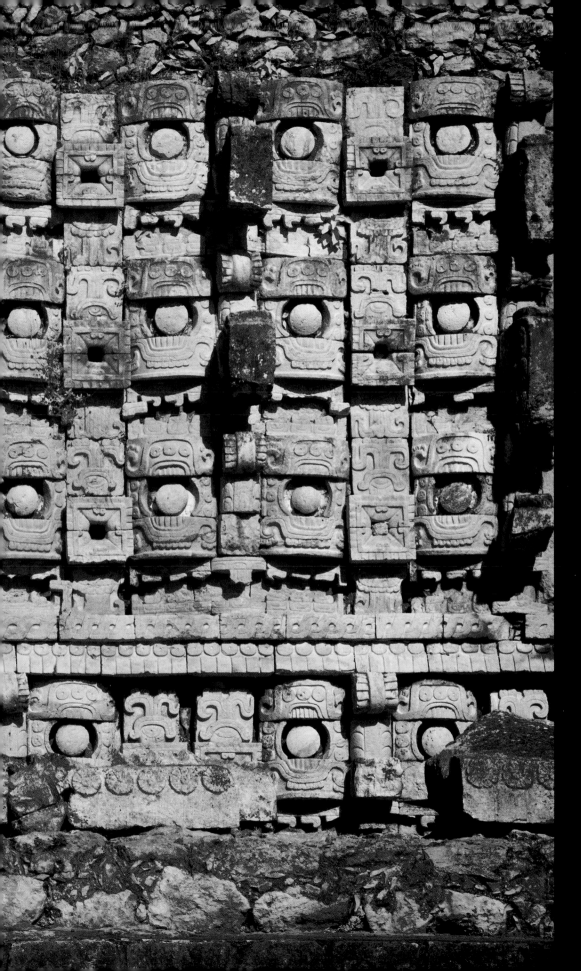

MEXICO

TEOTIHUACÁN, MEXICO

There are ruins and then there is Teotihuacán.

This ancient metropolis was the center of the first great civilization to emerge from central Mexico. Founded before the Christian era, Teotihuacán reached its full glory in the sixth century AD when it teemed with more than 125,000 inhabitants and sprawled over 14 square miles (36 sq. km), making it one of the largest cities in the world at that time.

Very little is known about the people who lived in Teotihuacán. They left no written records and their language fell silent long ago. However, their gift for large-scale planning, design, and construction is clearly evident in the elaborate underground drainage system, broad thoroughfares, and monumental buildings they left behind.

Their greatest architectural achievement, the Pyramid of the Sun, ranks among the largest structures of its kind. Measuring more than 700 feet (213 m) wide and 210 feet (64 m) tall, it stands on a base about the same size as that of the Great Pyramid of Egypt, but rises only half the height. It is made of an estimated 2.5 million tons of earth and rubble, which at the time of its completion, around AD 150, was covered in stucco painted bright red. The pyramid's name derives from accounts dating back to the sixteenth century describing it as a pilgrimage site devoted to the worship of a Sun god.

Like the Pyramid of the Sun, Teotihuacán's other major buildings—the smaller Pyramid of the Moon and the Temple of Quetzalcoatl—are prime examples of a slope-and-panel style of architecture known as *talud-tablero*. This mode of construction emanated from Teotihuacán and spread throughout Mesoamerica. It appears as far south as the Maya cities of Tikal and Copán, demonstrating Teotihuacán's far-reaching influence and cultural interaction.

After dominating life in the region for nearly five hundred years, Teotihuacán began to decline in the seventh century. The causes are not clear but archaeological evidence indicates that nomadic invaders or possibly local rebels burned several structures. A period of gradual abandonment and ruin followed.

When the Aztecs entered the deserted city in the fifteenth century they were awed by its immensity. Surely, they believed, no mere mortals could have built it. In veneration, the Aztecs named it *Teotihuacán*, meaning "birthplace of the gods."

The structures visible today, only a tenth of the city, were excavated at digs that began in 1864 and continue to the present. In 1987 UNESCO inscribed Teotihuacán as a World Heritage Site in part to protect it from being consumed by the sprawl of another metropolis, modern-day Mexico City.

PRECEDING PAGES: *Codz Poop, Kabah, Yucatán, Mexico*

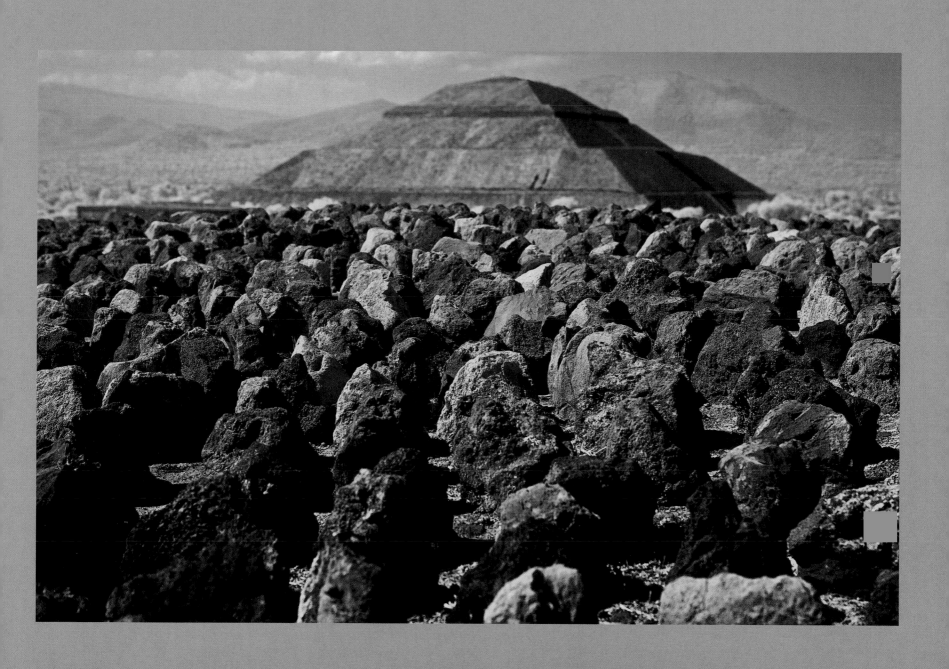

Pyramid of the Sun

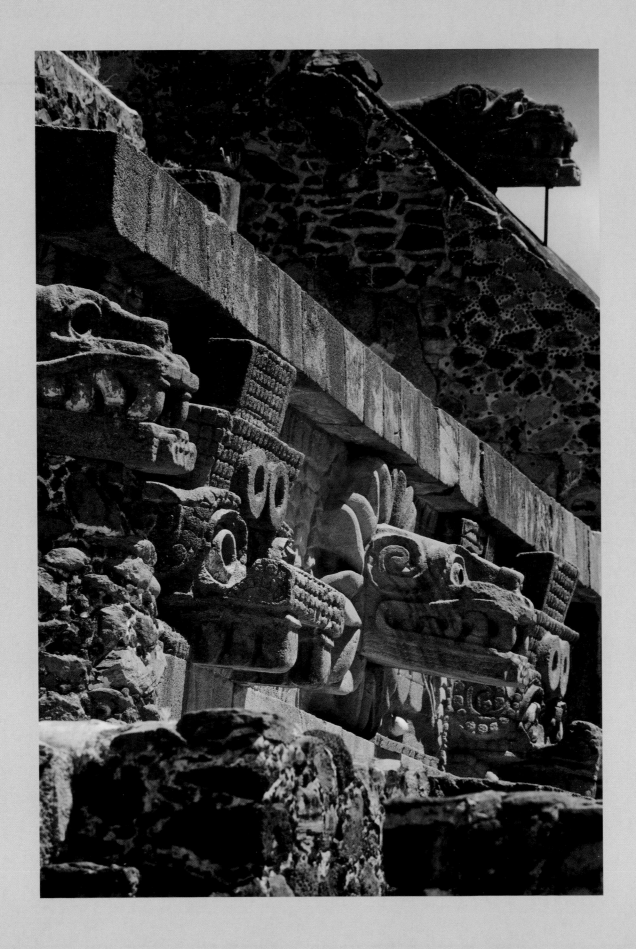

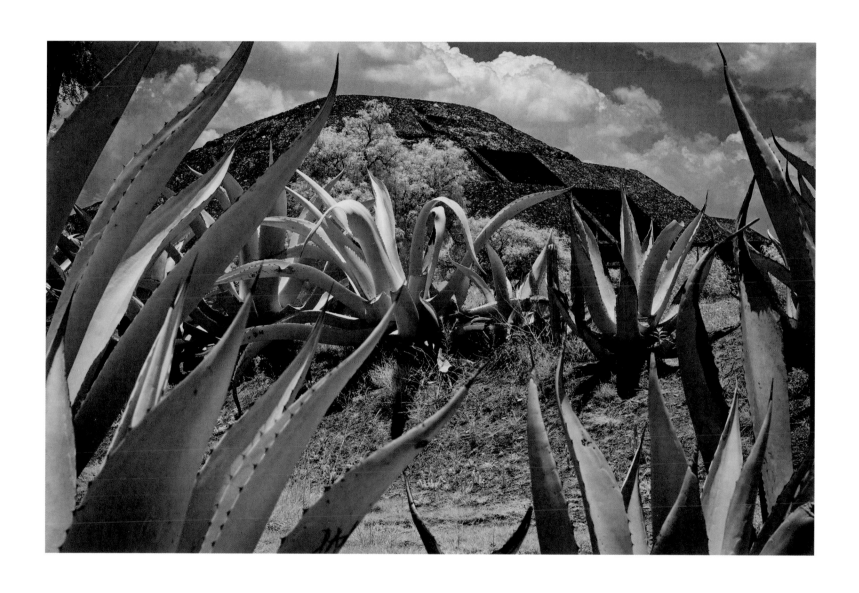

OPPOSITE: *Temple of Quetzalcoatl* ABOVE: *Pyramid of the Moon*

TULA, HIDALGO

After the fall of Teotihuacán, Tula, also known as Tollan, became the largest city in central Mexico. Though it would never rival its predecessor in size, Tula exerted great influence as the power center of the Toltec Empire, an extremely militaristic culture that during its golden age, between AD 900 and 1200, used its considerable might to control much of central and eastern Mexico.

The glorification of the martial way of life is still visible in Tula's most significant building, the Temple of Tlahuizcalpantecuhtli (Lord of the House of the Morning Star). At the top of the pyramid appear four atlantes, columns in human form. Standing 15 feet (4.6 m) tall and outfitted with butterfly breastplates, feathered headdresses, and a lethal supply of spears, these stone warriors served the empire as roof supports for a temple that crowned the pyramid.

Archaeologists have noted that the ruins at Tula share many architectural similarities with the Maya city of Chichén Itzá some 700 miles away, including regimental columns, fearsome carvings, and monumental structures with clean, strong lines. For decades these experts believed that the Toltecs had invaded Chichén Itzá and imposed their culture on the inhabitants. More recently, many have reversed their thinking and now assert that Tula was one of many cities with whom Chichén Itzá traded and that the common influences flowed the other way, from Chichén Itzá to Tula.

Despite its great military power, the Toltec empire fell in the late twelfth century, perhaps proving that those who live by the spear, die by it as well. Nomadic Chichimecs, escaping severe drought in the north, invaded, sacked, and burned Tula, as fleeing Toltecs dispersed throughout Mexico.

Antonio Garcia Cubas of the Mexican Society of Geography and History made the first formal study of the ruins in 1873. French archaeologist and photographer Désiré Charnay led the first dig at the site in the 1880s. Mexico's National Institute of Anthropology and History (INAH) has conducted further excavation and restoration of some structures.

OPPOSITE: *Temple of Tlahuizcalpantecuhtli*

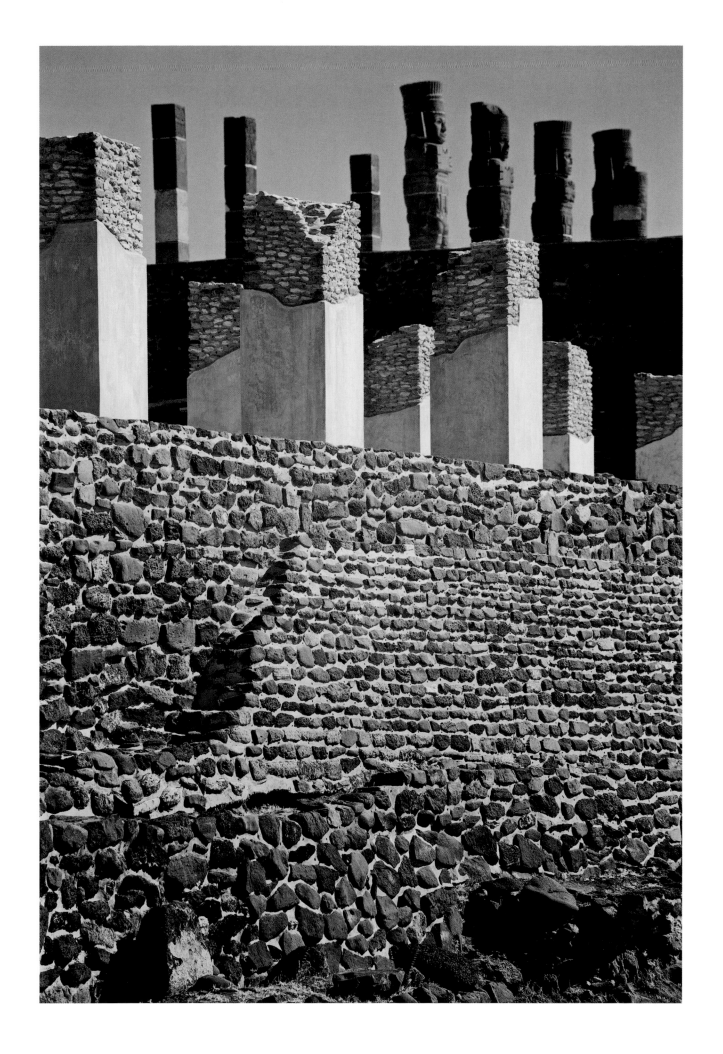

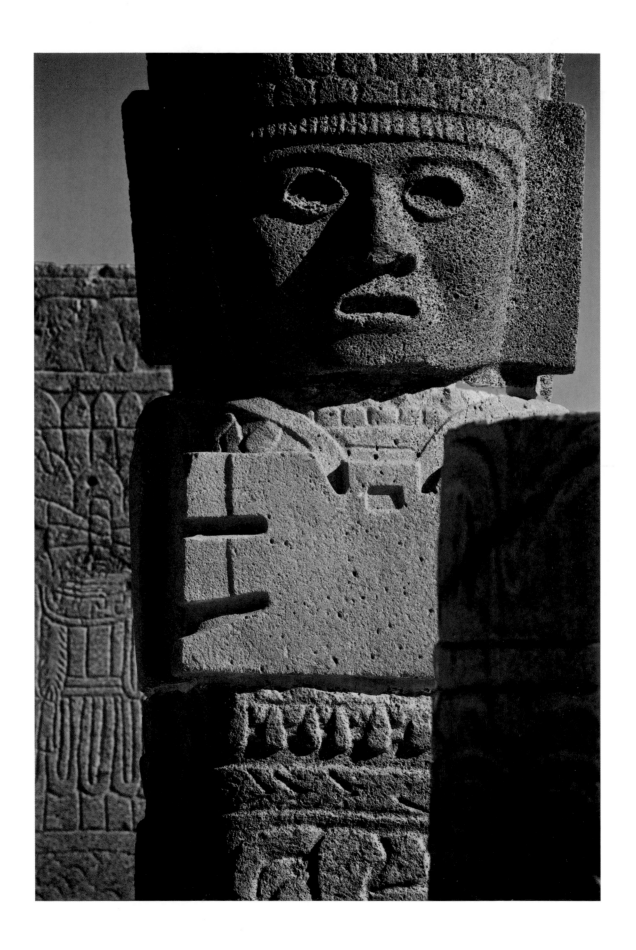

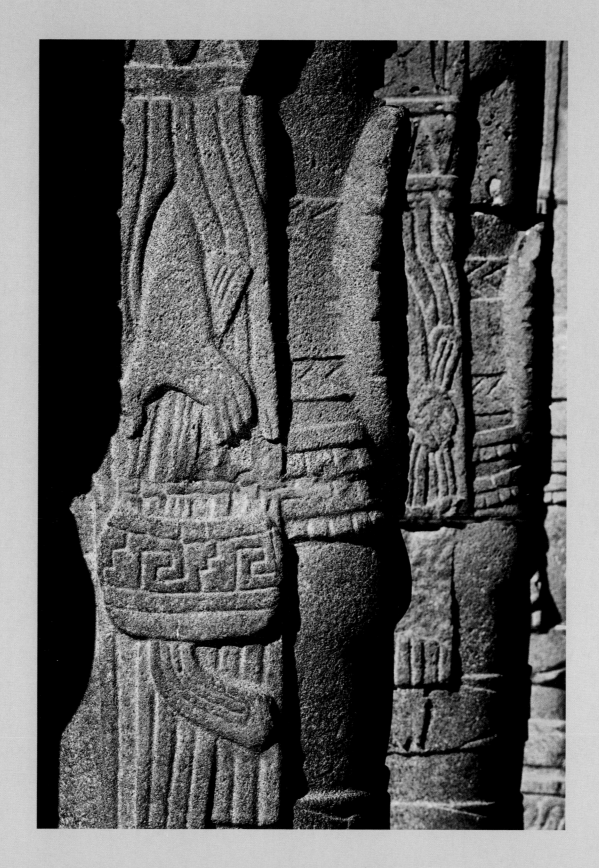

OPPOSITE AND ABOVE: *Atlantes*

61

EL TAJÍN, VERACRUZ

Part of a ruin's appeal is that it can never be fully known and remains a mystery. Answers to even the most basic questions sometimes elude archaeologists and other experts. El Tajín (pronounced: *ta-heen*) offers an intriguing example. Despite extensive excavation and reconstruction, it remains unclear who built it.

It is possible that the Totonacs, an indigenous people from eastern coastal Mexico who occupied the city in its later years, may have constructed some of its plazas, temples, and seventeen ball courts, the most of any Mesoamerican site. At the very least, the Totonacs deserve credit for naming it. El Tajín has been translated from their language to mean "of thunder or lightning bolt." The name may also have derived from their belief that overlords of the thunderstorm, known collectively as "Tajin," dwelled at the site.

Whoever built the city created the most important commercial and religious center in northeast Mesoamerica after the fall of Teotihuacán. El Tajín's cultural influence extended all along the Gulf and penetrated into the Maya region and central Mexico. At its peak, between AD 900 and 1100, the city covered four square miles and had a population of about 25,000.

The Pyramid of Niches dominates El Tajín. Rising more than 60 feet (18 m), the city's signature structure was originally painted red and its 365 niches, one for each day of the solar calendar, were colored black to enhance their shadows. The niches possibly represent caves, which ancient peoples believed were passageways to the underworld where many of their gods resided and, as such, were places to leave flowers, candles, and other offerings. As late as the mid-twentieth century, evidence of beeswax candles could still be found on the first level of the pyramid.

Around AD 1200 El Tajín was abandoned and partially destroyed after attacks by the Chichimecs, a semi-nomadic people from northern Mexico. It fell into ruin and lay unknown to Europeans until 1785 when Diego Ruiz, a Spanish official, stumbled upon it while looking for illegal tobacco plantings.

In the mid-1930s the Mexican archaeologist Agustin Garcia Vega undertook the first formal mapping, clearing, and exploration of El Tajín. José Garcia Payon carried on Vega's work for nearly forty years until his death in 1977. In that time he uncovered most of the major buildings and established El Tajín as an important ancient Mesoamerican city. UNESCO confirmed El Tajín's significance with a World Heritage Site designation in 1992.

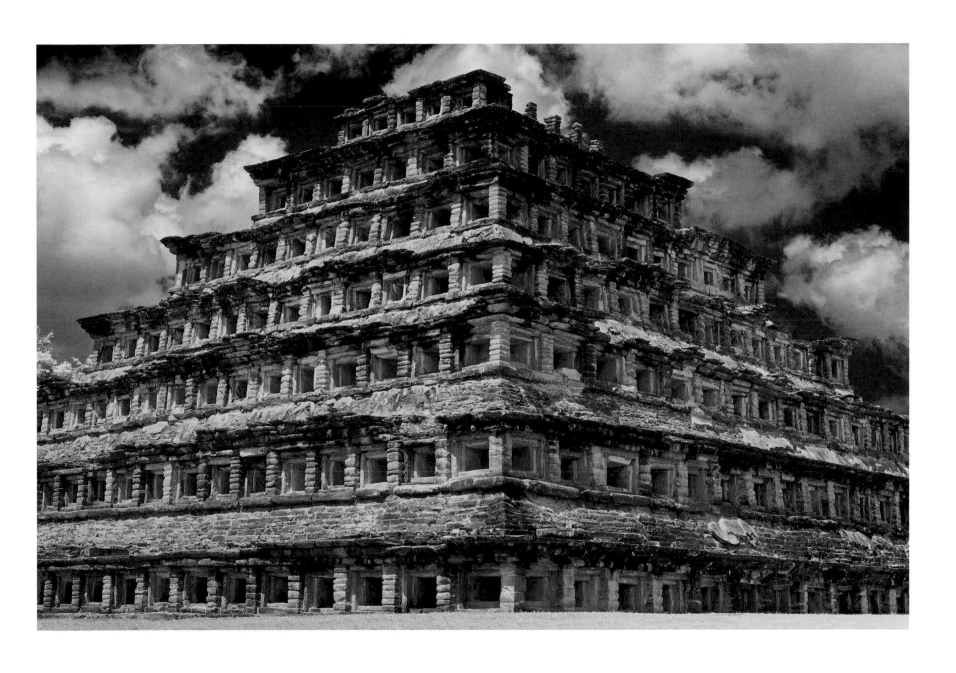

Pyramid of Niches, rear view

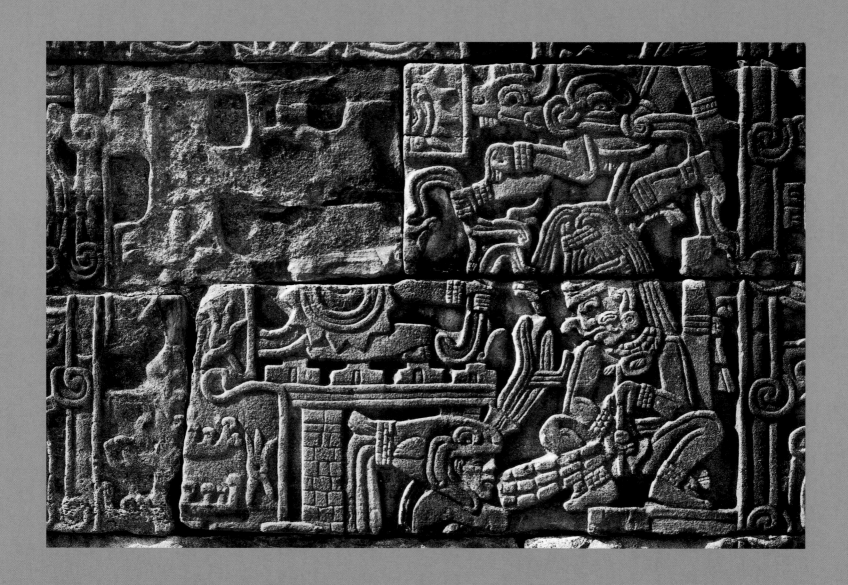

Ball Court relief

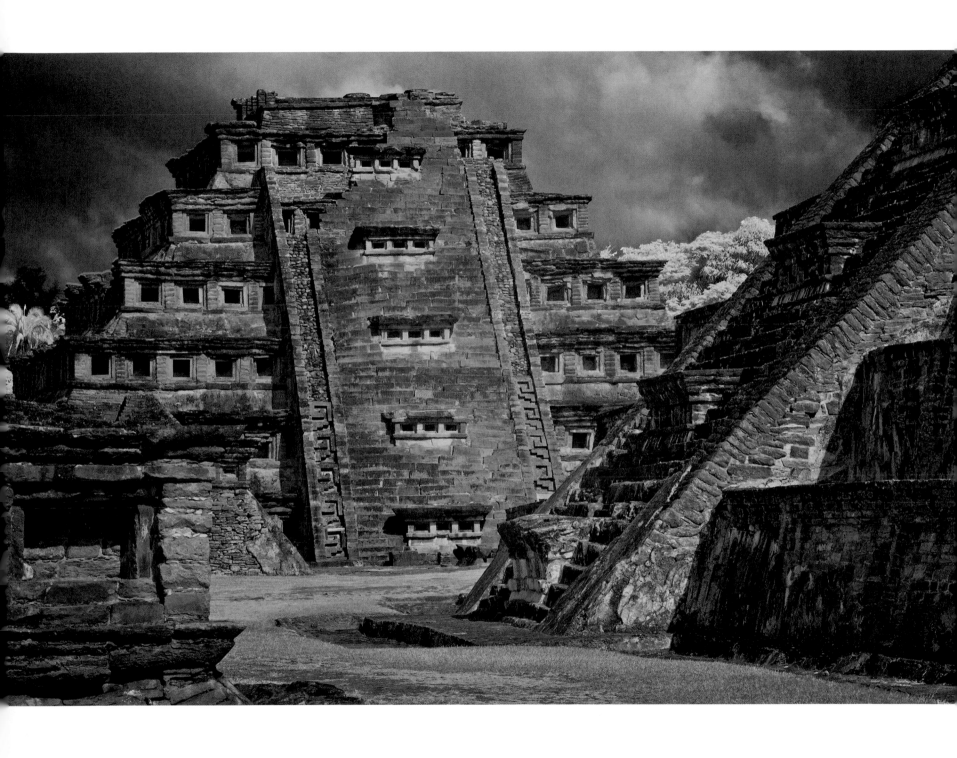

Pyramid of Niches, front view

MITLA, OAXACA

In the Zapotec language its name means "resting place," a burial ground for high priests and rulers, but Mitla is very much alive with a dizzying array of geometric designs that decorate its buildings and define its architecture.

The intricate mosaic fretwork dates to about AD 1200 to 1400. During that time Mitla had succeeded Monte Alban as the most important Zapotec city and flourished as the religious center of the Oaxaca Valley.

Of the five complexes that comprise Mitla, the one known as The Group of Columns dominates the site. Its main building, the Palace, served as the residence of the high priest who also performed rituals there including human sacrifices. Befitting its sacred function, the Palace stands out for its large-scale architecture, extensive ornamentation, and monolithic columns, which are unique to the site.

The mosaics, known as *grecas* for their resemblance to ancient Greek designs, are made from thousands of cut and polished stones fitted together without mortar. The stones are held in place by the weight of the stones that surround them and were originally set against a red stucco background. There are fourteen different designs throughout the complex.

Far from being static decorations, the grecas pulsate with movement. In concert with the rising and setting of the sun, the fretwork appears to emerge from the façades, taking on a vibrant, deep-shadowed dimension before receding back into the walls at day's end.

Some see the grecas as symbols of the sky, the earth, and Quetzalcoatl, the feathered serpent and supreme deity, while others view them as purely abstract creations. Whatever one sees, the quality and quantity of such unusual stonework distinguish this ruin from all others in Mesoamerica.

In 1521 conquistadors dismantled many of the buildings, reusing materials from these Zapotec masterworks to construct the double-domed Church of San Pablo, which sits atop part of the ruins.

In 1901 the Mexican archaeologist Leopoldo Bartres undertook the first restoration of Mitla. Although his methods were questionable, he succeeded in beginning the preservation efforts that continue to the present. As a result of Bartres' work, the government of President Porfirio Díaz chose Mitla to be a symbol of pre-Hispanic Mexico during the 1910 centennial celebration of the country's independence. Mitla's status as an indigenous cultural landmark later became permanent with its inclusion on Mexico's official list of national heritage sites.

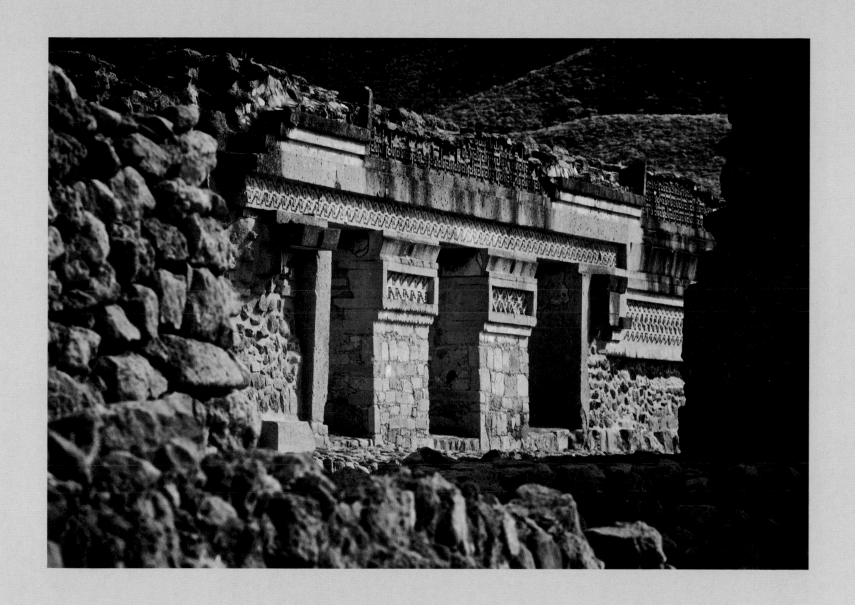

South group

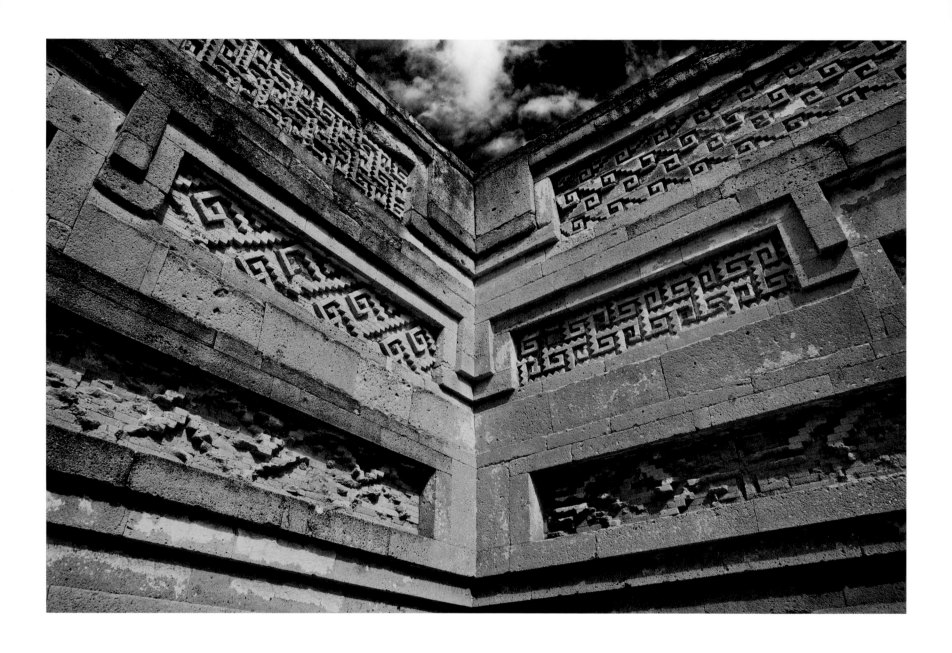

Palace interior

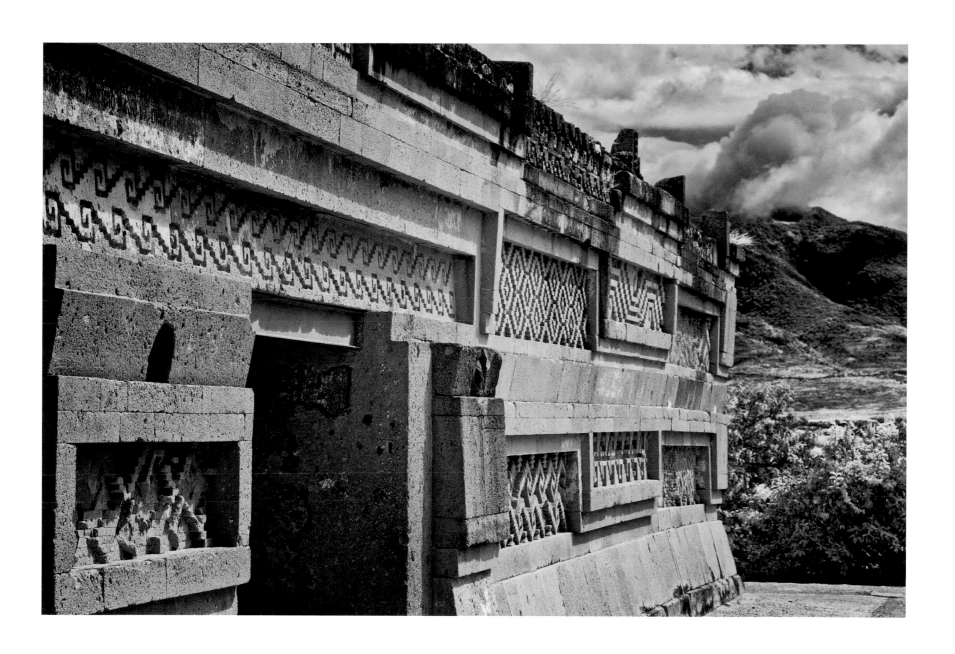

Palace exterior

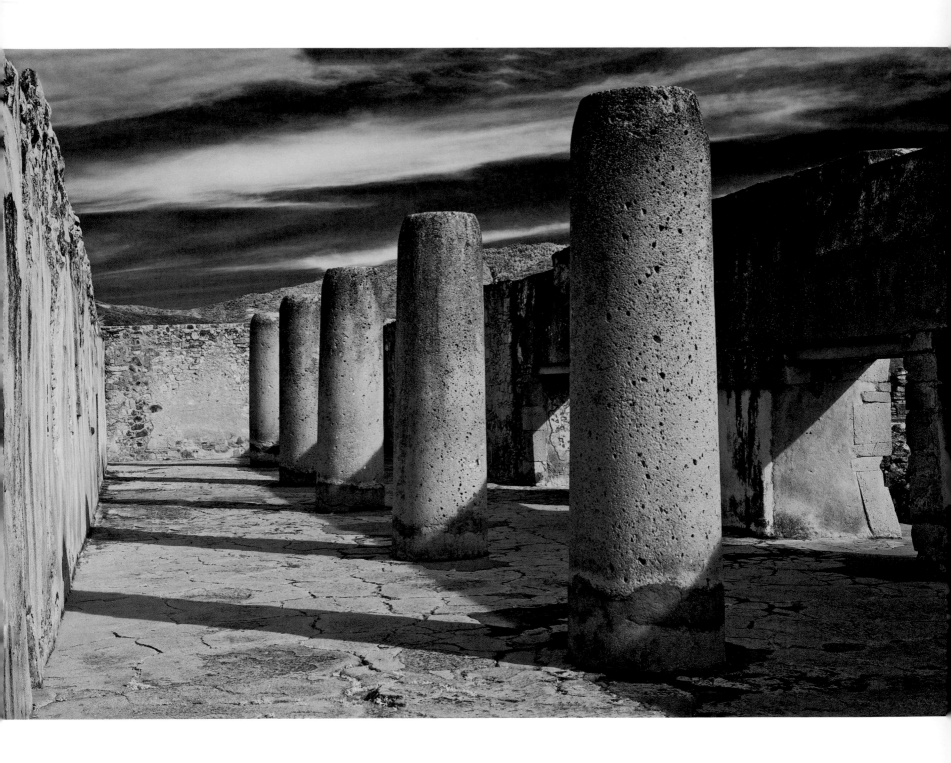

Grand Hall of Columns

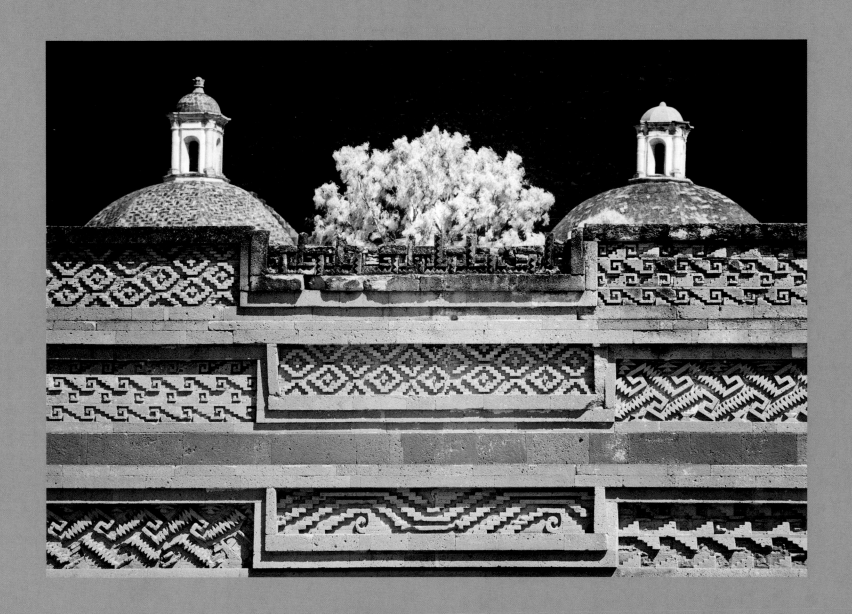

Church of San Pablo domes and Palace grecas

PALENQUE, CHIAPAS

"In the romance of the world's history," wrote nineteenth century American author and explorer John Lloyd Stephens in his classic work, *Incidents of Travel in Central America, Chiapas, and Yucatán,* "nothing ever impressed me more forcibly than the spectacle of this once great and lovely city, overturned, desolate, and lost…"[7]

With such elegiac prose Stephens summed up his visit to Palenque, a Maya city renowned for its elegant buildings, sculpted reliefs, and well-preserved glyphs. These works, most of which date from Palenque's golden age, between AD 615 and 800, stand as the legacy of the city's celebrated ruler, Pakal the Great. He initiated the construction that UNESCO's World Heritage Site designation calls "an incomparable achievement of Mayan art."

That art is on full display in the Group of the Cross, a compound of temples; and the Palace, which served as the royal residence and civic center. Its central structure, the Tower, is unique in Maya architecture. Rising more than three storeys, it may have functioned as an observatory. These buildings, like those at other Maya sites, were originally painted red while their roof comb designs, wall carvings, and other ornamentation were highlighted in yellow, white, green, and blue.

Sometime after AD 800 major construction in Palenque ceased. The timing of this development coincides with the social collapse of other southern Maya cities such as Copán and Tikal.

During the tenth century Palenque was abandoned, overgrown and left to ruin. The city remained unknown to the outside world until a Spanish priest, Fray Pedro Lorenzo de la Nada, discovered the ruins in 1567 and named the site *Palenque* (palisade or fortification). In ancient times, as wall carvings indicate, the city was known as Lakam Ha, or Big Water, after its many springs and cascades, which the Maya controlled with an elaborate aqueduct system.

Stephens and the artist Frederick Catherwood made the first reliable survey of Palenque in 1840. Their account inspired others to explore the site, including the French explorer Désiré Charnay, who in 1859–60 made the first photographs of Palenque and other ancient sites in Mexico.

Despite all that has been unearthed, only 5 percent of the city, according to one estimate, has been excavated. "The first visit to Palenque is immensely impressive," wrote Frans Blom, an archaeologist who studied the site extensively in the 1920s. "When one has lived there for some time this ruined city becomes an obsession."[8]

OPPOSITE: *Tower*

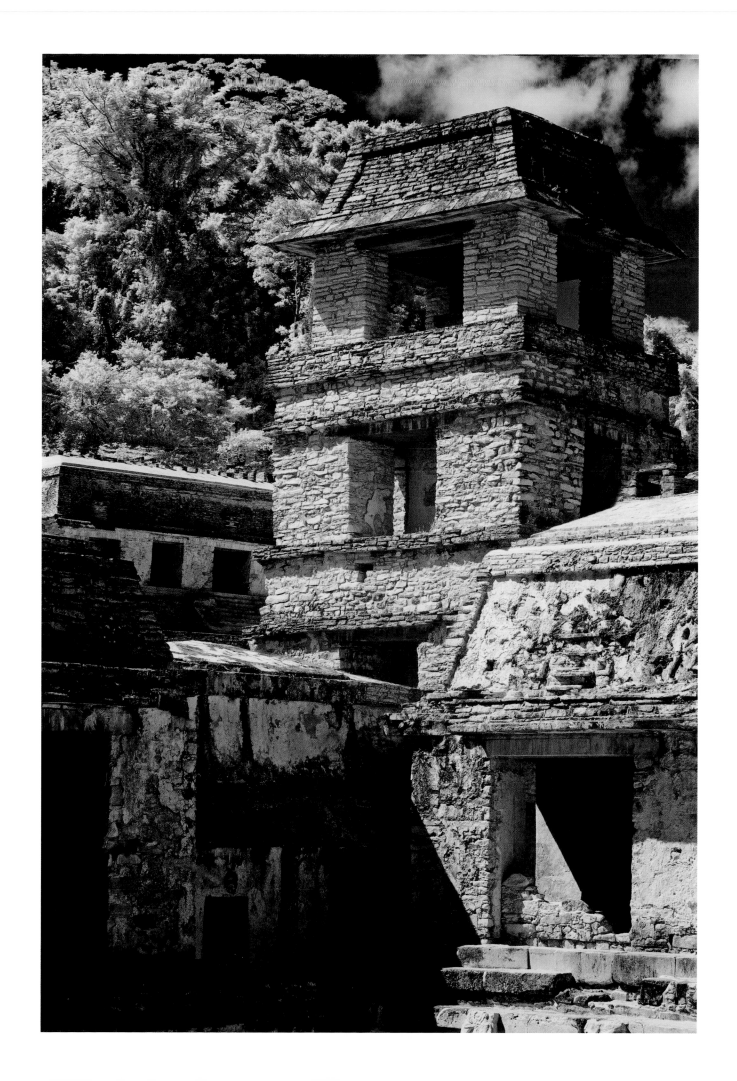

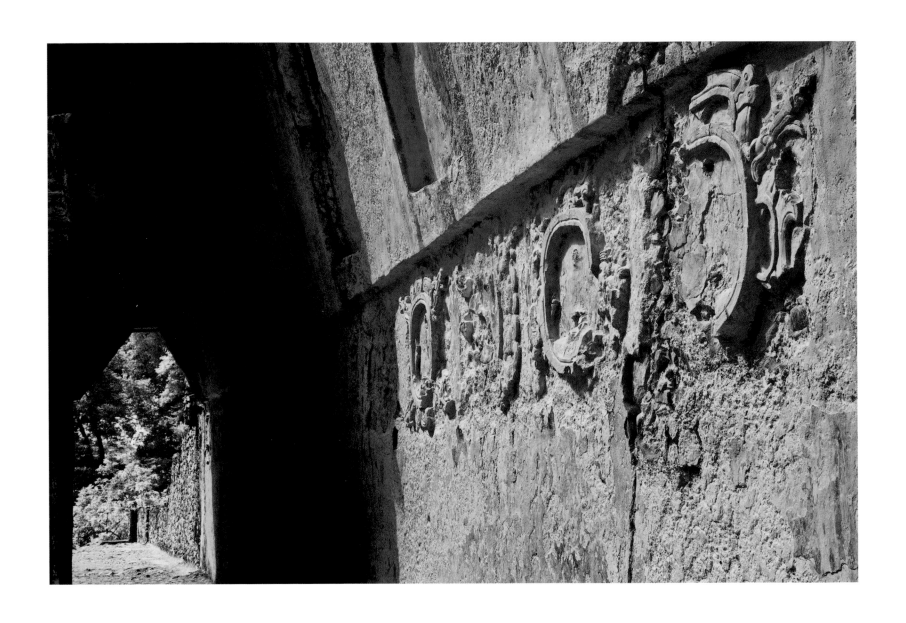

Palace galleria

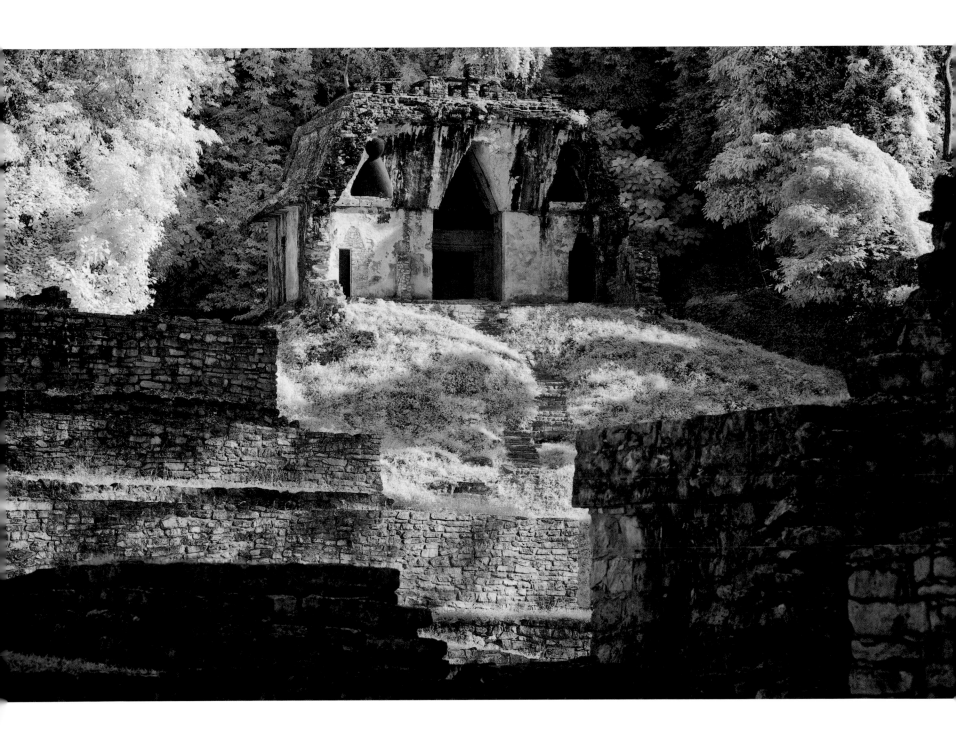

Temple of the Foliated Cross

UXMAL, YUCATÁN

Long ago, according to Maya legend, the ruler of Uxmal (pronounced: *oosh-mahl*) challenged a dwarf to build in one night a house taller than any other in the city or die. The dwarf became despondent and cried to his mother who told him not to lose hope. The next morning he awoke to see a completely finished pyramid towering over all the other buildings in the city.

Rising 115 feet (35 m), the Pyramid of the Dwarf (also known as the Pyramid of the Magician) is indeed the tallest building in Uxmal, the largest Maya city in Yucatán's Puuc region, a hilly area south of modern-day Mérida. The pyramid's great height, steep slope, and elliptical base also make it one of the most unusual buildings in Maya architecture. It was not constructed all at once overnight but rather five times, one on top of the other, between the sixth and tenth centuries when Uxmal emerged as the region's dominant urban center with a population of 25,000.

During this period, Uxmal also became the leading exponent of Puuc-style architecture. This mode of construction is best known for plain walls at the base and elaborate friezes on the upper levels. These decorations typically feature stone latticework; carvings of Kukulkan, the creator or fertility deity, depicted as a feathered serpent; and masks of Chac, the rain god, who inspired great devotion in an area devoid of permanent water resources.

Experts regard the Governor's Palace as the epitome of Puuc-style architecture. It took some 15,000 individual pieces of carved stone to create the upper frieze. "If it stood at this day . . . in Hyde Park or the Garden of the Tuileries," wrote American explorer John Lloyd Stephens in 1841, "it would form a new order . . . not unworthy to stand side by side with the remains of Egyptian, Grecian and Roman art."[9]

Uxmal flourished until about the mid-tenth century when it went into a rapid decline, perhaps the result of warfare with Chichén Itzá, a former ally. After Uxmal's collapse, the neighboring Xiu clan, occupied the city and, according to Spanish documents, held pagan ceremonies there in secret.

Explorers, led by the eccentric "Count" Jean-Frédéric Waldeck, rediscovered the site in the nineteenth century. Modern excavations did not begin until the 1930s. UNESCO, recognizing that Uxmal represents the pinnacle of the Puuc style, inscribed the city on the World Heritage Site List in 1996.

OPPOSITE: *Pyramid of the Dwarf (aka Pyramid of the Magician)*

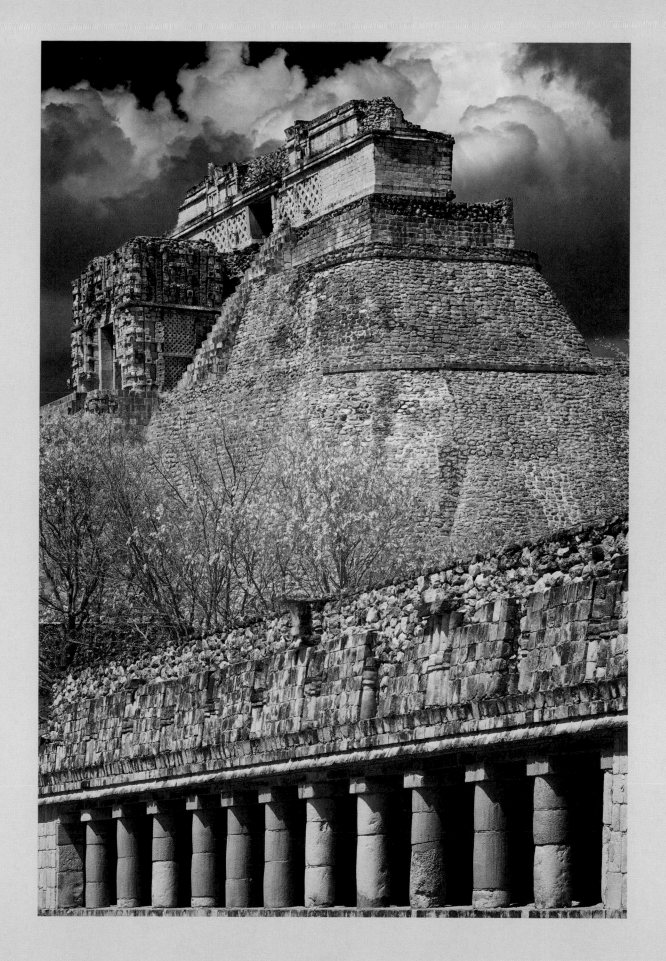

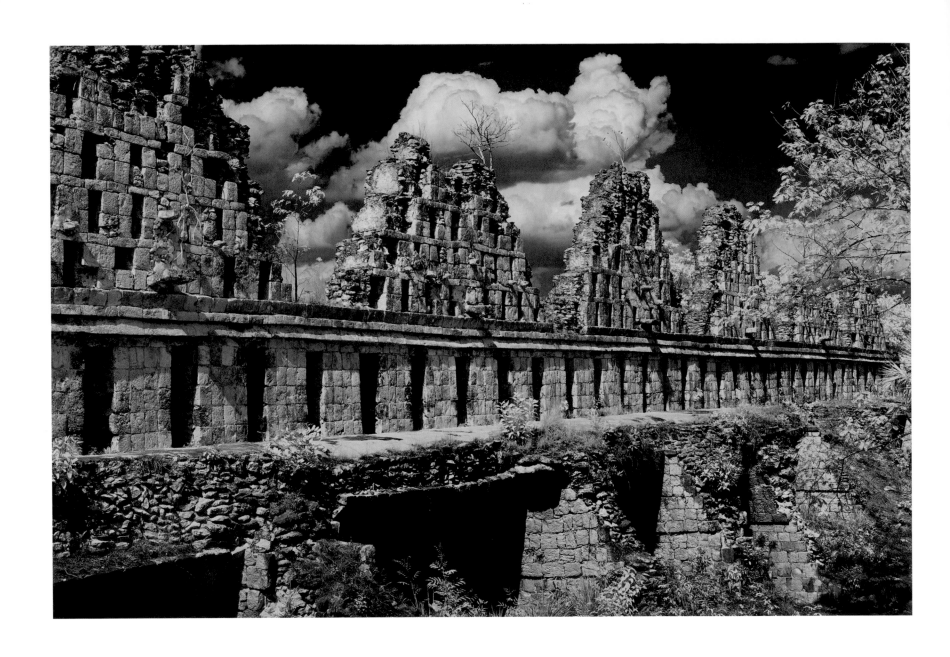

Dovecote

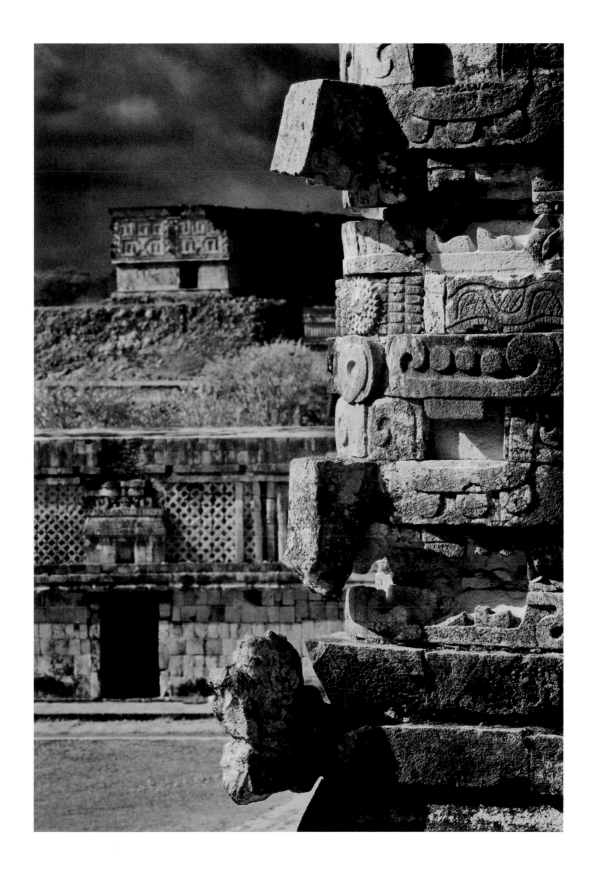

View of Governor's Palace from Nunnery Quadrange

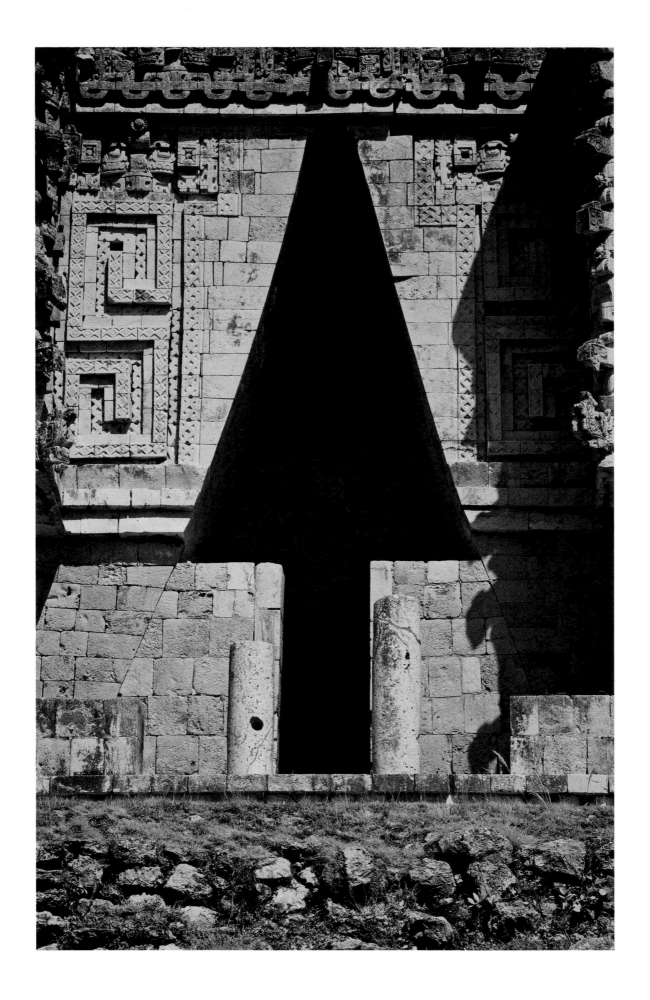

OPPOSITE: *Arch, Governor's Palace* ABOVE: *Cemetery*

KABAH, LABNÁ, AND SAYIL, YUCATÁN

Ruins at three small Maya sites linked to Uxmal stand out among the hills of the Puuc region. Built between AD 750 and 1000, they represent some of the finest examples of the architectural style unique to this region.

At Kabah, the building known as Codz Poop is one of the most ornate structures in the Maya world. Some 250 stone masks of Chac, the rain god, cover the entire façade. This massive, concentrated repetition of a single decorative element is unusual in Maya architecture. It graphically illustrates the intense devotion to Chac in the arid Puuc region. Without permanent water sources, inhabitants were totally dependent on rainfall, which they stored in underground reservoirs called *chultunes*. Codz Poop, which in Mayan means "rolled mat," a symbol of authority, probably served as an administrative building.

The Great Palace at Sayil is a monumental building with more than 90 rooms and eight chultunes. Most likely it was a multi-purpose complex that included living quarters for perhaps as many as 350 members of the city's ruling dynasty. Although the palace appears to be simply three storeys high, in fact, each level is supported by a layer of piled stones.

Rising 20 feet (6 m), the Arch of Labná is one of the tallest structures of its kind in Maya architecture. The corbel vault most likely functioned as a formal passageway between residential and administrative sectors reserved for Labná's elite. Opposite the arch, on a steep pile of rocks, sits El Mirador, a temple with an impressive roof comb. John Lloyd Stephens called it "the most curious and extraordinary structure" he had seen in Mexico.

Labná clearly charmed Stephens, who along with his companion, artist Fredrick Catherwood, were the first outsiders ever to see it. "If a solitary traveler from the Old World could by some strange accident have visited this aboriginal city when it was yet perfect," the nineteenth century American writer wrote, " his account would have seemed more fanciful than any in Eastern story, and been considered a subject for the Arabian Nights' Entertainment."[10]

In 1996 UNESCO considered Kabah, Sayil, and Labná high points of Maya art and architecture and included them in its designation of Uxmal as a World Heritage Site.

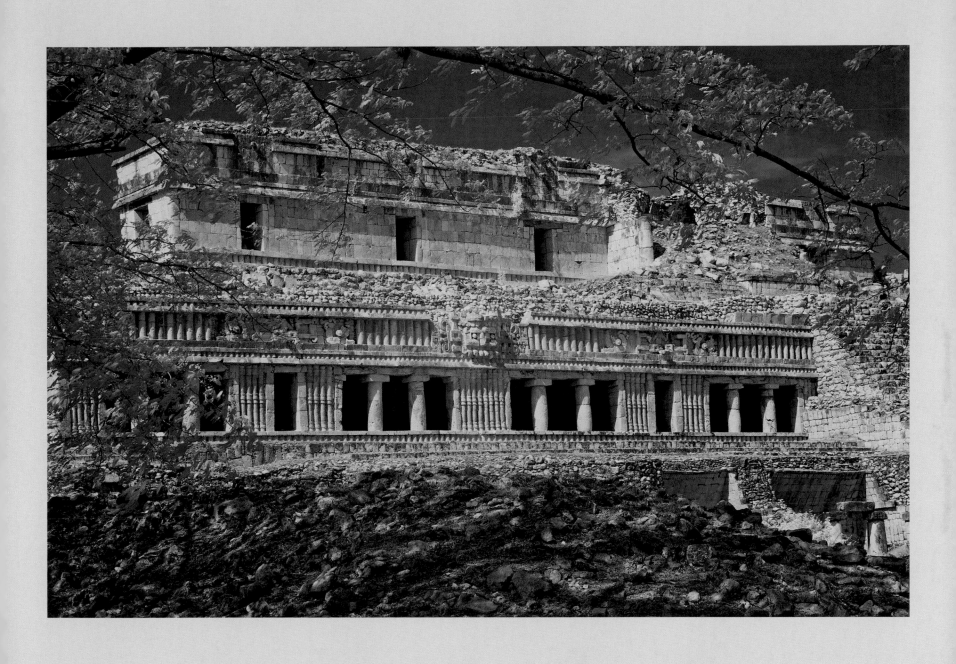

Great Palace, Sayil

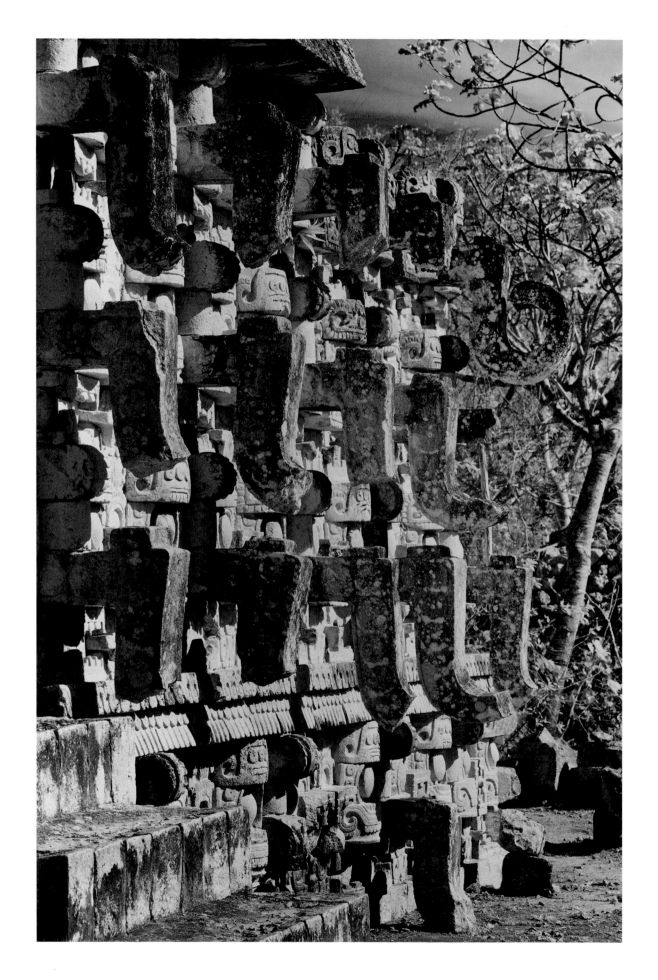

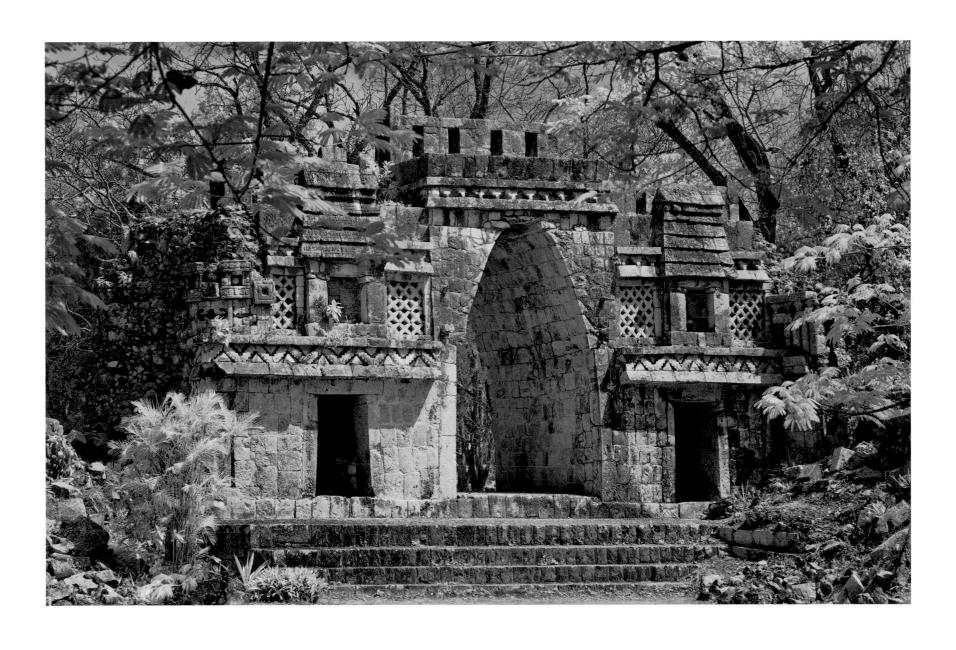

OPPOSITE: *Codz Poop, Kabah* ABOVE: *Arch, Labná*

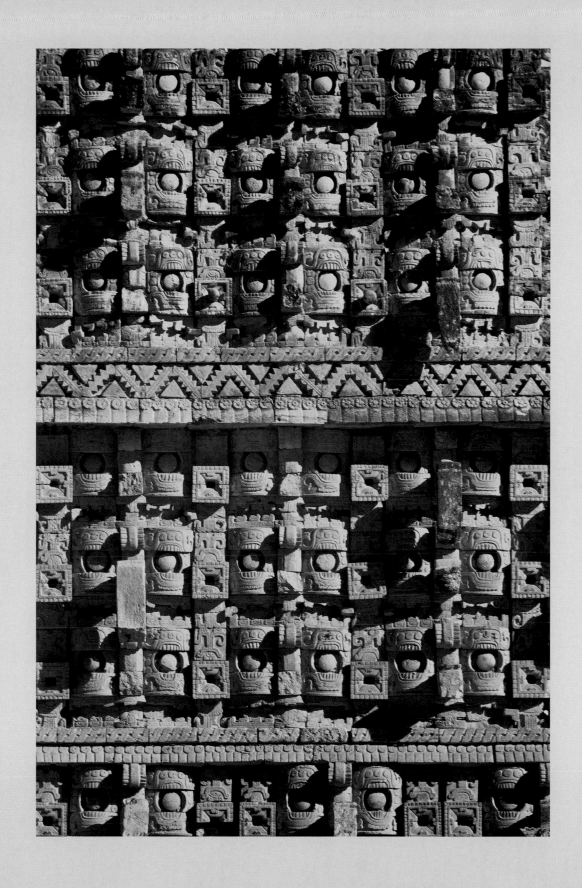

OPPOSITE: *El Mirador, Labná* ABOVE: *Codz Poop, Kabah*

CHICHÉN ITZÁ, YUCATÁN

Of all the ruins nestled in the jungle of the Yucatán Peninsula, few rival Chichén Itzá in size, scope, and splendor. Its name means "at the mouth of the well of the Itzas," after a semi-nomadic people who lived there. It was at this sacred cenote that Chichén Itzá sprang up in the fifth century and grew to become one of the last great Maya cities.

Unlike many sites, Chichén Itzá features two major architectural styles that reveal not only its distinct stages of development but also its significance as a cultural crossroads.

The city's ascendance began between AD 600 and 900 when early Maya settlers constructed buildings in the classic Puuc style. Among these structures is one with an ornate façade decorated with masks of Chac, the rain god, that conquistadors later named La Iglesia (the Church). Its real function is unknown.

Chichén Itzá's second and most important phase of development took place around AD 1000 when Toltecs migrated there from central Mexico. The fusion of Toltec and Maya artistic traditions attained its fullest expression in major architectural works such as the Great Ball Court, the largest in Mesoamerica; the Observatory also known as El Caracol (the Snail); and above all, the Pyramid of Kukulkan, which the conquistadors called El Castillo (the Castle), erected in honor of the Maya supreme deity.

The construction of these edifices coincided with Chichén Itzá's golden age between AD 1000 and 1200 when the city boasted more than 35,000 inhabitants and boomed as a regional power center whose sphere of influence extended beyond the Yucatán, up into the Gulf Coast and down into what is now Central America.

Chichén Itzá fell into decline at the end of the twelfth century, the result of internal conflict and warring with rival city-states. Eventually abandoned, the city remained an important pilgrimage site, even after the conquistadors arrived in the 1500s.

Chichén Itzá was not widely known until 1843 when John Lloyd Stephens published *Incidents of Travel in Yucatán*, which included an account of his visit to the ruins with the artist Frederick Catherwood. Inspired by the book, archaeologists poured in to explore the site. Excavations continue under the direction of INAH, Mexico's National Institute of Anthropology and History.

Describing its main structures as "undisputed masterpieces of Mesoamerican architecture," UNESCO declared Chichén Itzá, "the most important archaeological vestige of the Maya-Toltec civilization in the Yucatán" and designated it a Word Heritage Site in 1988.

OPPOSITE: *Pyramid of Kukulkan*

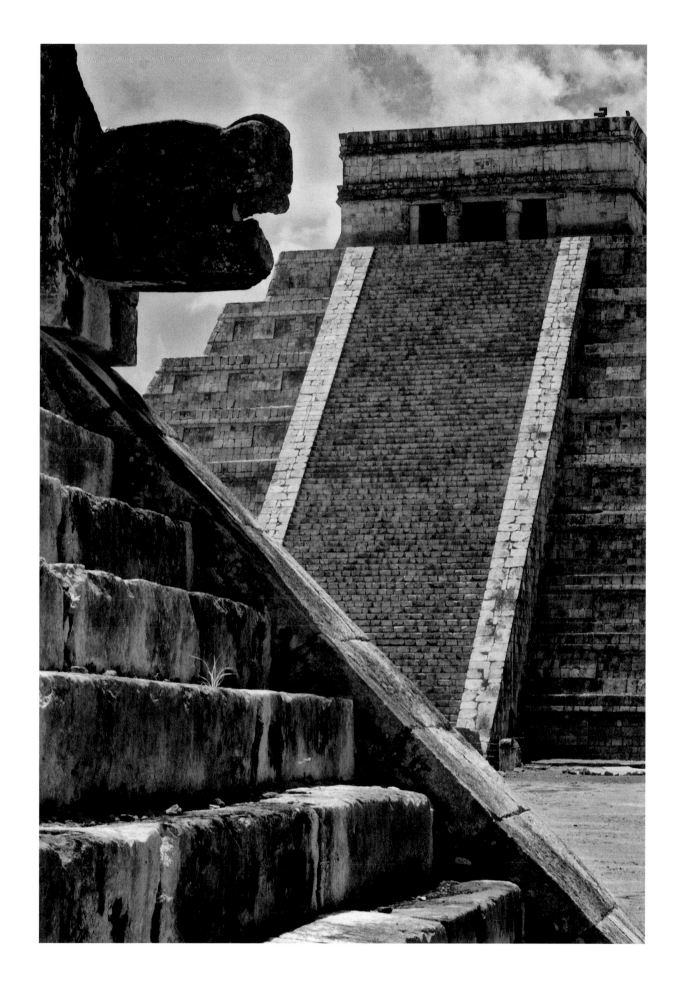

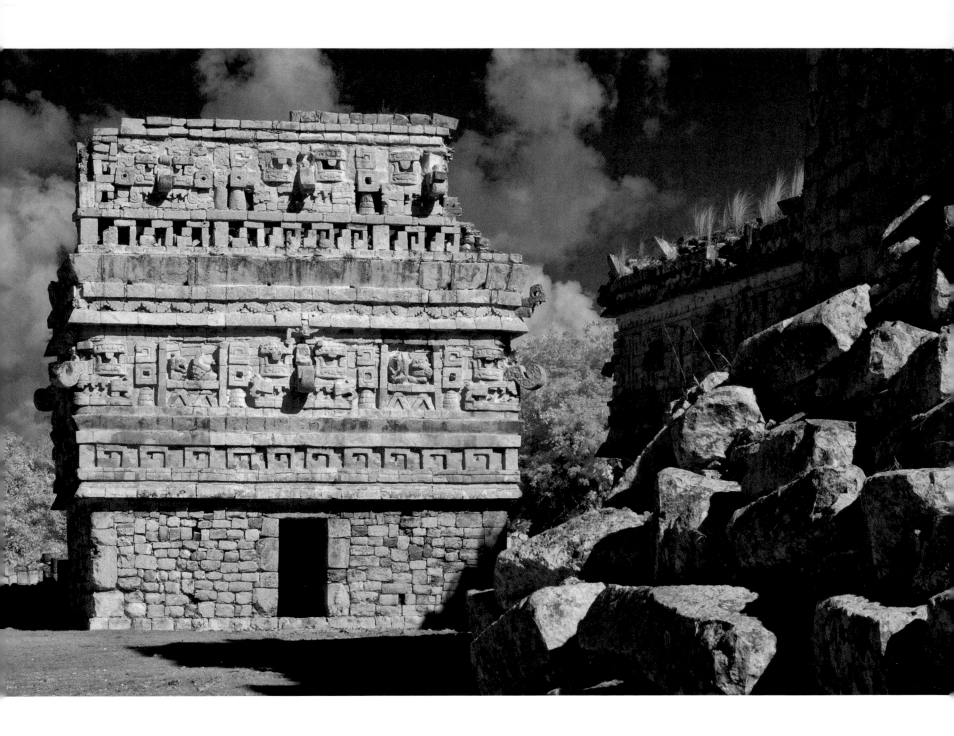

Church

Market

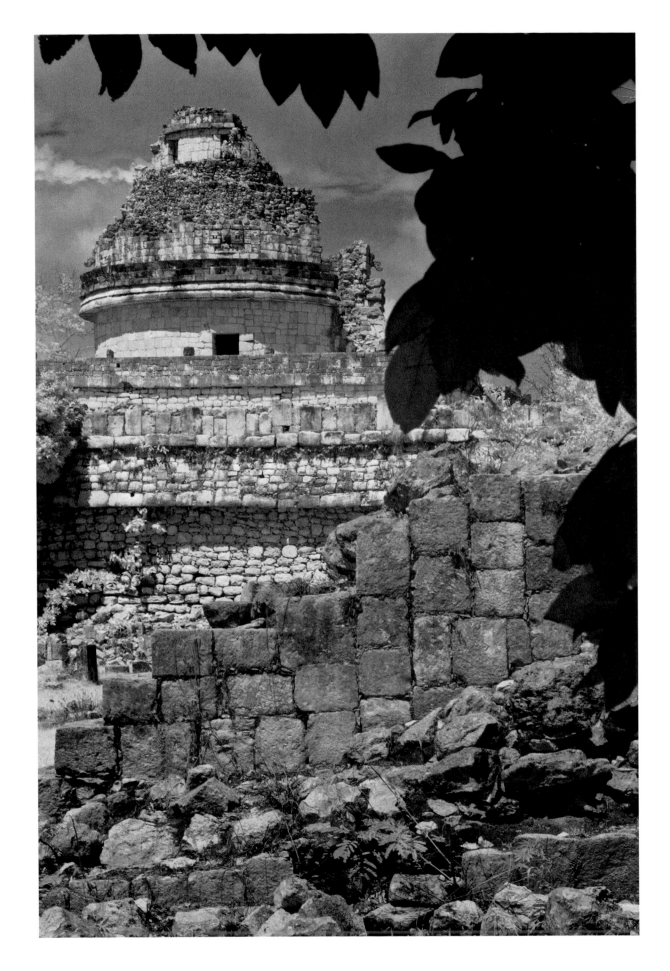

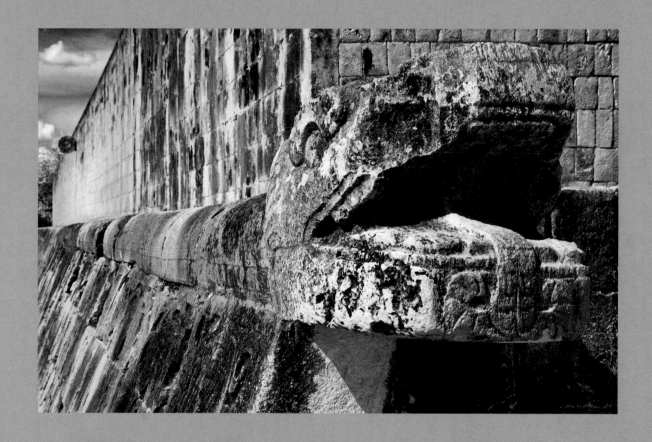

OPPOSITE: *Observatory* ABOVE: *Ball Court*

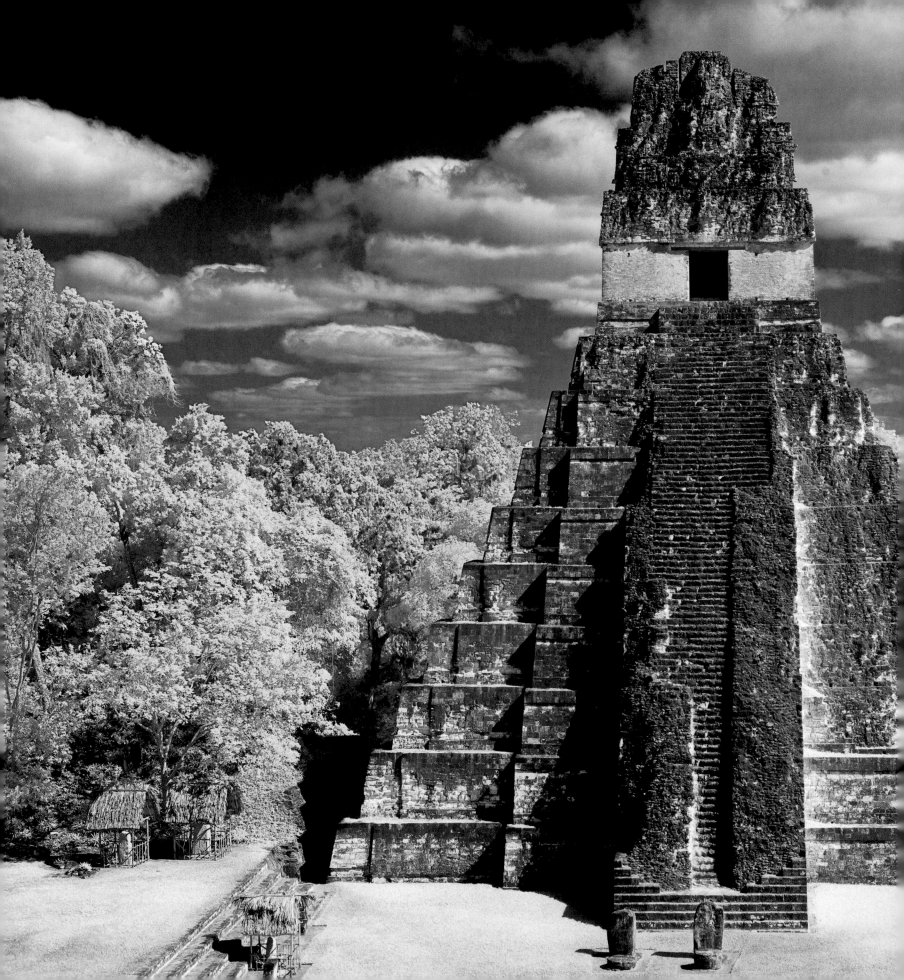

CENTRAL
AMERICA

✠

TIKAL, EL PETÉN, GUATEMALA

Deep in the rainforest of northern Guatemala, where the call of howler monkeys rumbles through the trees and the iridescent colors of oscillated turkeys shimmer in the sun, stands Tikal, one of the largest and most powerful Maya kingdoms. At its zenith, in the eighth century, Tikal had a population of perhaps as many as 100,000 and dominated much of the Maya world.

During its peak, Tikal began construction of its most significant architecture, including the Great Plaza where large public events were held, the acropolises where the elite worked and lived, and the steep, slender pyramids that probably served as funerary temples for Tikal's royalty. Rising as high as 210 feet (64 m), these pyramids are among the tallest structures in ancient Mesoamerica.

Toward the end of the ninth century, major construction ceased. Less than a hundred years later Tikal was completely abandoned. Many archaeologists believe that overpopulation and depletion of resources caused its demise. These environmental factors may also have triggered a wider social collapse that affected Copán, another early Maya metropolis.

Reclaimed by the rainforest, Tikal was almost forgotten until 1848 when the Guatemalan government sent an expedition to investigate the site. Word spread, interest grew and fieldwork began, including that of the British archaeologist and photographer A. P. Maudslay, who became a pioneer of Maya studies.

The first major archaeological survey was conducted by a team from the University of Pennsylvania, which in 1956 began a thirteen-year project to unearth, preserve, and restore the pyramids and other important structures. As a result of their work, Tikal is the most extensively excavated Maya site. Despite this distinction, most of the vast ancient city remains buried beneath mounds of trees and thick vegetation, awaiting further exploration.

In 1955 the Guatemalan government preserved Tikal as a national park, the first in Central America. UNESCO selected Tikal as a World Heritage Site in 1979.

PRECEDING PAGES: *Temple of the Great Jaguar, Tikal, Guatemala* OPPOSITE: *Temple of the Jaguar Priest*

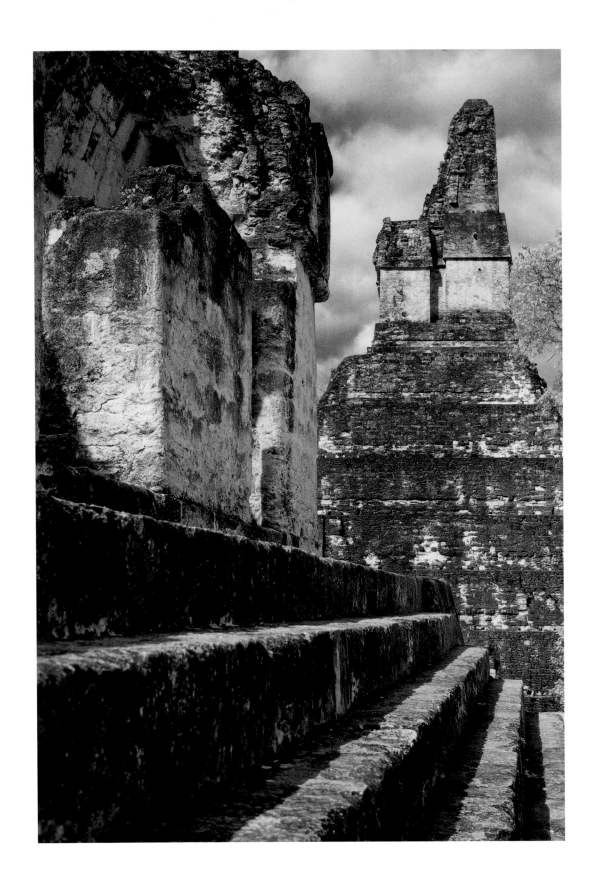

ABOVE: *Temple of the Great Jaguar* OPPOSITE: *Mundo Perdido*

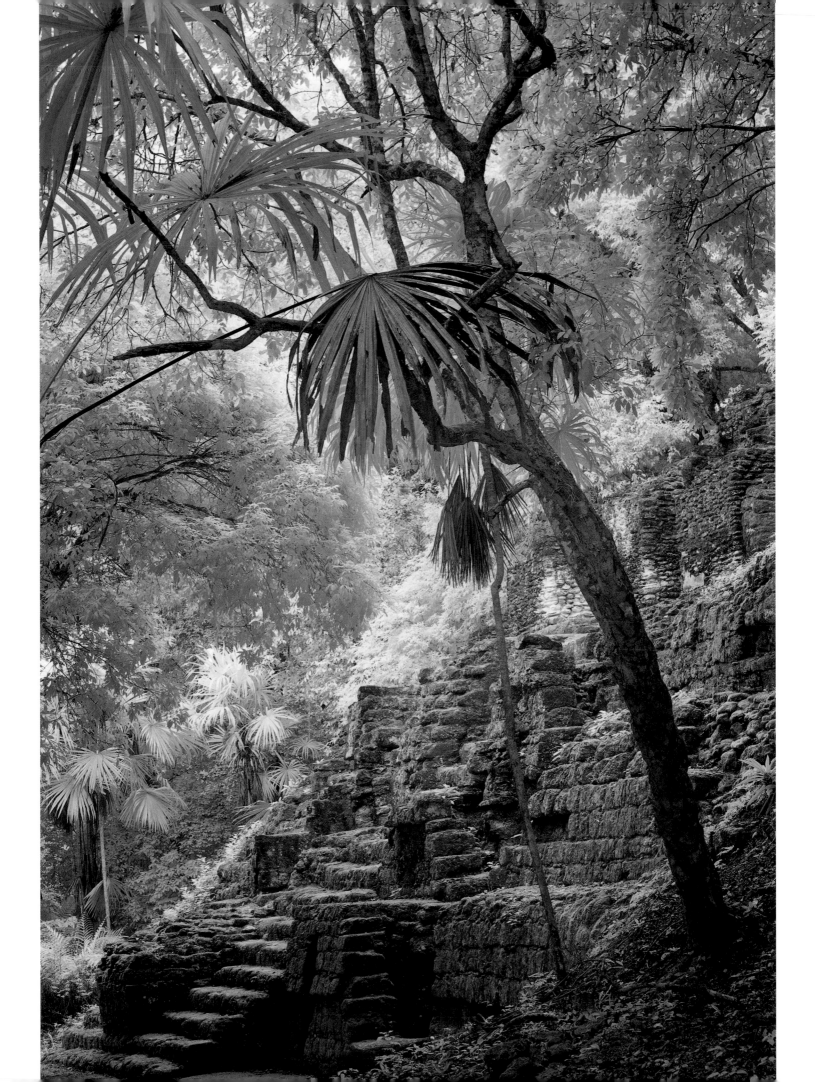

COPÁN, COPÁN RUINAS, HONDURAS

"It lay before us like a shattered bark in the midst of the ocean…"[11] wrote John Lloyd Stephens, author and explorer, in his 1841 account, *Incidents of Travel in Central America, Chiapas, and Yucatán.*

What lay before Stephens and his traveling companion, the British artist Frederick Catherwood, was the ancient Maya city of Copán. Stephens conducted the first archaeology at the site and was most impressed by its stelae, the large stone shafts carved on all four sides, which give Copán its distinctive character and helped it earn World Heritage Site status in 1980.

Standing 14 feet tall, the stelae feature giant, full-length sculpted portraits of different rulers and glyphs recounting historic events. These monuments were so intricate in design and masterful in execution that Stephens concluded they were equal to the finest in Egypt and proved "the people who once occupied the Continent of America were not savages."[12]

The stelae were erected between the sixth and eighth centuries, a period of great cultural achievement in Maya civilization. During this golden age, Copán had a population of about 20,000 and served as the capital of a large kingdom that dominated the southeastern borderlands of the Maya world.

Overpopulation and depleted resources contributed to Copán's eventual demise. The city was abandoned in the tenth century and left for the jungle to reclaim. That is, until Stephens and his guides hacked their way through with machetes nine hundred years later.

Copán so captivated Stephens that he paid a local landowner fifty dollars for it. His dream was to float the city down river and put it on exhibit in the United States. His grand plan never came to pass. Just as well. Only in its original setting can one experience the splendor of Copán just as Stephens had when he first saw it:

"The beauty of the sculpture, the solemn stillness of the woods, disturbed only by the scrambling of monkeys and chattering of parrots, the desolation of the city, and the mystery that hung over it, all created an interest higher, if possible, than I had ever felt among ruins of the Old World."[13]

OPPOSITE: *Forest of Kings*

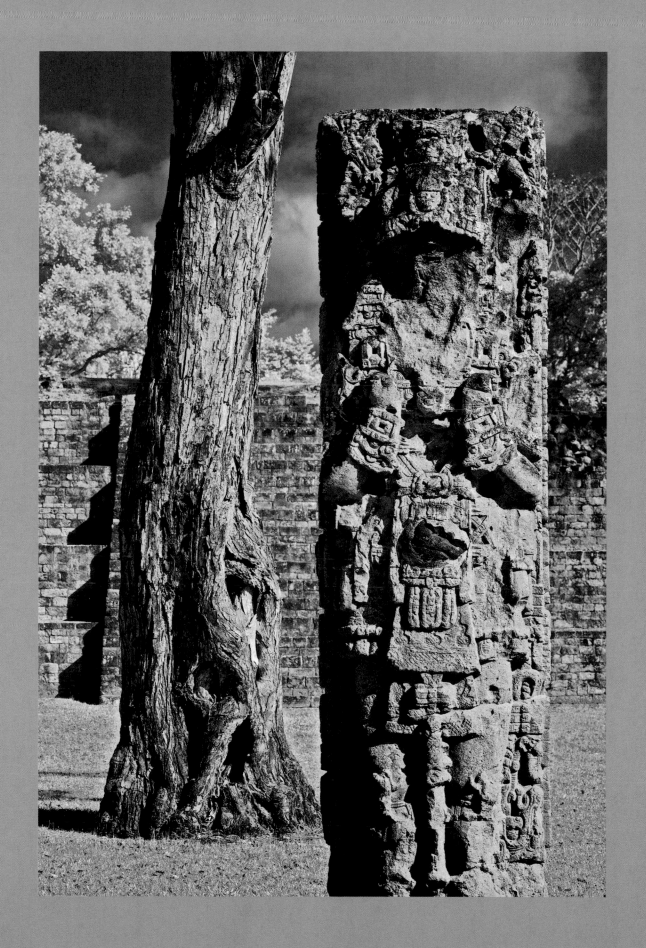

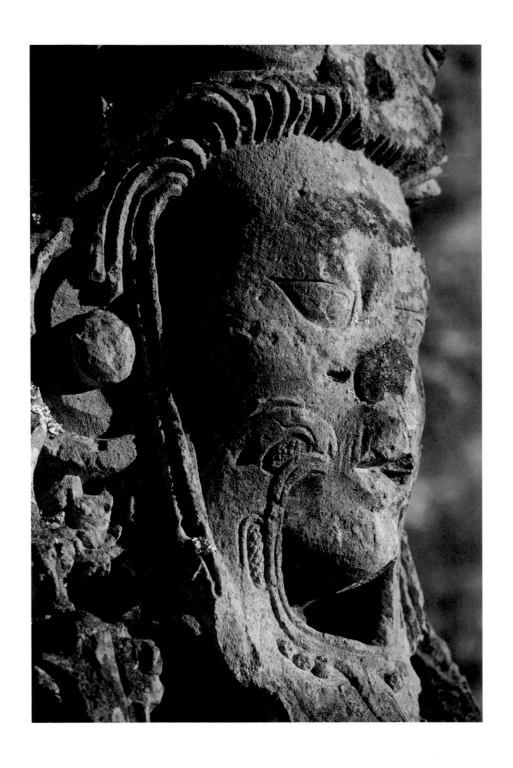

ABOVE: *Stela F* OPPOSITE: *Stela B*

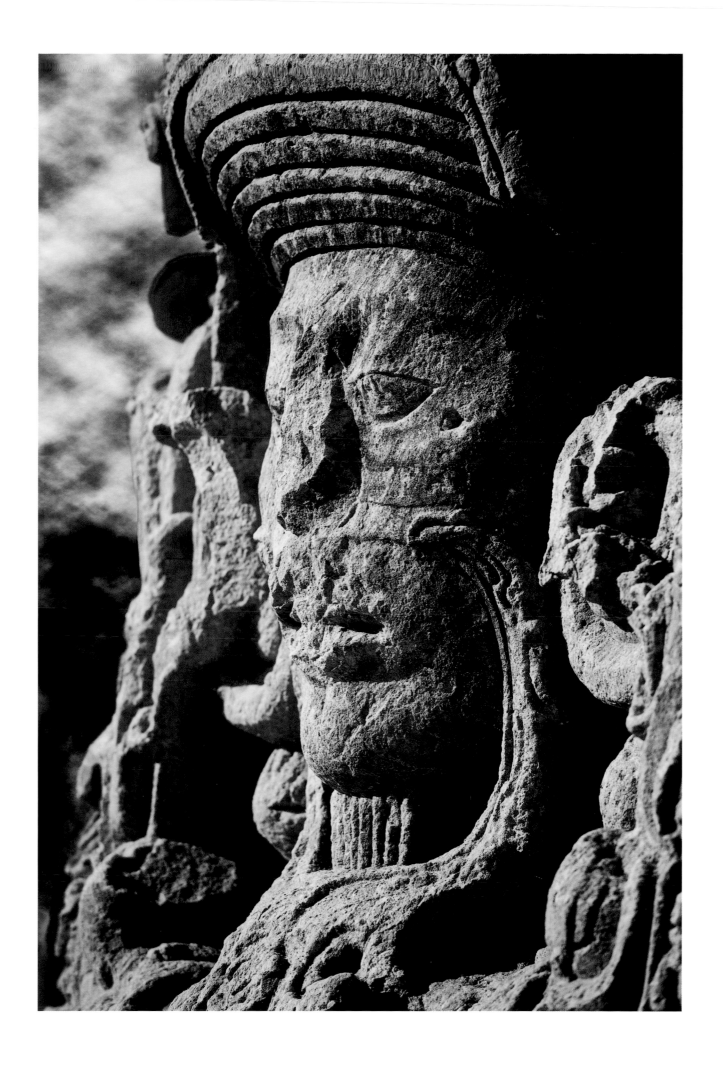

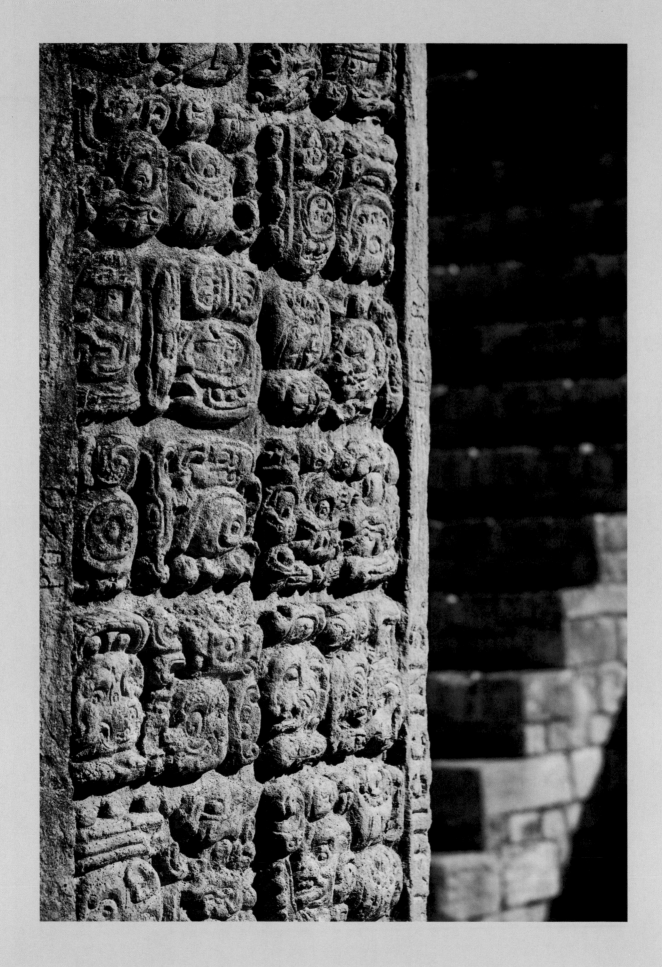

OPPOSITE: *Stela A inscription* ABOVE: *Ball Court*

PANAMÁ VIEJO, PANAMA

Founded in 1519 by the conquistador Pedrarias Dávila, Panamá Viejo is the oldest European settlement on the Pacific coast of the Americas. It was the point of departure for the first European explorations along the Pacific, which had been discovered in 1513 by Vasco Núñez de Balboa, and became an important commercial and administrative center for Spanish interests in the region.

Laid out in a grid system according to Spanish urban tradition, Panamá Viejo featured a central plaza, the city's bustling social and economic hub. The buildings closest to the plaza were the most important in the city, made of the most durable materials, and were occupied by the most powerful families and institutions in colonial society.

Though ravaged by an earthquake in 1621 and devastated by a fire in 1644, nothing could prepare Panamá Viejo for Henry Morgan's attack in 1671. The British privateer captured, sacked, and burned the city before departing with 175 mule-loads of loot and 600 prisoners. Two years later, a new and more heavily fortified city was founded at the location of the present-day capital.

Only the charred and crumbling walls of buildings that used to surround the plaza remain. They include the Jesuit convent and, most prominently, the tower of the city's cathedral, built between 1619 and 1623. As a religious symbol, it signified the power of the Catholic Church in Spanish colonial America. As a national icon, it represents Panama's enduring pride in its Spanish heritage.

For Panamá Viejo's link to the discovery of the Pacific, its place in the history of Spanish expansion in South America, and its role in the commercial network between the Americas and Europe, UNESCO named it a World Heritage Site in 1997.

OPPOSITE: *Cathedral*

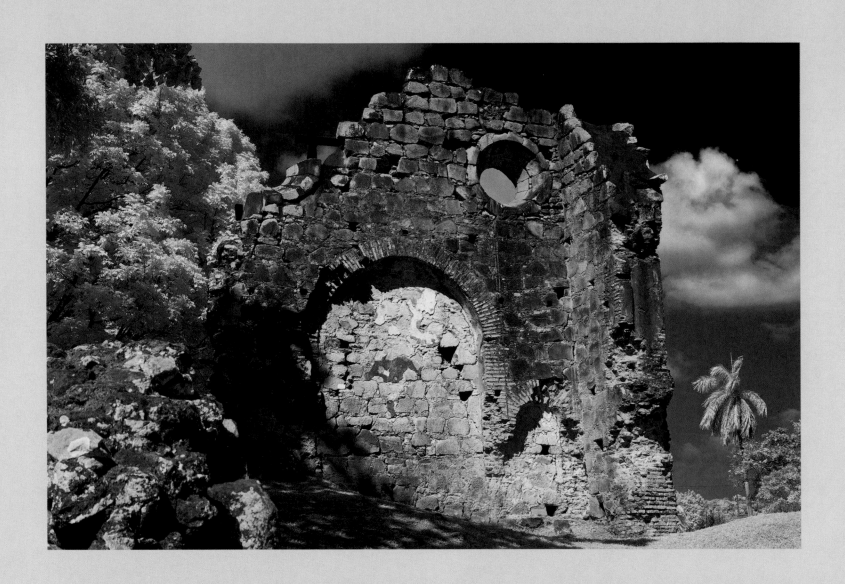

Jesuit Convent

Old Panama/New Panama

PANAMA FORTS

SAN LORENZO, COLÓN · SANTIAGO, PORTOBELO · SAN JERÓNIMO, PORTOBELO

During the Age of Discovery, Panama emerged as the crossroads of the Spanish empire, the place where valuable commodities, including silver and gold plundered from the Incas in Peru, were loaded onto galleons bound for Spain. King Phillip II commissioned Juan Bautista Antonelli, a prominent, Italian-born military engineer, to identify potential sites for fortifications to protect Panama's Caribbean coast from pirate attacks. Based on Antonelli's recommendation, forts were constructed at Portobelo and Colón.

Perched above the Chagres River where it meets the Caribbean, Fort San Lorenzo came under constant attack almost as soon as it was established in 1595. Henry Morgan, the notorious British privateer, captured the fortress in 1671 and used it as his base for an assault on Panama City. When he returned, he blew up the fort before sailing triumphantly back to England with boatloads of booty.

Rebuilt in 1677, San Lorenzo came under attack again when the British admiral Edward Vernon bombarded, captured, and demolished the fort during the War of Jenkin's Ear in 1740. Ten years later it was rebuilt, the ruins of which still stand.

When Panama declared independence in 1821, Spanish troops left the region, departing from Ft. San Lorenzo. During the California Gold Rush, the fort served as a camping ground for forty-niners traveling across the isthmus to California.

A little further up the coast lies Portobelo, long ago the site of the world's largest trade fair, a boisterous annual event during which the town gained notoriety as "a hideaway for thieves and a burial ground for pilgrims."[14] Forts Santiago and San Jerónimo defended this colonial port, considered to be one of the finest natural harbors along the Spanish Main.

Like San Lorenzo, these forts came under constant attack from pirates and the British Navy. In the aftermath of Admiral Vernon's assaults, the Spanish crown ordered that its most important coastal defenses, including those at Portobelo, be expanded and refortified, resulting in the streamlined, neo-classical layouts still visible today.

Citing their value as "magnificent examples of Spanish military architecture" and as "an essential link to our understanding American history," UNESCO designated Panama's Caribbean fortifications a World Heritage Site in 1980.

OPPOSITE: *San Jerónimo, Portobelo*

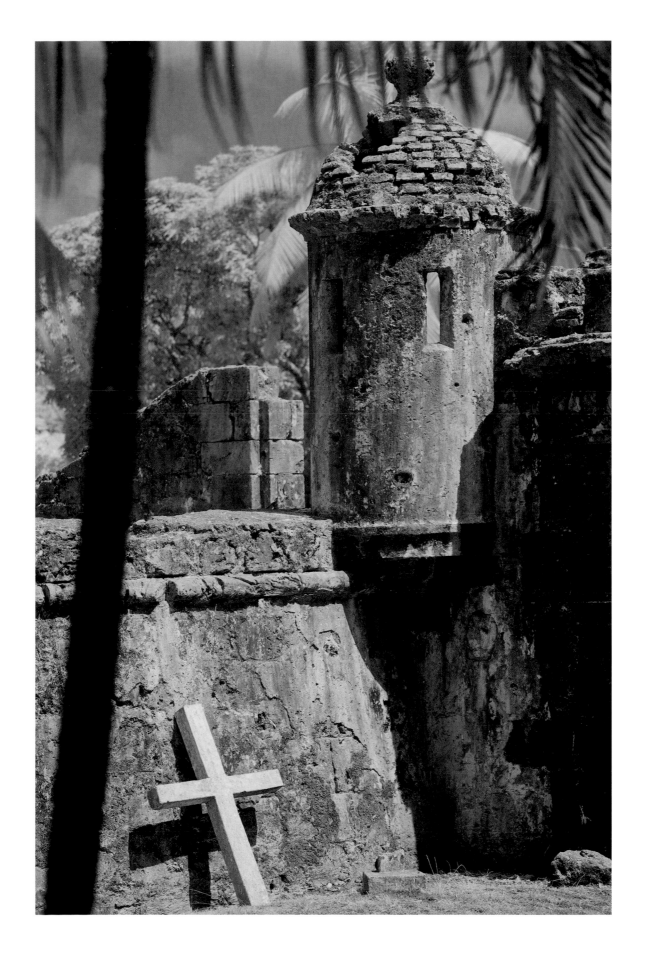

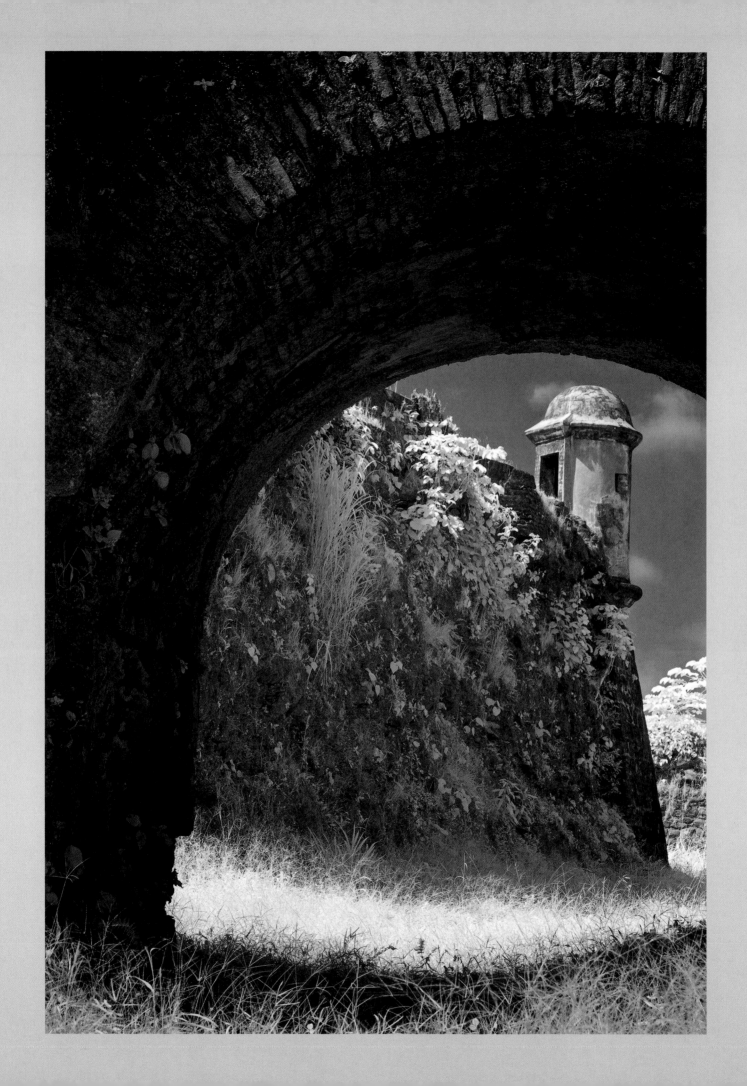

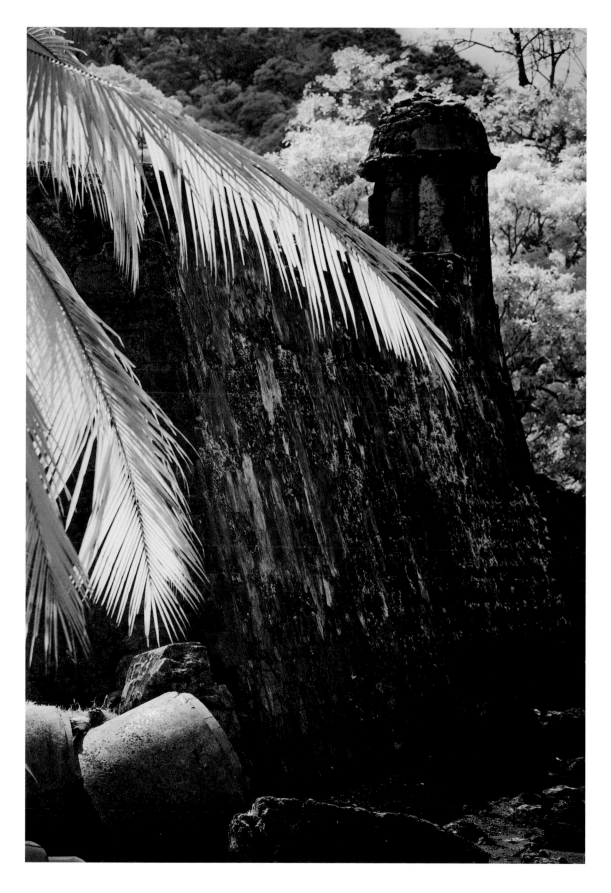

OPPOSITE: *San Lorenzo, Colón* ABOVE: *Santiago, Portobelo*

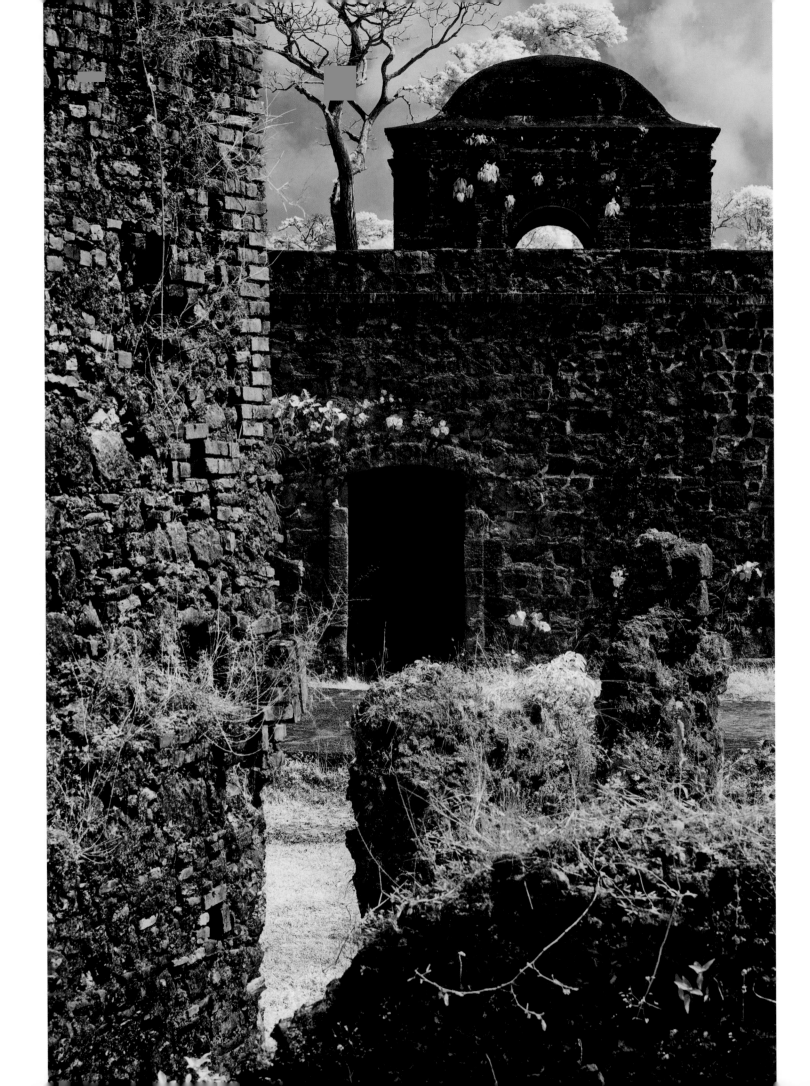

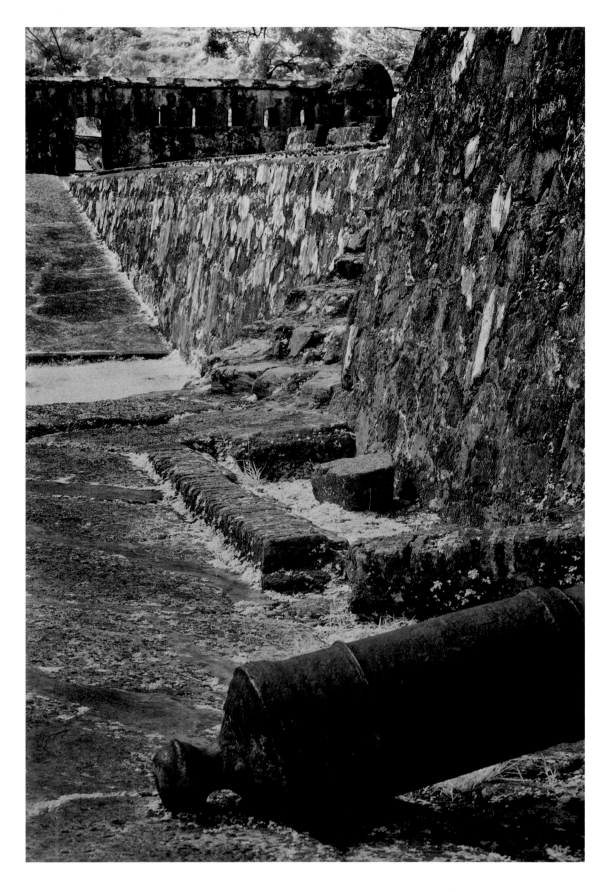

OPPOSITE: *San Lorenzo, Colón* ABOVE: *Santiago, Portobelo*

CHURCH RUINS, ANTIGUA, GUATEMALA

Church ruins resonate with an irony uniquely their own. They are built as architectural expressions of religious faith yet they are often destroyed by an "act of God." In the rubble there is much to sift through and ponder whether it is evidence of God's wrath or man's fallibility. This is especially the case in Antigua, Guatemala, site of the most spectacular church ruins in the Americas.

In the mid-sixteenth century the city, then known as Ciudad de Santiago de los Caballeros de Goathemalan (City of St. James of the Knights of Guatemala), served as the capital of the Kingdom of Guatemala, an area that comprised much of what is now Central America. As the cultural and civic center of the region, the city was home to more than thirty religious orders who built elaborate monasteries, convents, and churches.

Ciudad de Santiago's soaring towers, heavenly domes, and ornate columns cut one of the most distinctive skylines in the Americas during the colonial era. But it all came tumbling down on September 29, 1717 when a magnitude 7.4 earthquake destroyed every church and major building, along with 3,000 dwellings.

The city was rebuilt, but on July 29, 1773 a magnitude 7.5 earthquake destroyed it yet again. As many as 600 people perished in the disaster and at least 600 more died in the aftermath from disease. The quake was so devastating that the King's engineer arrived from Spain to report on the destruction. In 1776 the crown issued an order reestablishing the capital at what is now Guatemala City.

Residents evacuated Ciudad de Santiago, but it was never completely abandoned. Around 1830 it began to grow again and took on a new name, La Antigua Guatemala (Old Guatemala), but the ruins of the once grand churches, monasteries, and convents remained.

In 1942 the Pan American Institute of History and Geography made La Antigua a Monument of the Americas. Two years later, Guatemalan President Jorge Ubico officially designated Antigua a national monument. UNESCO affirmed Antigua's importance as a colonial city by declaring it a World Heritage Site in 1979.

OPPOSITE: *La Recolección*

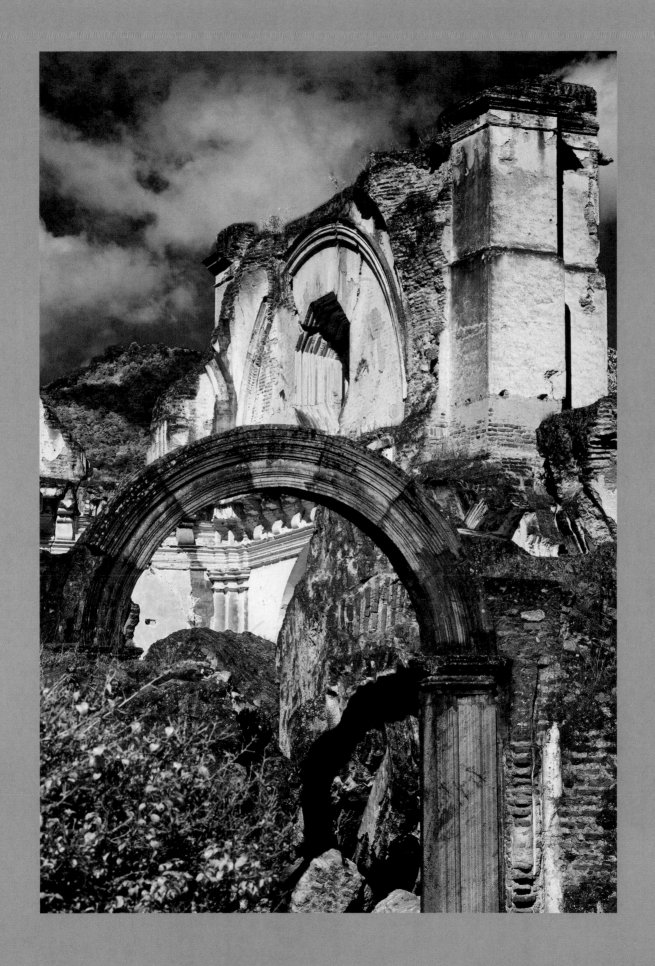

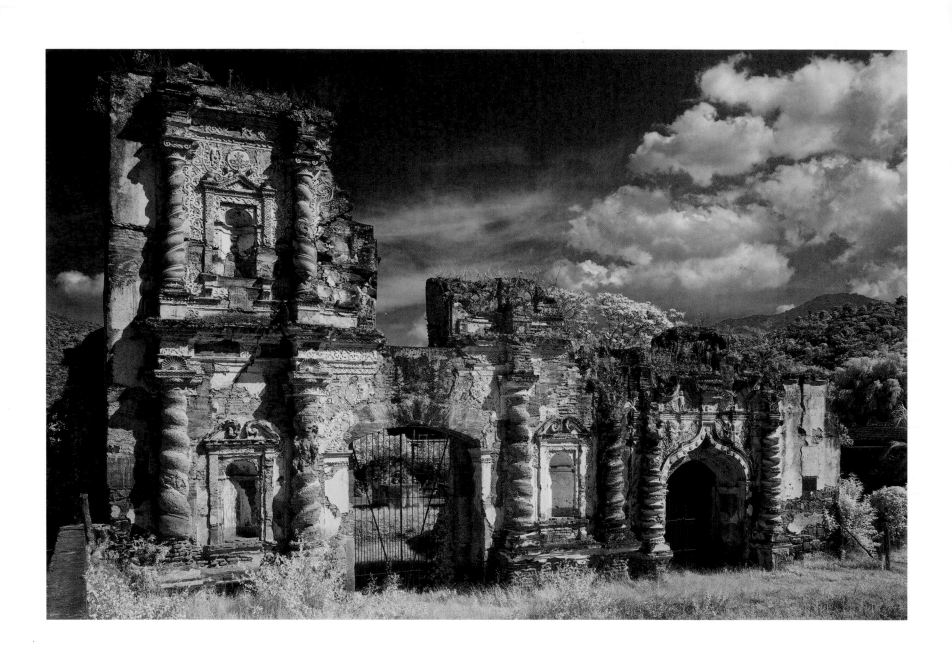

Candelaria

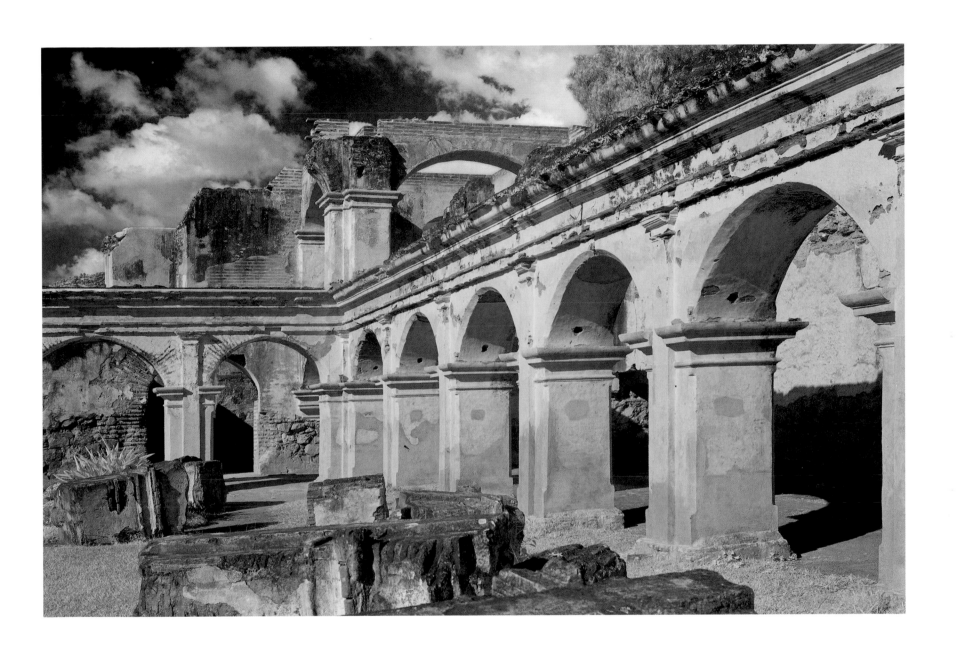

Santa Clara

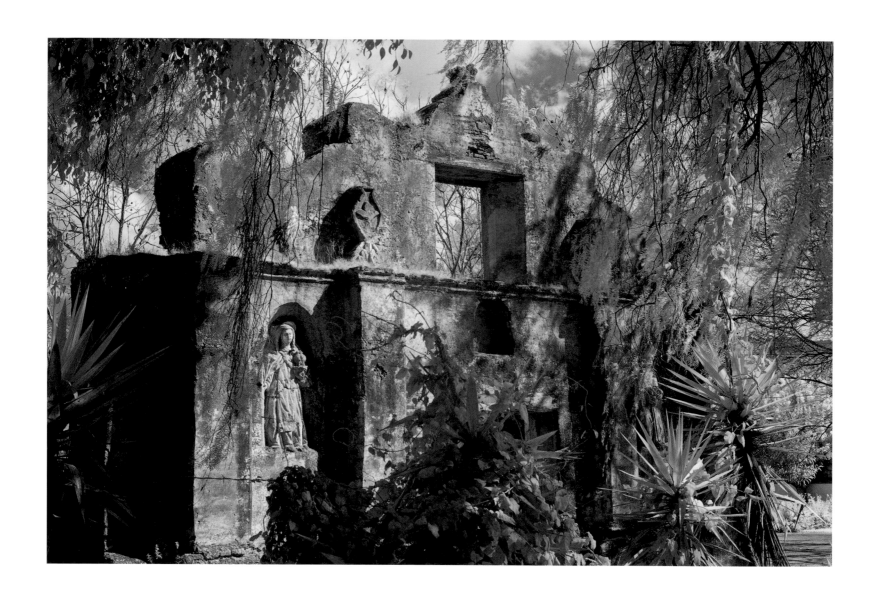

ABOVE: *San Jerónimo* OPPOSITE: *Cathedral of San José*

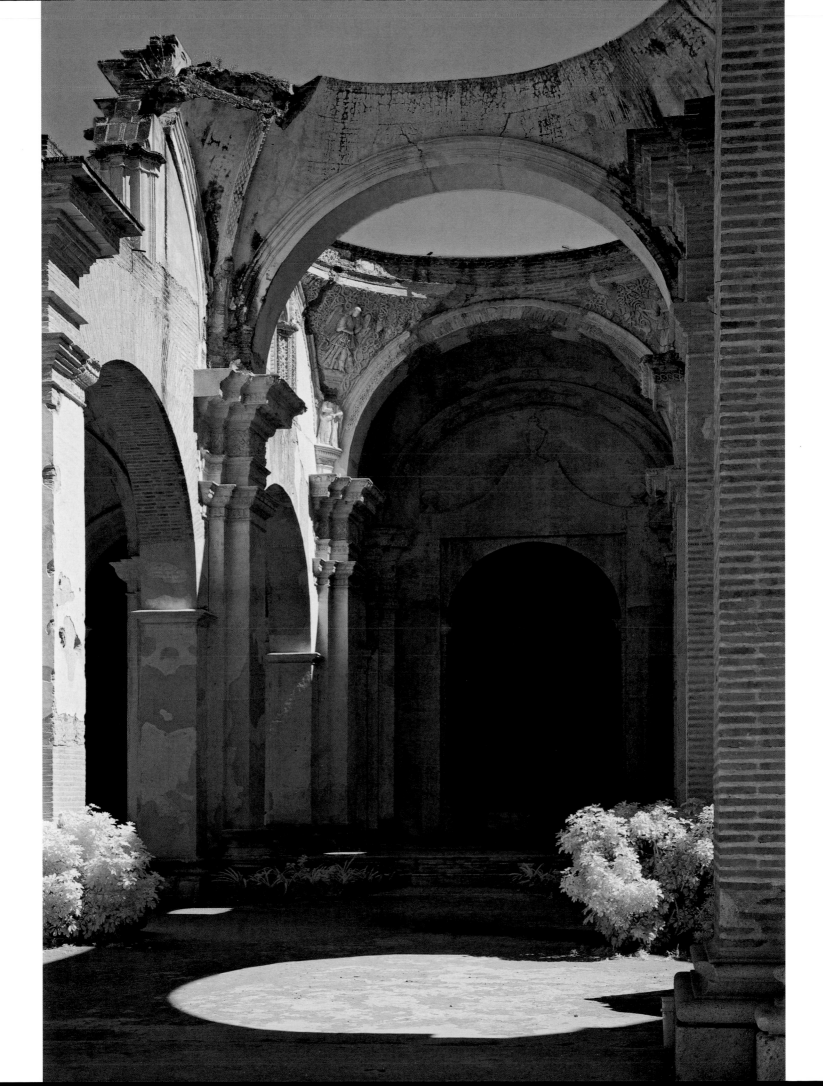

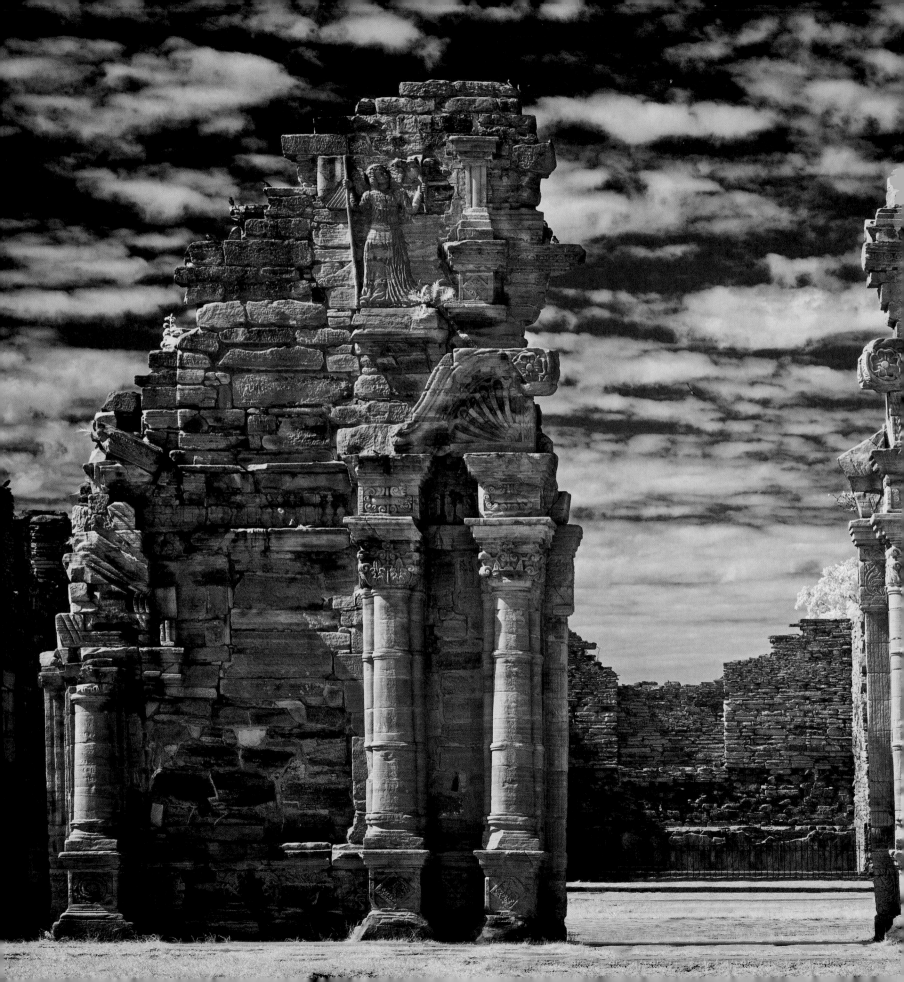

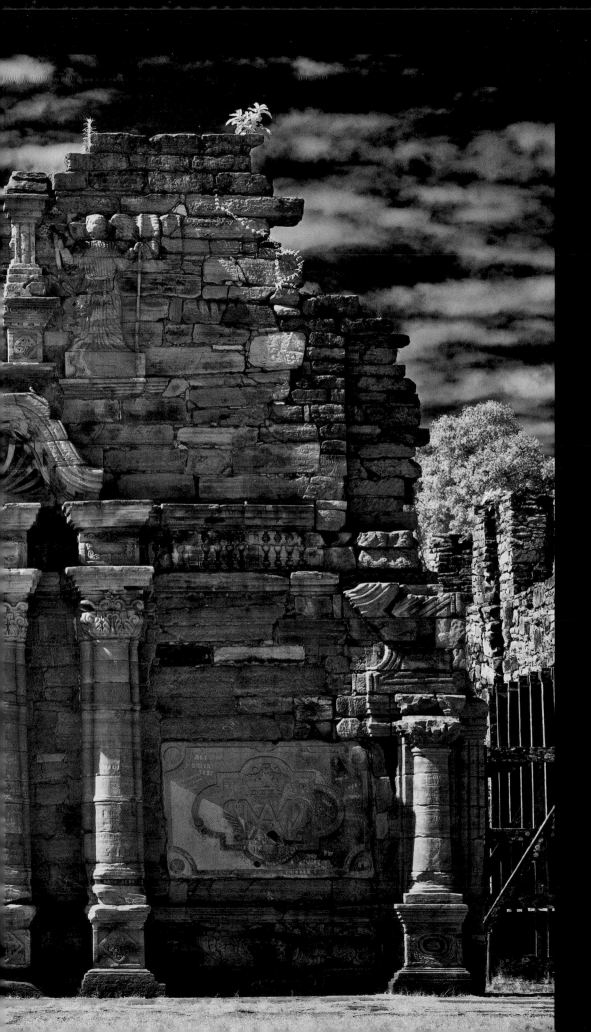

SOUTH AMERICA

TIWANAKU, INGAVI PROVINCE, BOLIVIA

Only 45 miles (72 km) west of La Paz but seemingly worlds away from its chaos and clutter, the ruins of Tiwanaku stand in the cool stillness of the Andean Altiplano. At nearly 13,000 feet above sea level, it is the highest city in ancient America.

Tiwanaku flourished as the principal ceremonial center of the Tiwanaku Empire, a vast territory that at its zenith, from AD 500 to 950, dominated parts of present-day Peru, Argentina, Chile, and Bolivia.

Kalasasaya or "Temple of Vertical Stones" is one of few remaining principal structures of this Andean metropolis. Made of huge blocks of red sandstone and andesite, a volcanic rock, its large courtyard is dominated by two monolithic figures standing nearly 20 feet (6 m) tall. They are known as El Fraile (Priest) and Ponce, named after Carlos Ponce Sanginés, the Bolivian archaeologist who discovered the figure in 1965.

Adjacent to the monoliths stands the Gateway to the Sun. Carved from a single block of andesite weighing an estimated 10 tons (9 tonnes), it marked the summer solstice and other solar events. In the 1500s, conquistadors looted the gold ornaments that filled its niches.

At the foot of Kalasasaya lies the Subterranean Temple. One-hundred-and-seventy-five crudely carved but completely different looking stone faces poke out from its walls. Some experts believe they represent the different ethnic groups that populated the empire.

Tiwanaku flourished until about AD 1100. According to a popular theory, climate change in the form of severe drought caused a sharp decline in food production, forcing residents to abandon the area around AD 1200. The land was not inhabited again for many years. In 1445 the Inca emperor Pachacuti began his conquest of the region, eventually absorbing the remnants of the Tiwanaku Empire into his own.

In the last two centuries Tiwanaku suffered further damage at the hands of those who carted away many of its stones to build churches, homes, bridges, public buildings, and to use as landfill.

In 2000 UNESCO declared Tiwanaku a World Heritage Site in recognition of its importance as a pre-Colombian Andean civilization.

PRECEDING PAGES: *Church Façade, San Ignacio Miní, Argentina*

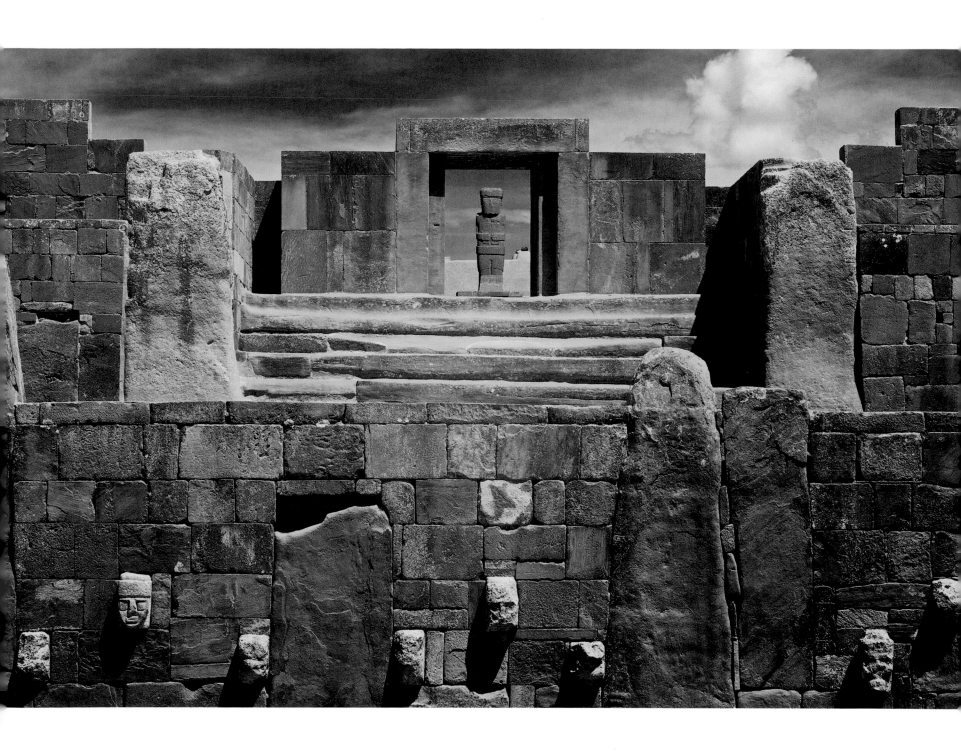

Kalasasaya and Subterranean Temple

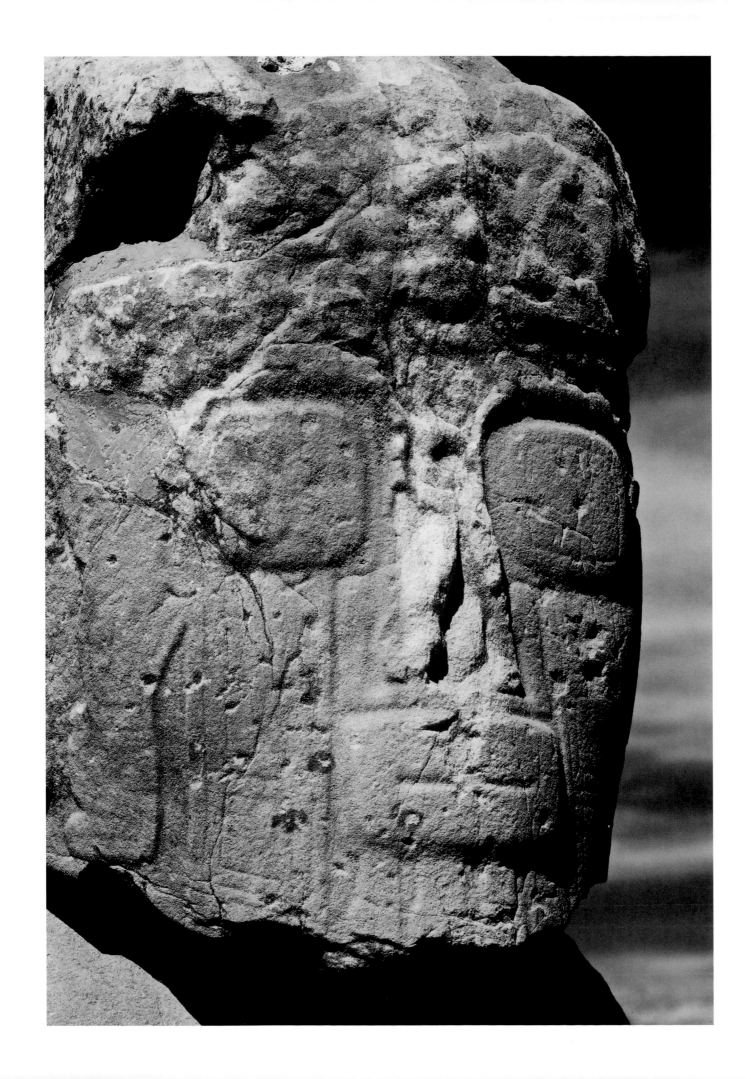

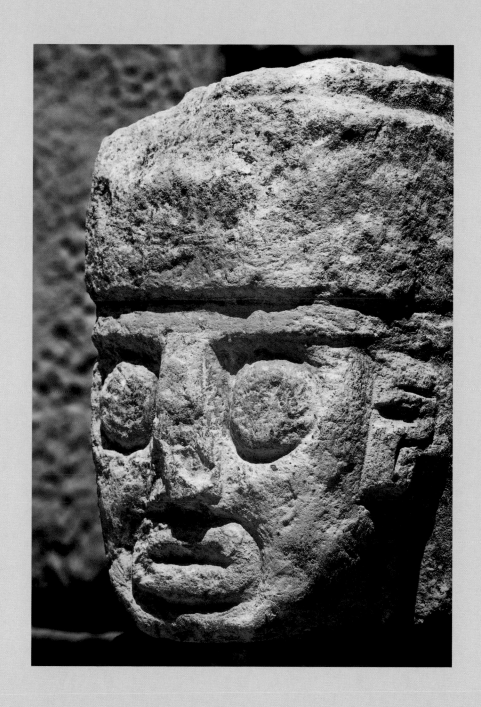

OPPOSITE: *El Fraile (Priest)* ABOVE: *Subterranean Temple head*

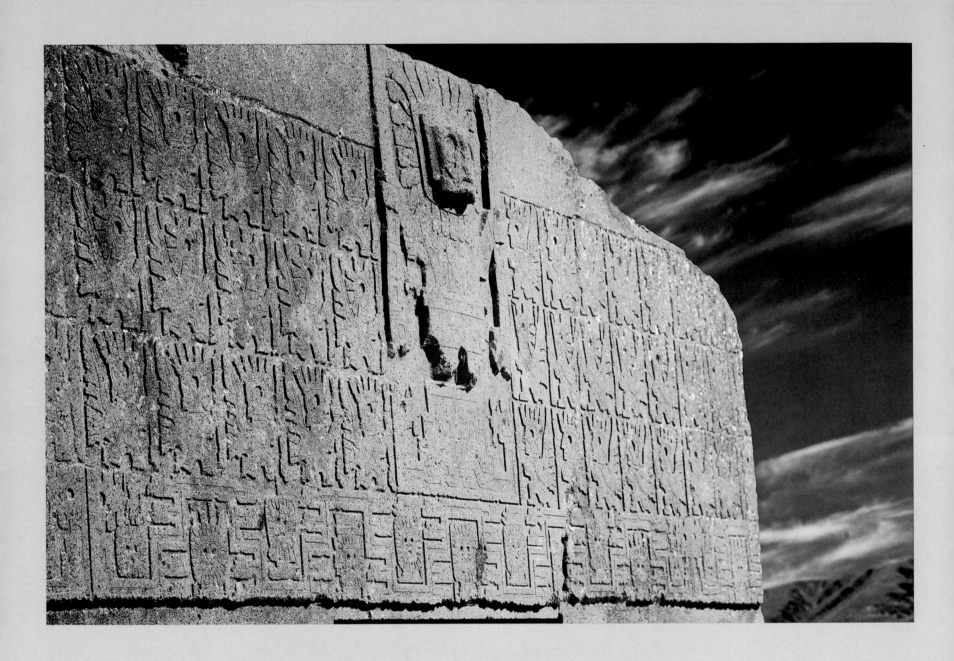

Sun Gate

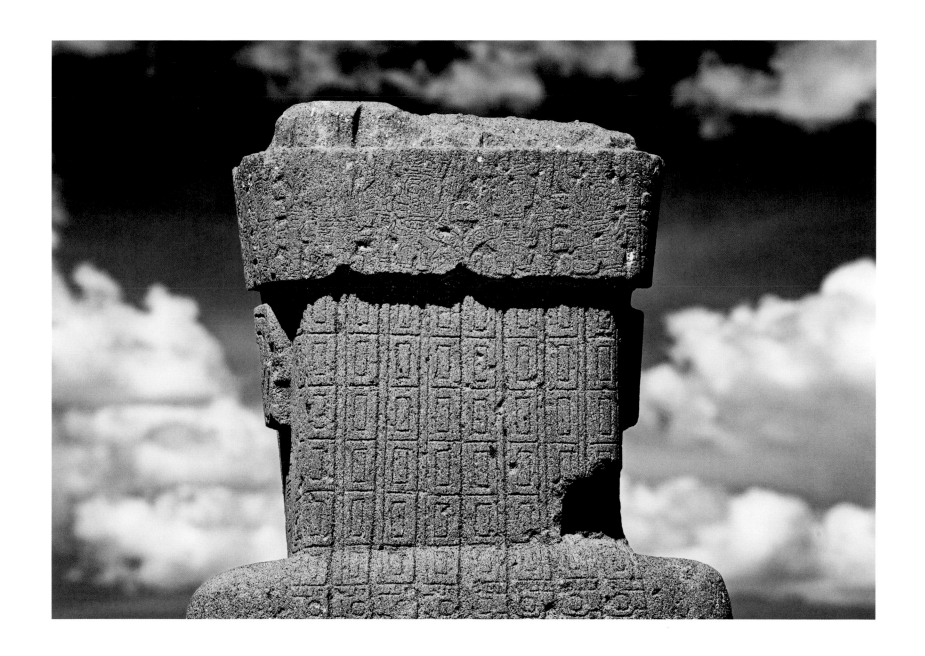

Ponce

CHAN CHAN, LA LIBERTAD, PERU

From a distance they appear to be sand dunes, nothing more. Drawing closer, they assume a more structured shape that only hints at what they once were. These are the mud walls of Chan Chan, the world's largest adobe city as well as the largest pre-Hispanic city in South America.

Chan Chan was the capital of Chimor, a kingdom once located on the north coast of Peru. At its zenith in the fifteenth century, Chan Chan had a population of perhaps as many as 50,000 and a fortune in gold and silver. The Spaniards plundered this treasure in the 1500s after Chimor had fallen to the Incas. Today only the mud walls remain of this once glittering city by the sea.

Chan Chan is composed of nine subcities or royal complexes, each built by a succeeding ruler. Only Nik-An, meaning "center house," also known as the Tschudi Complex (after Johann Jakob von Tschudi, a nineteenth century Swiss naturalist who explored the site) has been partially restored and made accessible.

From mere mud and adobe the Chimu created simple yet sophisticated art and architecture. The wall friezes in the main plaza, where religious ceremonies and celebrations took place, feature an abstract design combining a repeating pattern of an animal thought to be a sea otter and horizontal lines representing ocean waves.

The adobe work becomes more elaborate in the *audiencias,* the administrative offices of Chimor's elites. The decorations in these spaces, including geometric patterns representing fishnets, and reliefs of sea birds and fish, illustrate the Pacific's vital importance to Chan Chan as a source of sustenance.

UNESCO declared Chan Chan a World Heritage Site in 1986, the same year it was added to the List of World Heritage in Danger. Erosion seriously threatens the adobe structures, which require continuous conservation and restoration. Without these efforts, strong winds and heavy rains —foes more tenacious than the Incas and more destructive than the Spaniards —will eventually conquer Chan Chan.

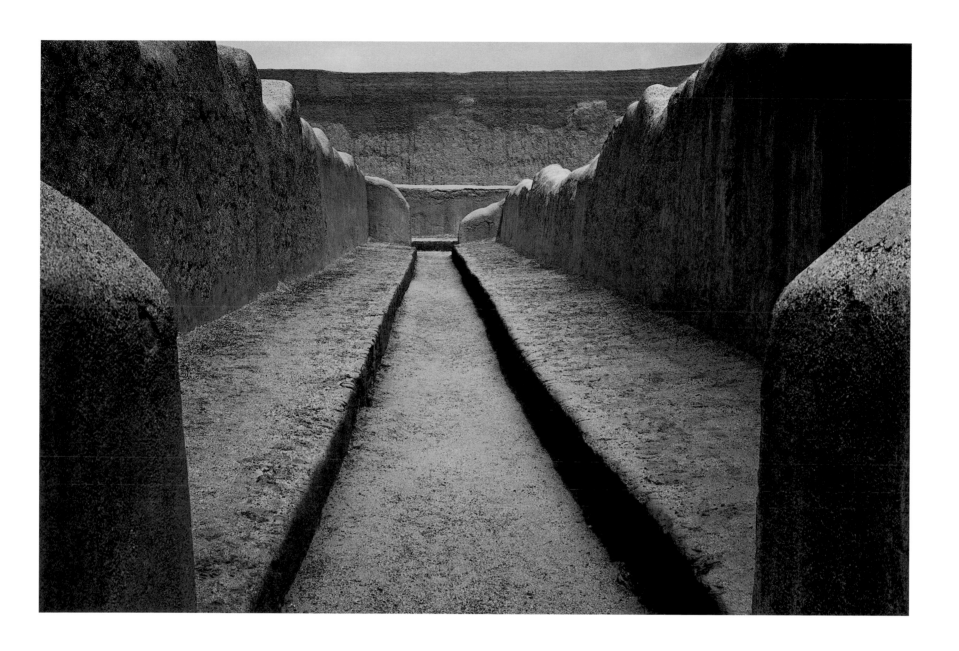

Pathway

ABOVE: *Plaza wall* OPPOSITE: *Audiencia*

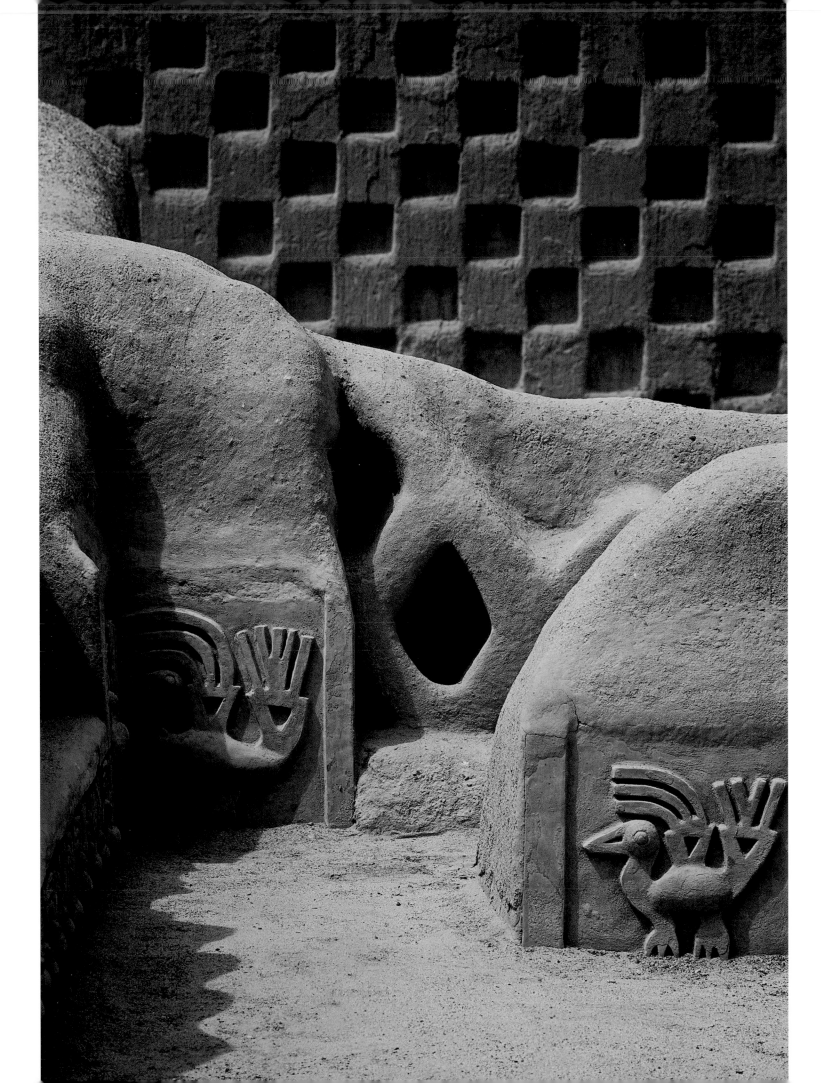

OPPOSITE: *Huaca Esmeralda* ABOVE: *Ceremonial pool*

SACSAYHUAMÁN, CUSCO, PERU

"It seems to be the work of giants,"[15] wrote a sixteenth century Spanish chronicler about Sacsayhuamán.

This colossal Inca fortress overlooks Cusco, the former capital of the Inca Empire. Its three levels are made of some of the biggest stones ever used in megalithic construction. The ones on the lowest level are the most massive; the largest stands 28 feet (8.5 m) tall and weighs an estimated 398 tons (361 tonnes). Carved into polygonal shapes, these giant boulders are held together without any mortar yet fit so precisely that Pedro Pizarro, a page to the conquistador, reported, "the point of a pin could not have been inserted in one of the joints."[16] In awe, the noted Peruvian historian, "El Inca" Garcilaso de la Vega, wrote that Sacsayhuamán "surpasses the constructions known as the Seven Wonders of the World."[17]

Sacsayhuamán was not the work of giants but rather the Killke, a pre-Inca people, who began construction around AD 1100. The Incas later occupied and expanded the fortress. Exactly how they constructed the walls is unclear. Modern-day reenactments of ancient megalithic construction techniques, including carving, towing, and lowering colossal stones into precise positions, have achieved limited success.

Sacsayhuamán was not only ingenious but also seemingly impregnable. Its zigzagging walls prevented a frontal attack and exposed an enemy's flanks. However, these deterrents did not keep the Spaniards from storming the fortress in 1536 during the Inca Rebellion. Despite the loss of their captain, Juan Pizzaro, the Spaniards prevailed.

In the aftermath, the conquistadors made off with Sacsayhuamán's smaller blocks to build their churches and residences in the city below. Thus began four centuries of destruction, as the complex became a quarry for Cusco's stonemasons. Until 1930 *Cusquenos* (Cusco residents) could take, for a small fee, any stones they wanted to build their houses. As a result, only about 20 percent of the original structure remains. Yet even in its diminished state, Sacsayhuamán stands as a monument to ancient American engineering.

In 1983 UNESCO added Sacsayhuamán, as part of Cusco, to the World Heritage List.

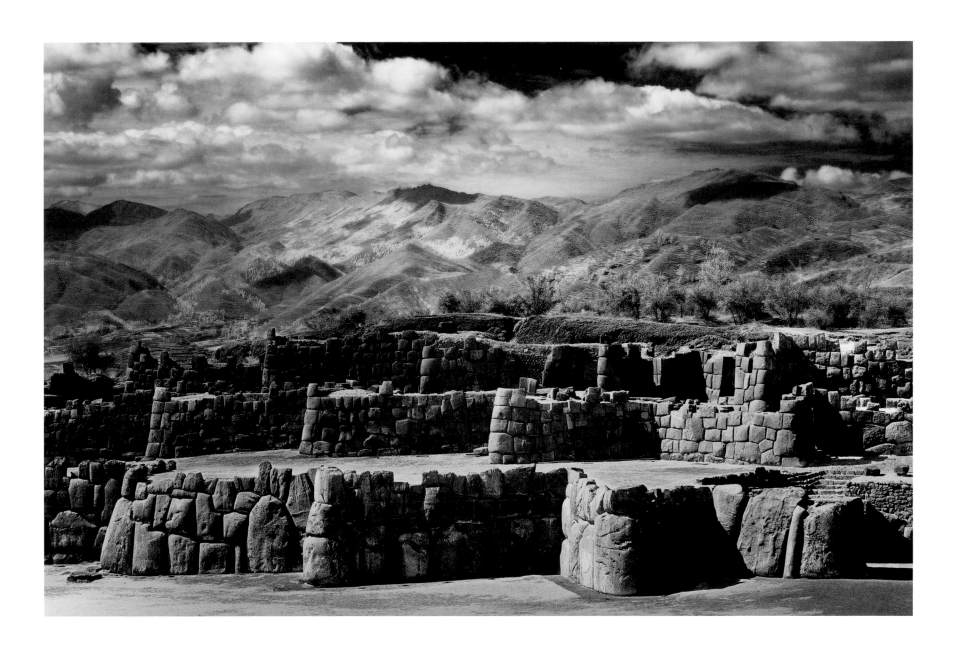

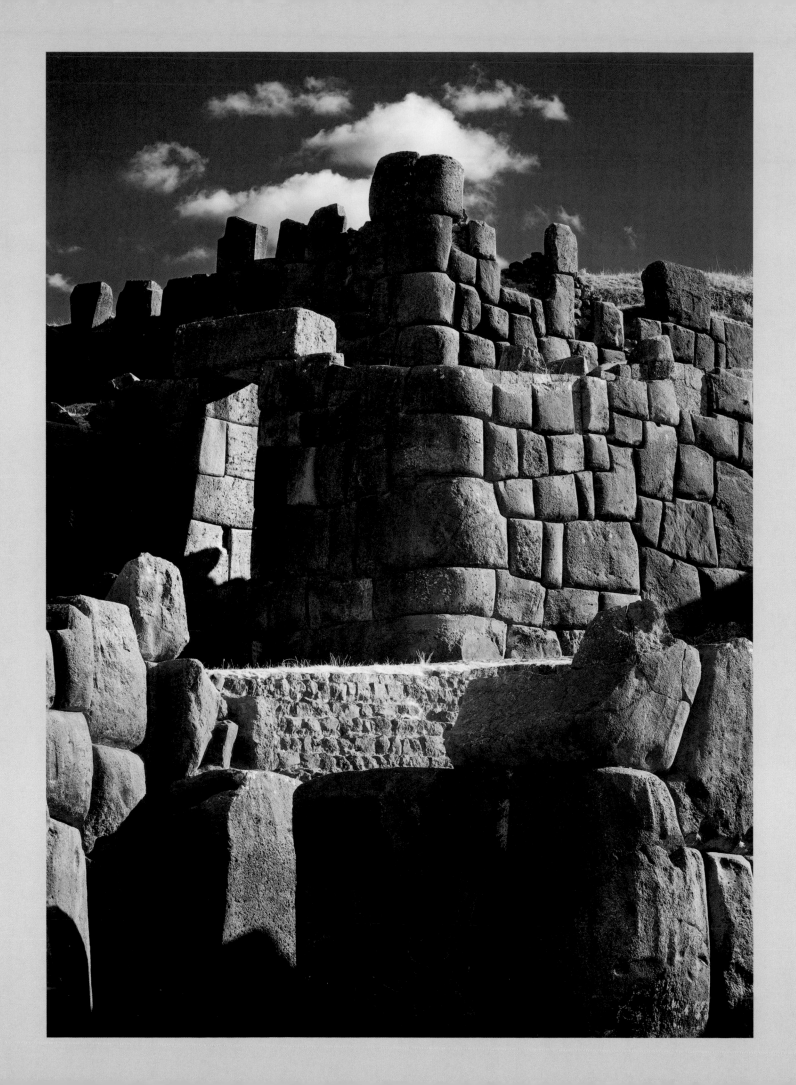

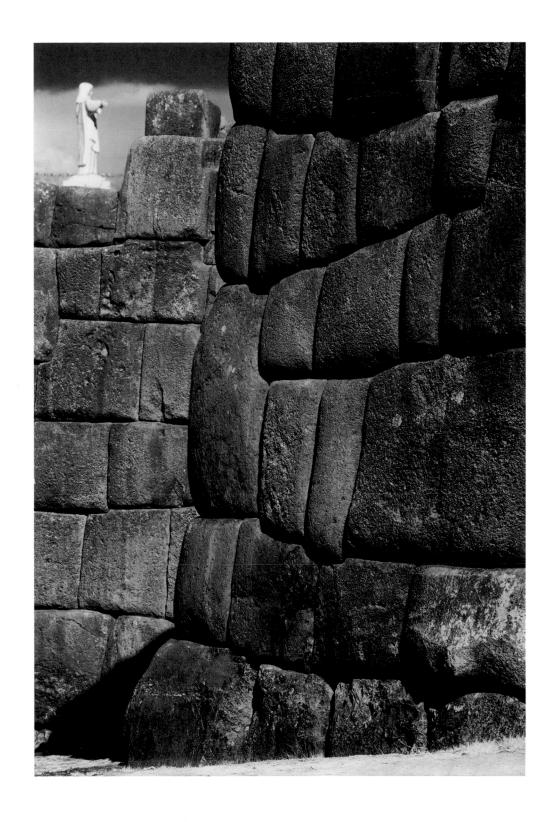

OLLANTAYTAMBO, URUBAMBA, PERU

With its condor's-eye view of the Sacred Valley and its importance as a rampart in resistance to conquest, the lofty citadel of Ollantaytambo stands as a symbol of Inca glory.

After their defeat at Sacsayhuamán in 1536, Inca warriors, led by Manco Inca, retreated to this fortress about 40 miles (64 km) away. They could not have picked a better place to regroup and resurrect their rebellion against the Spaniards.

Built in the mid-1400s for the emperor Pachacuti, Ollantaytambo represents one of the finest achievements of Inca engineering. Just transporting massive blocks of granite from a quarry to the construction site 4 miles (6 km) away required an extensive network of roads, ramps, and slides, as well as the diversion of the Urubamba River.

The Incas used much of the quarried stone to build the steep terraces that made farming feasible on otherwise unusable terrain. The Incas kept the harvested quinoa, grains and potatoes in storehouses on Pinkuylluna and other tall mountains surrounding Ollantaytambo. The cooler temperatures at higher elevations protected the yield from spoilage.

The terraces, as Manco knew, also provided a strong defense against attack. Hernando Pizarro found that out when his small army assaulted the fortress in January 1537. From atop the terraces, Manco's rebels showered the Spaniards with arrows, spears, and boulders, preventing their ascent. Pizarro ordered a hasty retreat.

The battle at Ollantaytambo marked the only time the Incas successfully resisted a Spanish attack. Their victory, however, would be short-lived. The Spaniards soon returned with a larger force that captured Ollantaytambo and drove Manco and his men into the jungle.

As much as it was a fortress, Ollantaytambo was also a religious and ceremonial center. Above the terraces remain six enormous granite blocks that form a wall of the Temple of the Sun. The scattered blocks of carved stone at the foot of the temple indicate that it was still under construction at the time of the conquest. Though unfinished, Ollantaytambo's place in Inca history as an architectural and cultural landmark is complete.

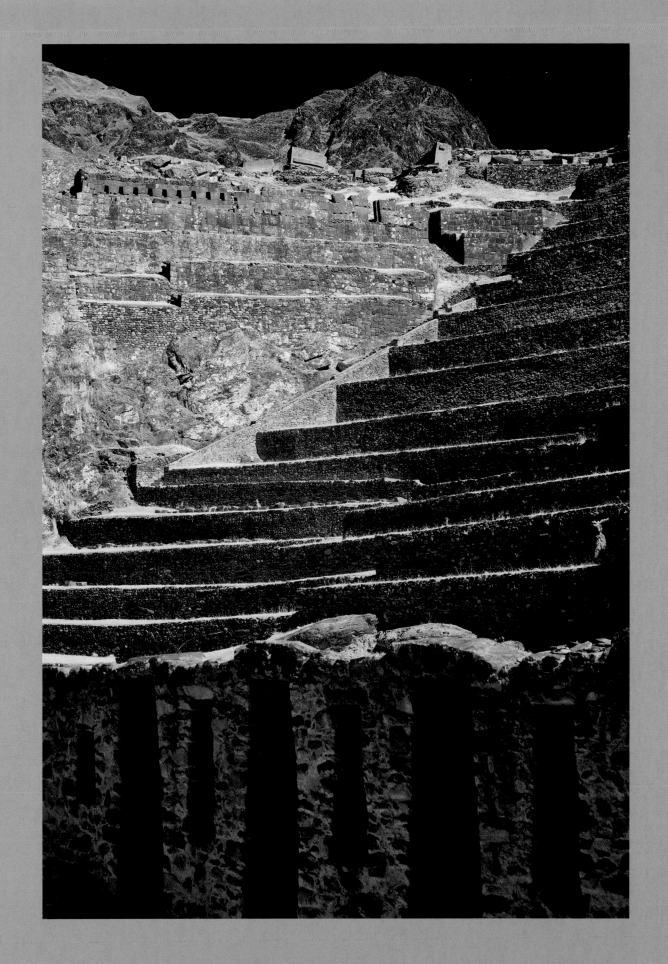

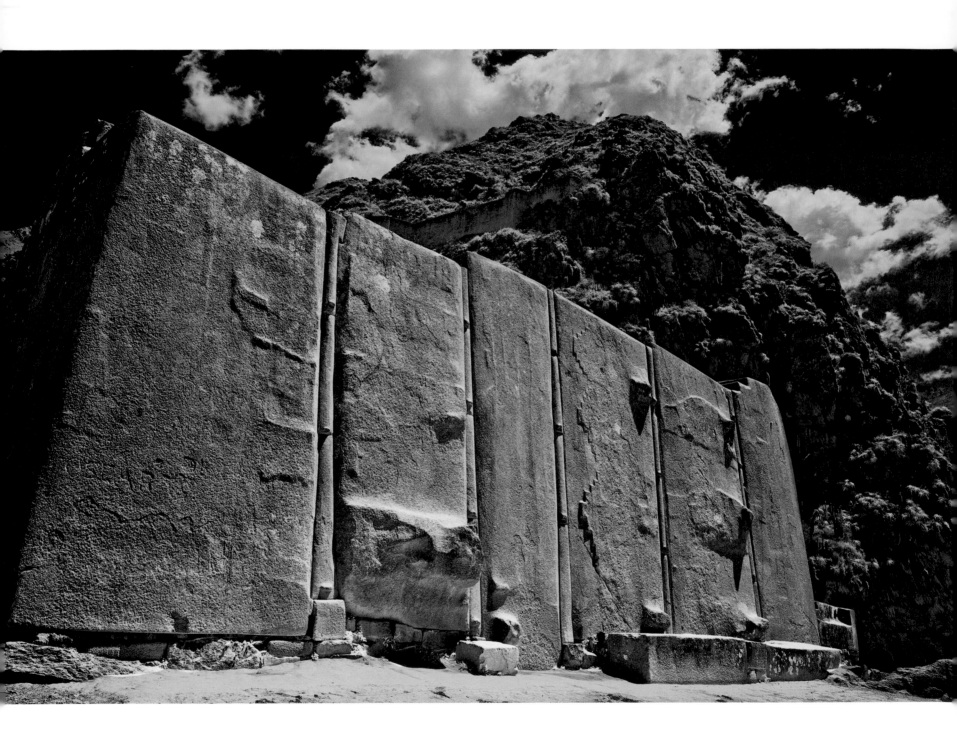

ABOVE: *Sun Temple* OPPOSITE: *Pinkuylluna*

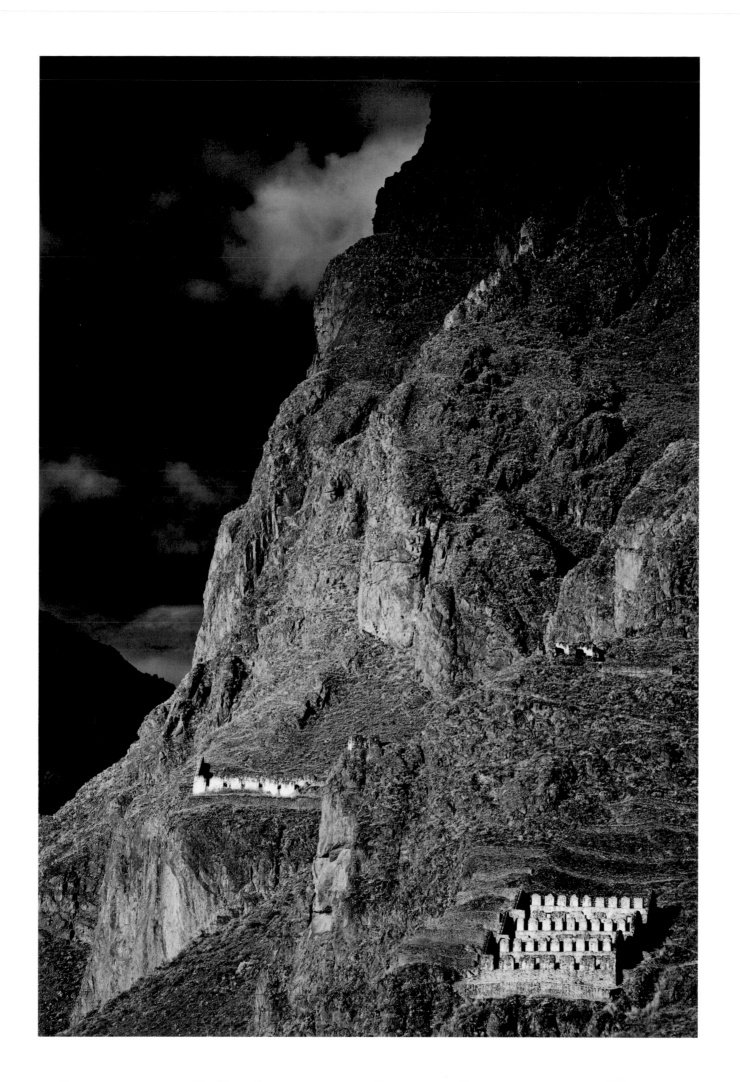

MACHU PICCHU, URUBAMBA, PERU

"It fairly took my breath away," recounted Hiram Bingham decades later. "What could this place be?"[18]

The place was Machu Picchu, the most magnificent Inca ruin. It left Bingham, the explorer credited with being its "scientific discoverer," breathless when a local Quechua boy guided him to the site during an expedition in 1911. "Surprise followed surprise in bewildering succession," Bingham wrote.[19]

What most surprised Bingham was finding a true archaeological rarity—a vast and virtually intact Inca city, unmolested by the conquistadors. "Machu Picchu," he speculated, "might prove to be the largest and most important ruin discovered in South America since the days of the Spanish conquest."[20]

More than a ruin, Machu Picchu is a magical world unto itself. Though only 50 miles (80 km) from Cusco, it sits secluded in the saddle between two verdant mountains, Machu Picchu and Huayna Picchu, about 8,000 feet (3,600 m) above sea level. With panoramic views of surrounding peaks, lush vegetation clinging to plunging cliffs, and enveloping mists rising from the Urubamba River below, Machu Picchu, wrote Che Guevara, "drives any dreamer to ecstasy."[21]

In 1913 Bingham brought this "lost city of the Incas" to the world's attention in a *National Geographic* cover story. The publicity made Machu Picchu the best-known ruin in South America. Yet in some ways, it remains one of the least known. Like the mists that shroud the ruins, Machu Picchu is veiled in a mystery that may never be completely solved.

Definitive answers to questions such as how the Incas, without the use of the wheel or strong draft animals, constructed Machu Picchu, or when and why they abandoned it, remain elusive. Even determining its purpose has confounded archaeologists. The Incas never told. They left no written record. However, scholarly research has convinced many that Machu Picchu was probably built in the fifteenth century as a royal retreat for the emperor Pachacuti, under whose rule the Inca domain expanded to become the largest indigenous empire in the New World.

While archaeologists search for answers, there is no question that in its harmonious integration of natural and manmade features, the precision of its stonework, and the beauty of its layout, Machu Picchu is, according to UNESCO's 1983 World Heritage Site designation, "an absolute masterpiece of architecture and a unique testimony to the Inca civilization."

OPPOSITE: *Western sector*

146

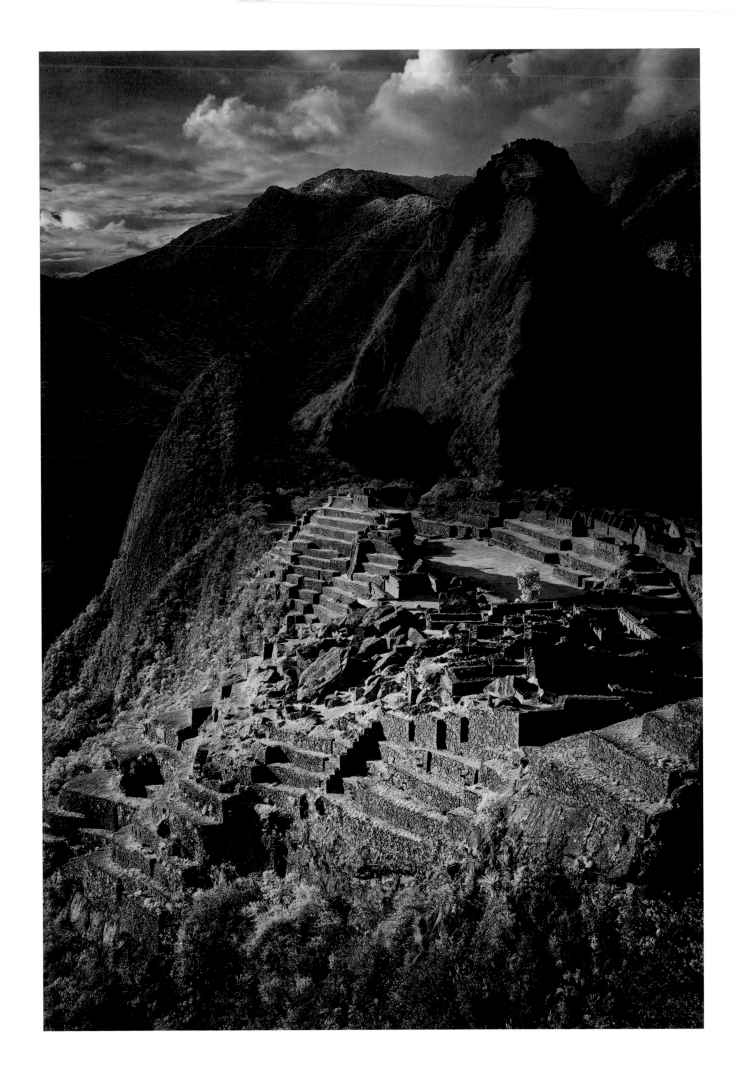

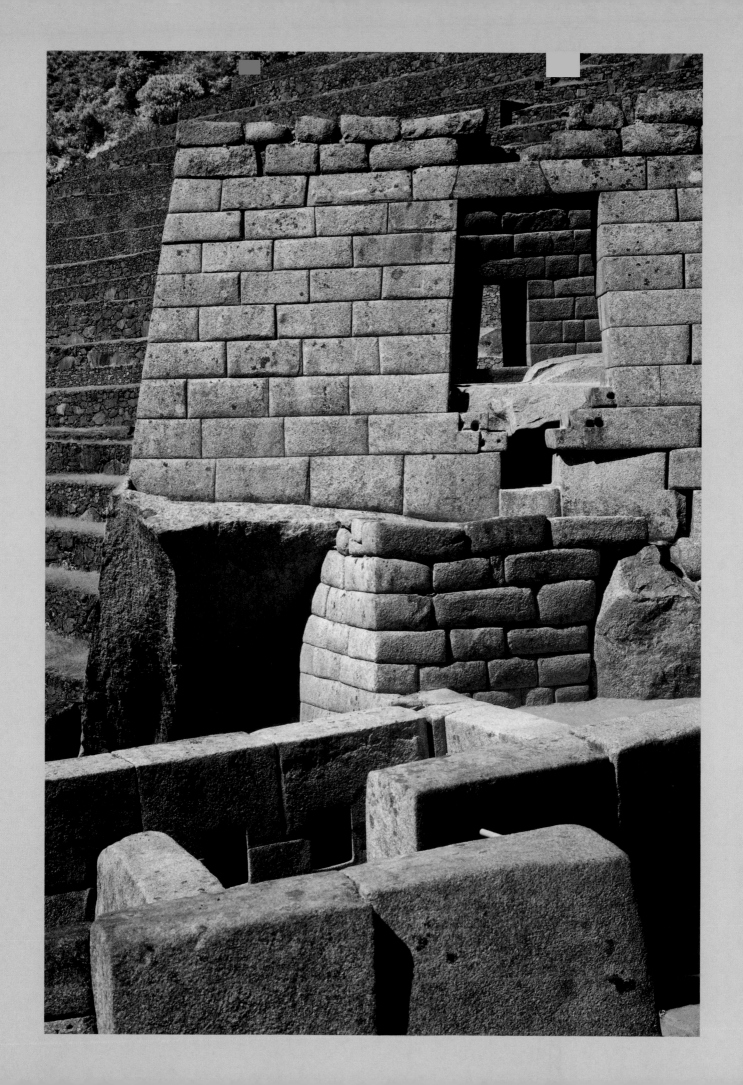

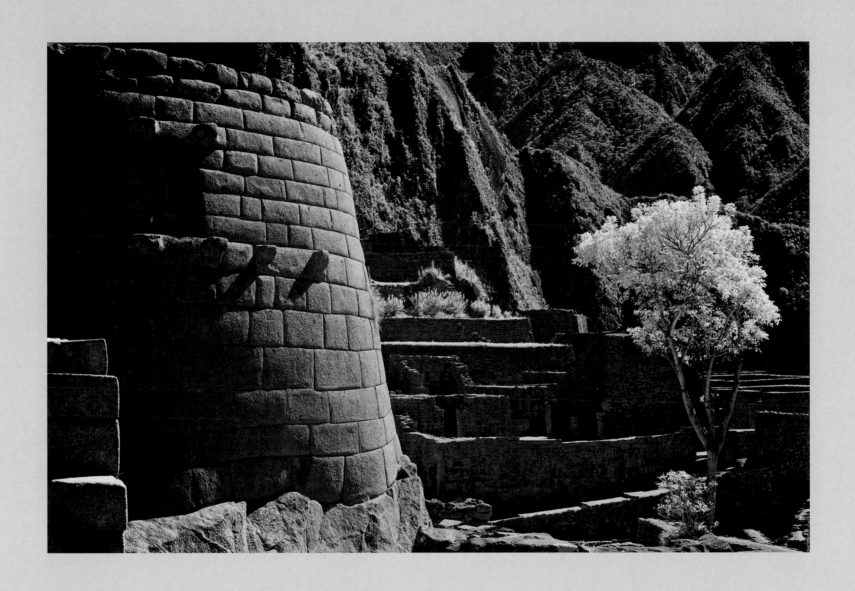

OPPOSITE AND ABOVE: *Sun Temple*

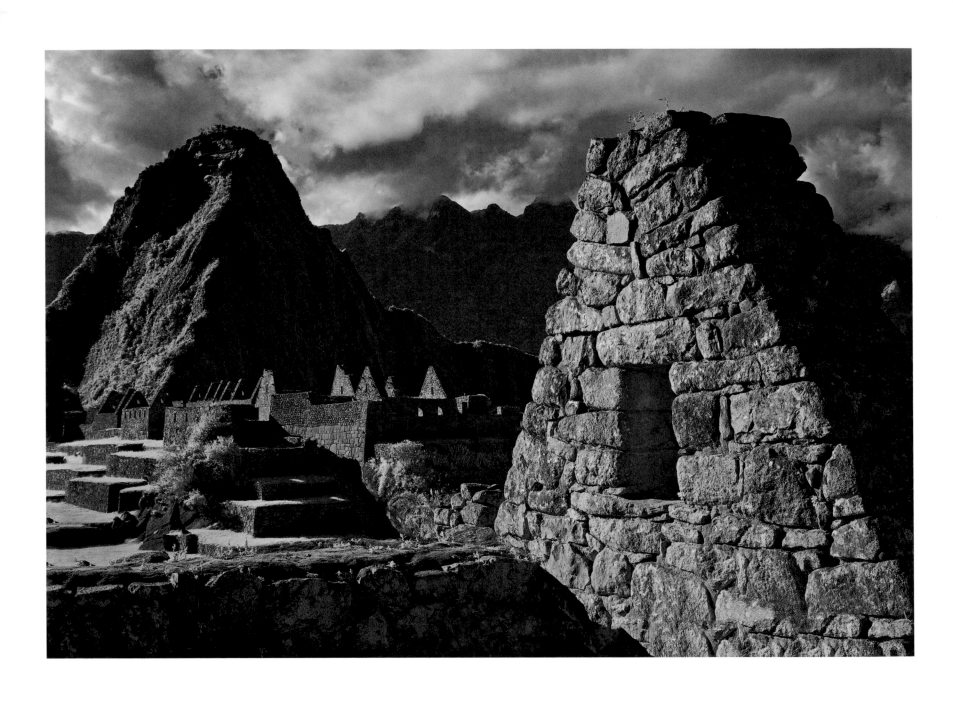

ABOVE: *Plaza view* OPPOSITE: *Eastern urban sector*

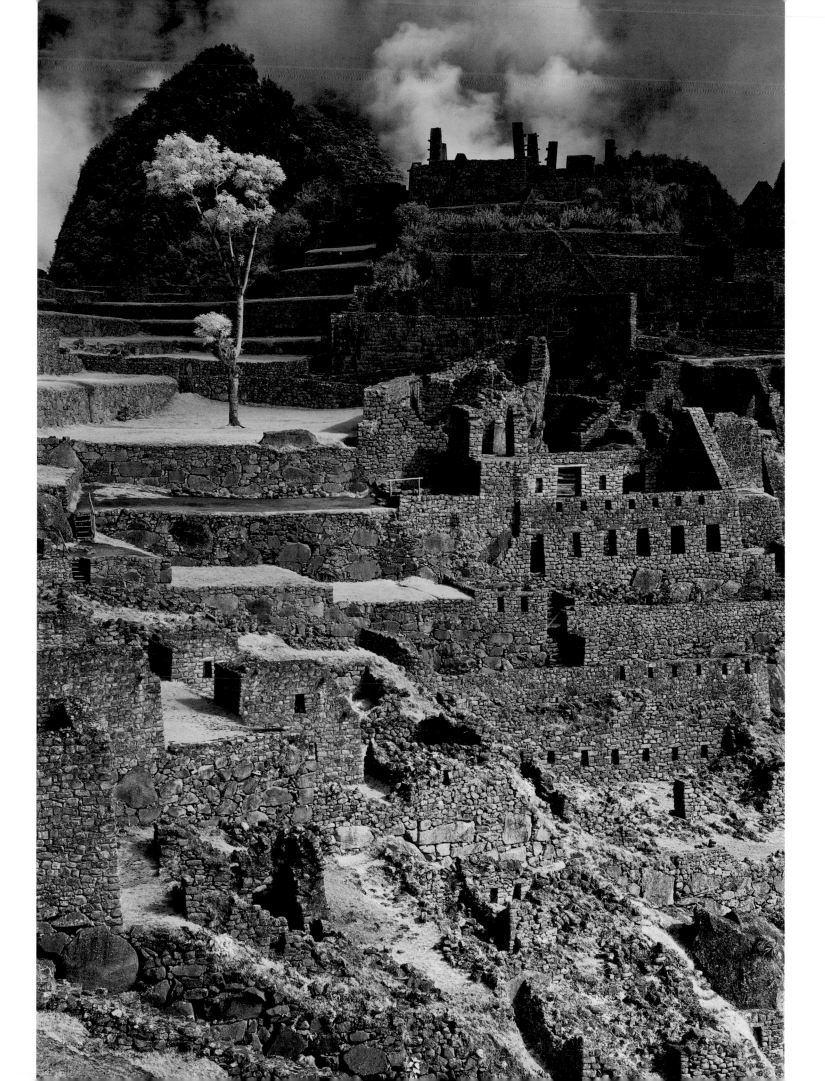

JESUIT MISSIONS OF THE GUARANIS

SAN MIGUEL, BRAZIL · SAN IGNACIO MINÍ, ARGENTINA · TRINIDAD, PARAGUAY

"Go forth and set the world on fire." With these words St. Ignatius of Loyola, the founder of the Society of Jesus, encouraged members of his religious order to be apostles for good. The Jesuits who ventured into the wilds of South America in the seventeenth and eighteenth centuries would indeed set the world on fire, and the embers still glow in the ruins they left behind.

Beginning in 1609 these intrepid men of faith established a chain of thirty missions across a vast region that includes present-day Argentina, Brazil, and Paraguay. There they set up communities of Guaranis, an indigenous people, whom they educated and converted to Christianity.

The typical mission featured a large central plaza dominated by a church that was designed by master architects and built by Guarani craftsmen and laborers. With their imposing towers, complex stonework, and graceful sculptures, these churches not only rivaled those in Spain but also gave rise to a new style called "Guarani Baroque."

The sophisticated architecture reflected the quality of life inside the missions. In sharp contrast to other religious orders proselytizing in the New World, the Jesuits made a conscious effort to convert indigenous people without eradicating their culture or language. Moreover, the Jesuits allowed the Guaranis to govern themselves, cultivate their minds as well as the fields,

and share equally in the fruits of their labor. In this manner each mission became self-sufficient and together they formed what was known as the "Jesuit Republic of the Guaranis," which at its peak supported a population of more than 140,000.

To Enlightenment philosophers pondering the state of nature, the noble savage, and human progress, the Jesuit missions were, in the words of the French thinker Voltaire, "a triumph of humanity which seems to expiate the cruelties of the first conquerors."[22]

However, just outside their walls, the missions faced serious threats. Raiding parties of *bandeirantes* from Brazil regularly hunted, captured, and enslaved the Guaranis. In self-defense, the Guaranis formed armies that frequently clashed with Spanish and Portuguese forces.

Meanwhile, the pope as well as Spanish and Portuguese royalty regarded the independent-minded Jesuits with growing suspicion. In 1767 Carlos III of Spain, following Portugal's lead, banned the Jesuits from his dominions. With the priests gone, the Guaranis gradually dispersed and the missions fell into ruin. These last days were dramatized in the film *The Mission* (1986), starring Robert de Niro.

In 1983 and 1984 UNESCO recognized the architectural and historical significance of the Jesuit missions of the Guaranis and added them to the list of World Heritage Sites.

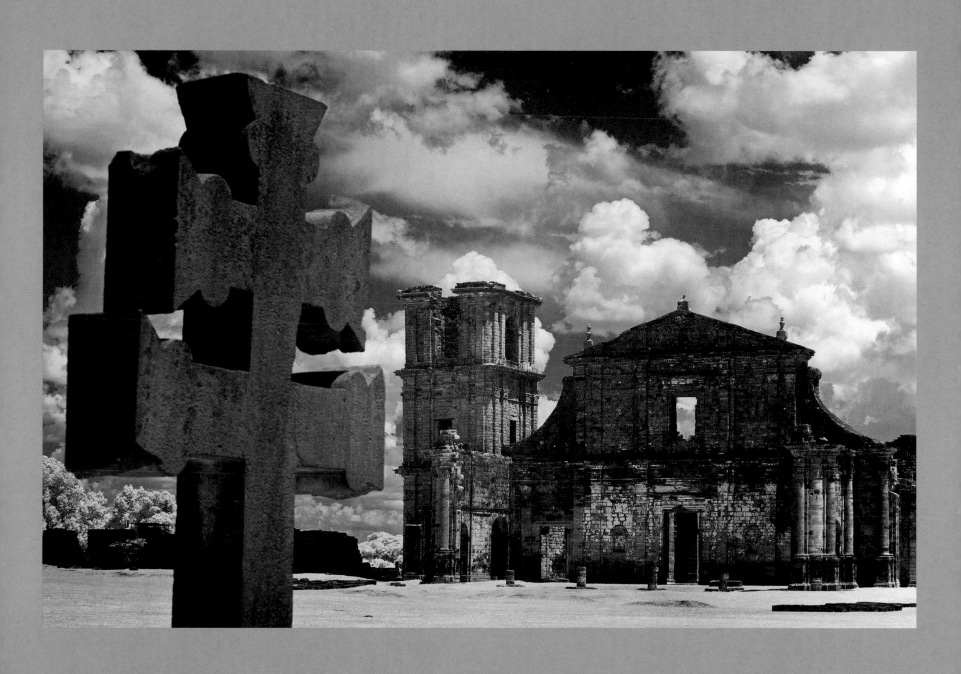

San Miguel, Brazil

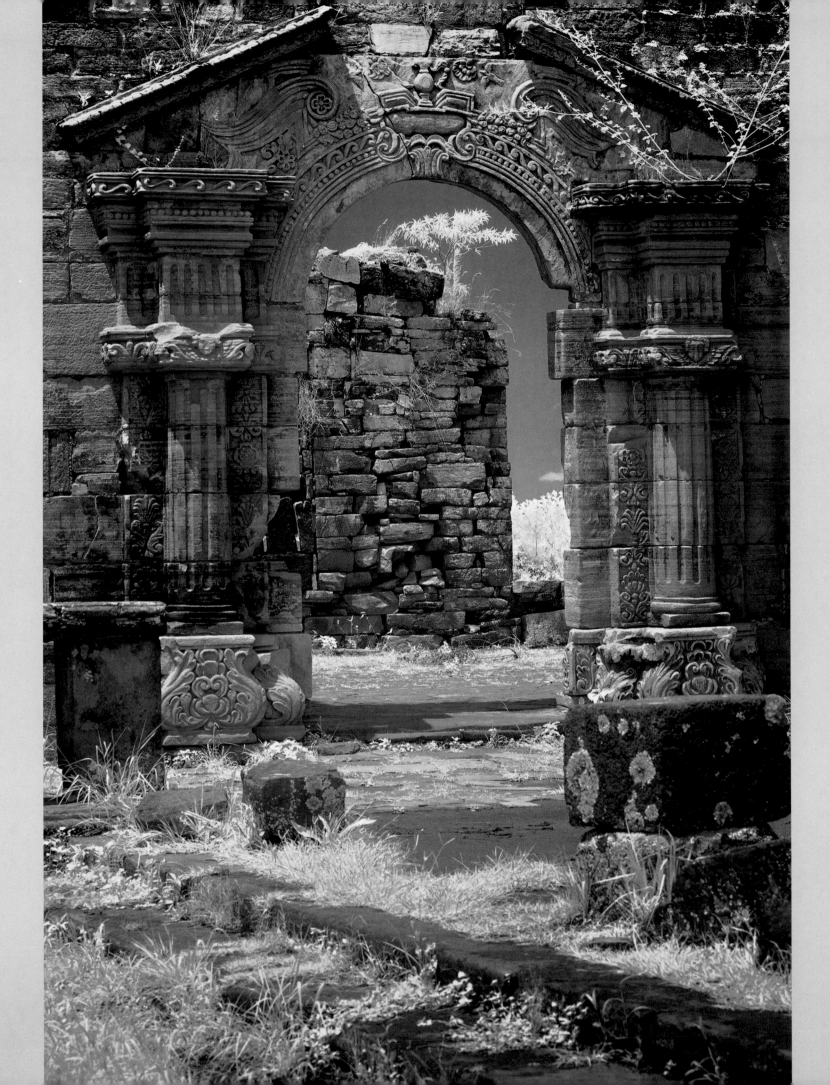

OPPOSITE AND ABOVE: *San Ignacio Miní, Argentina*

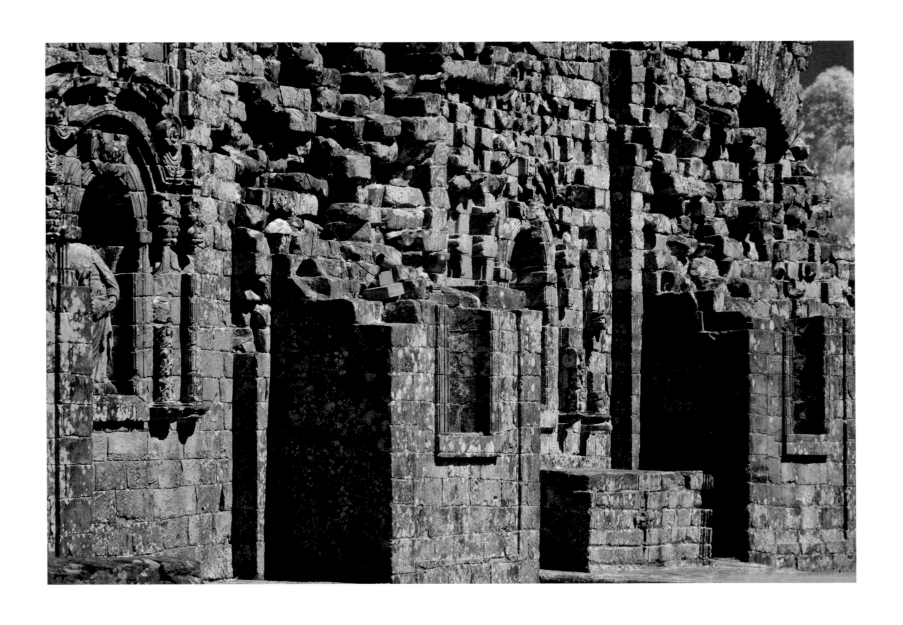

ABOVE AND OPPOSITE: *Trinidad, Paraguay*

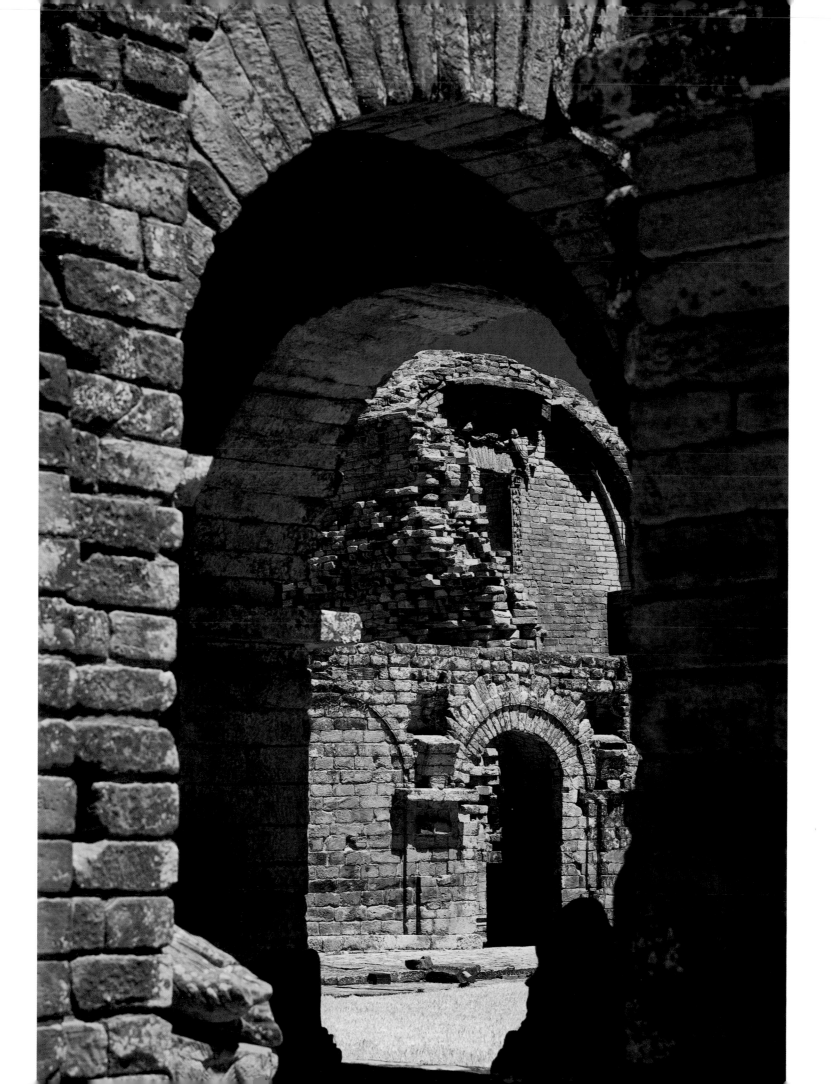

ACKNOWLEDGMENTS ARTHUR DROOKER

Lost Worlds would not have been possible without the involvement of many people. I proudly acknowledge them and their considerable contributions.

Gary Chassman, president of Verve Editions, produced *Lost Worlds.* His dogged pursuit of the right publisher demonstrated his unflagging faith in the project. Quite simply, his belief in *Lost Worlds* made all the difference.

Diana Steel, Marco Jellinek, John Brancati, and Elizabeth Choi at Antique Collectors' Club expressed strong enthusiasm for *Lost Worlds,* resulting in a commitment to publish, thus ensuring a happy ending to this three-year journey.

R. Mac Holbert of The Image Collective performed the imaging of the photographs that appear in *Lost Worlds.* His superior visual artistry and technical wizardry make him an "imagician" of the first order.

Kari Finkler designed *Lost Worlds* with utmost care and sensitivity. Her elegant layout elevates the material, turning fonts and files into magical realms, and history into reverie.

Luis Ernesto Alipaz Loetz, cultural attaché, at the Bolivian Embassy in Washington, D.C.; the Department of Tourism in the Dominican Republic; the Haiti Ministry of Tourism; the Jamaica Tourism Board; the U.S. Virgin Islands Department of Tourism; and the Tourism Authorities of Barbados, Martinique, Panama, and St. Kitts all provided invaluable support and gracious hospitality.

Wonderful hosts, guides, and drivers generously gave their time, shared their knowledge, and patiently stood by as I made my photographs. By the end of my stay in their respective countries, they had become friends. They are: the family of Luis Ernesto Alipaz Loetz (Bolivia), Charlot Altiery and Nic Bussenius (Haiti), Carlos and Bienbo (Dominican Republic), Adelqui Palomino Castañeda and Edwin H. Medina Lattore (Peru), Daffy and Kiddy (Jamaica), Victor Manuel "Coyote" García (Antigua, Guatemala), Alejandro Ricalde and Alejandra Velasquez Rosas (Mexico), and Rodolfo de la Vega (Argentina, Brazil, and Paraguay).

I would also like to acknowledge Penelope Cray and Susannah Hecht, expert proofreaders and copy editors; Evelyn Handler, my travel agent; John Bilotta, webmaster extraordinaire; Jeff Fishman, my financial planner; and friends and family who throughout the making of *Lost Worlds* urged me to "Go and look beyond the Ranges."

Most of all, I owe eternal thanks to my wife, Ivy, who joined me on a few trips, proving that it is indeed possible to be in a relationship and be a photographer at the same time. Her critical eye, fine-tuned ear, and helping hand grace every page of *Lost Worlds.*

BIBLIOGRAPHY

Information about the ruins in this book came from official signage at the sites as well as these sources:

Abou, Selim. *The Jesuit Republic of the Guaranis (1609–1768) and Its Heritage.* New York: The Crossroads Publishing Co., 1997.

Bao, Sandro, et. al. *Lonely Planet: Argentina, 2010.* Footscray: Lonely Planet Publications, 2010.

Bingham, Alfred M. *The Tiffany Fortune and Other Chronicles of a Connecticut Family.* Chestnut Hill: Abeel & Leet Publishers, 1996.

Bingham, Hiram. *Lost City of the Incas.* New York: Phoenix Paperbacks, 2003.

Bourbon, Fabio. *The Lost Cities of the Mayas.* Vercelli: Edozioni White Star, 1999.

Davis, Keith F. *Désiré Charnay: Expeditionary Photographer.* Albuquerque: University of New Mexico Press, 1981.

de la Vega, Garcilaso. *Royal Commentaries of the Incas and General History of Peru.* Parts 1 and 2. Translated by Harold V. Livermore. Austin: University of Texas Press, 1966.

F., Ricardo Agurcia. *Copán: Kingdom of the Sun.* Teguciggalpa: Editorial Transamerica, 2007.

Froude, James Anthony. *The English in the West Indics or The Bow of Ulysses.* New York: Charles Scribner and Sons, 1900.

Graham, Ian. *Alfred Maudslay and the Maya.* London: British Museum Press, 2002.

Hemming, John. *The Conquest of the Inca.* New York: Harcourt, Inc., 1970.

Hill, Oliver. *Moon Handbooks: Jamaica.* Emeryville: Avalon Travel Publishing, Inc., 2007.

Janson, Thor. *Tikal, A Visitor's Guide.* Antigua: Editorial Laura Lee, 1996.

Kelly, Joyce, and Jerry Kelly. *An Archaeological Guide to Central and Southern Mexico.* Norman: University of Oklahoma Press, 2001.

Laughton, Timothy. *The Maya: Life, Myth and Art.* London: Duncan Baird Publishers, Ltd. 1998.

MacQuarrie, Kim. *The Last Days of the Incas.* New York: Simon & Schuster Paperbacks, 2007.

Mann, Charles C. 1491: *New Revelations of the Americas Before Columbus.* New York: Vintage Books, 2006.

Noble, John. *Lonely Planet: Mexico.* Victoria, Australia: Lonely Planet Publications, 2006.

Noble, John, and Susan Forsyth. *Lonely Planet: Guatemala.* Footscray: Lonely Planet Publications, 2004.

Prado, Liz and Gary Chandler. *Moon Handbooks: Yucatán Peninsula.* Emeryville: Avalon Travel Publishing, 2007.

Quirogag, Sylvia and Javier Escalante. *Tiwanaku.* Bolivia: Magica Editores, n.d.

Rider, Nick. *Yucatán and and Mayan Mexico.* Northampton: Interlink Publishing Group, 3rd Ed., 2005.

Rogers, George. "The History and Classification of the Farley Fern, Adiantum tenerum 'Farleyense.'" *American Fern Journal.* 88, (1): 32–46.

Rose, William Ingersoll. *Natural Hazards in El Salvador.* Boulder: Geological Society of America, 2004.

St. Louis, Regis, et. al. *Lonely Planet: Brazil.* Footscray: Lonely Planet, 2008.

Salazar, Fernando E., and Salazar Edgar Elorietta. *Cusco and the Sacred Valley of the Incas.* Cusco: TANKAR E.I.R.L., 2005.

Stephens, John Lloyd. *Incidents of Travel in Central America, Chiapas, and Yucatán.* Vols. 1 and 2. Reprint. New York: Cosimo Classics, 2008 (1841).

Stephens, John Lloyd. *Incidents of Travel in Yucatán.* Vols. 1 and 2. Reprint. New York: Cosimo Classics, 2008 (1843).

Webster, David L. *The Fall of the Ancient Maya: Solving the Mystery of the Maya Collapse.* London: Thames & Hudson, 2002.

Wilkerson, S. and K. Jeffery. *El Tajín: A Guide for Visitors.* S.J.K. Wilkerson: 1986.

Wright, Ruth M., and Alfredo Valenica Zegarra. *The Machu Picchu Guidebook.* Boulder: Johnson Books, 2004.

WEB SOURCES:

Brimstone Hill Fortress National Park (2009). Brimstone Hill Fortress: An Historical Perspective. Retrieved June 13, 2010, from: www.brimstonehillfortress.org

Garcia, Nelly Robles (2000). Monte Alban and Mitla as Themes in the Fields of Archaeology and Restoration. Retrieved November 16, 2010, from: www.saa.org

Jamaica Travel and Culture (2006). Folly Ruins. Retrieved May 12, 2010, from: www.jamaicaravelandculture.com

National Geographic Society (2008). Ancient Temple Discovered Among Inca Ruins by Kelly Hearn. Retrieved August 24, 2010, from: http:///news.nationalgeographic.com

Sacred Destinations (2005–11). Palenque. Retrieved November 30, 2010, from: www.sacred-destinations.com

Sacred Destinations (2005–11). Tiwanaku. Retrieved September 17, 2010, from: www.sacred-destinations.com

Stevens, Al (2003). The Grecas of Mitla. Retrieved November 16, 2010, from: www.ourmexico.com

Teitloff, John (2010). Errol Country, Part II. Retrieved: May 12, 2010, from: www.theerrolflynnblog.com

UNESCO World Heritage Centre (1992–2011). World Heritage List. Retrieved: 2010-2011, from: http://whc.unesco.org

Windows to the Universe Team (2010). Mt. Pelée. Retrieved: April 20, 2010, from: www.windows2universe.org

Wright, David (2001). How Sugar Was Made on St. John During the Danish Colonial Period. Retrieved June 26, 2010, from: www.stjohnhistoricalsociety.org